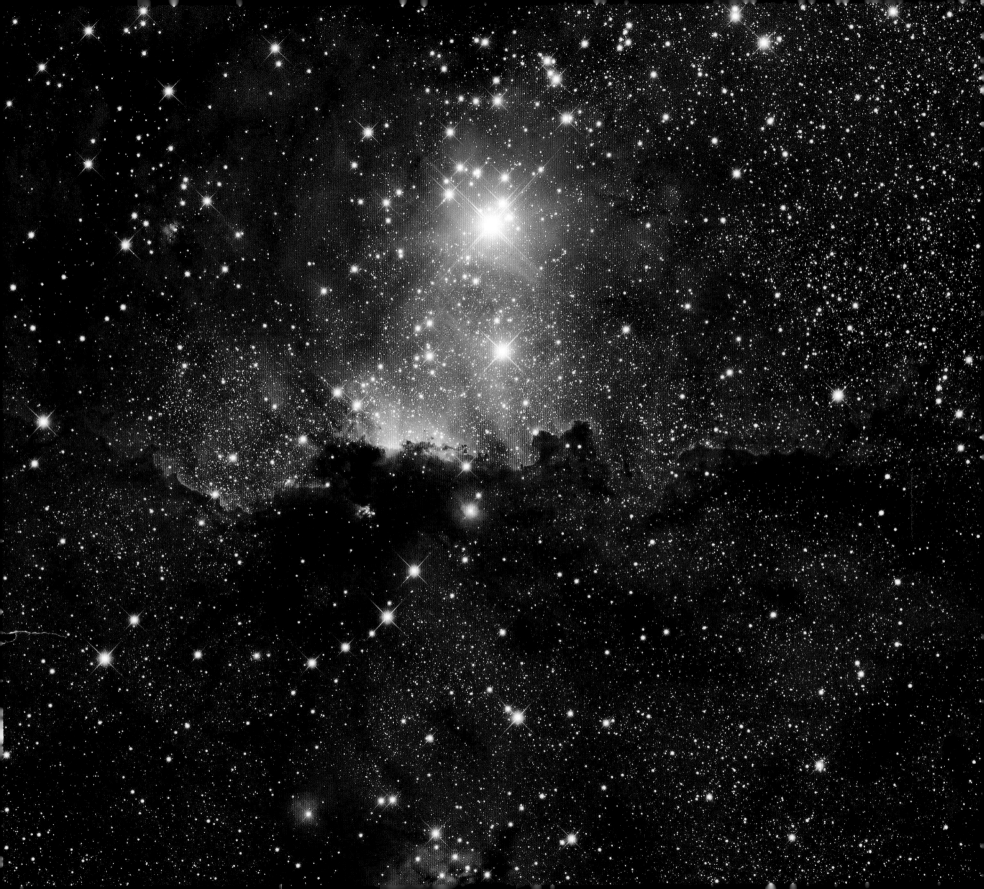

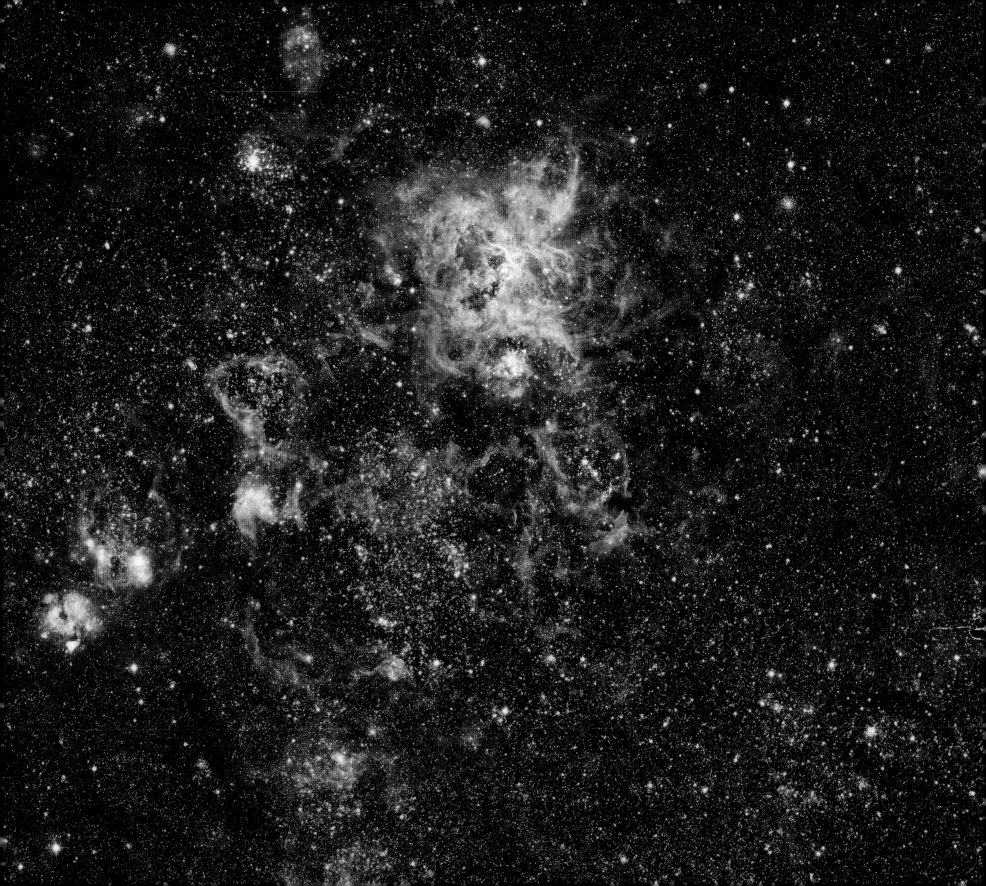

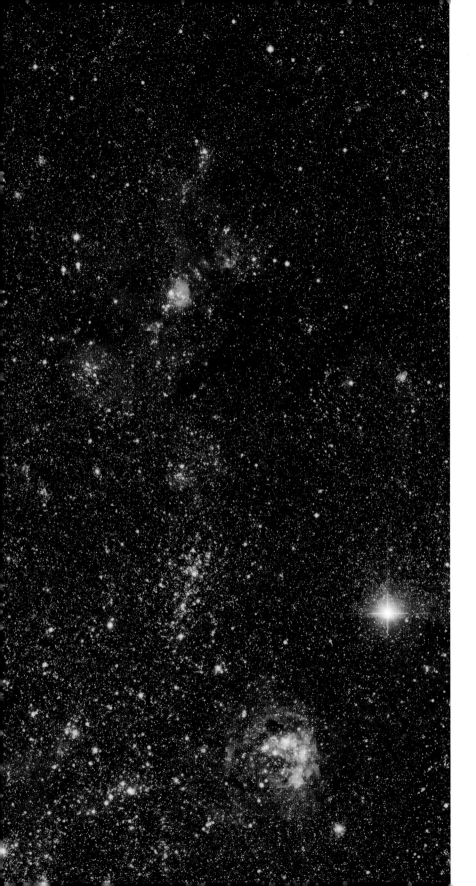

CAPTURING
THE STARS

Astrophotography
by the Masters

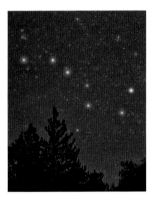

Robert Gendler

Foreword by Neil deGrasse Tyson

Voyageur Press

First published in 2009 by Voyageur Press, an imprint of MBI Publishing Company,
400 First Avenue North, Suite 300, Minneapolis, MN 55401 USA

Voyageur Press titles are also available at discounts in bulk quantity for industrial or
sales-promotional use. For details write to Special Sales Manager at MBI Publishing
Company, 400 First Avenue North, Suite 300, Minneapolis, MN 55401 USA.

To find out more about our books, visit us online at www.voyageurpress.com.

Library of Congress Cataloging-in-Publication Data

Capturing the stars : astrophotography by the masters / by Robert Gendler ;
foreword by Neil deGrasse Tyson. — 1st ed.
 p. cm.
 Includes index.
 ISBN 978-0-7603-3500-0 (hb w/ jkt)
 1. Space photography. 2. Astronomical photography. I. Gendler, Robert.
 TR713.C37 2009
 779'.9523—dc22
 2008042493

Editor: Danielle Ibister
Designer: Cindy Samargia Laun

Printed in China

Page 1

The stellar nursery NGC 6188 has formed generations of young, vibrant stars and iridescent nebulae. *Robert Gendler and Martin Pugh*

Page 2

The interlocking giant shells and hollow cavities of the Tarantula Nebula are believed to have formed from generations of powerful stars and their supernovae. *Robert Gendler*

Page 3

The Big Dipper comprises the seven brightest stars of the constellation Ursa Major, the Great Bear. *Bill and Sally Fletcher*

Page 6

Abell S0740 is a dazzling assortment of galactic specimens 450 million light years distant. *Lisa Frattare and Zolt Levay*

Page 8

The phenomenon Baily's Beads is exhibited during the total solar eclipse of 2006. *Fred Espenak*

Page 10

A core of massive stars illuminate the Trifid Nebula (M20). *Johannes Schedler*

Page 12

Although Sunspot 898 appears small against the sun's disk, its size approaches that of the planet Neptune. *Greg Piepol*

Page 14

The Large Magellanic Cloud is a nearby dwarf galaxy named for the explorer Ferdinand Magellan, who noted its presence in 1519. *Robert Gendler*

Front cover
Whirlpool Galaxy. *Lisa Frattare and Zolt Levay*

Back cover
IC 1274. *Jean-Charles Cuillandre and Giovanni Anselmi*

To all photographers past and present
who have aspired to capture
an extraordinary moment in time.

To my father, a photographer by profession,
who by nature and nurture has shaped my passion.

—*R. G.*

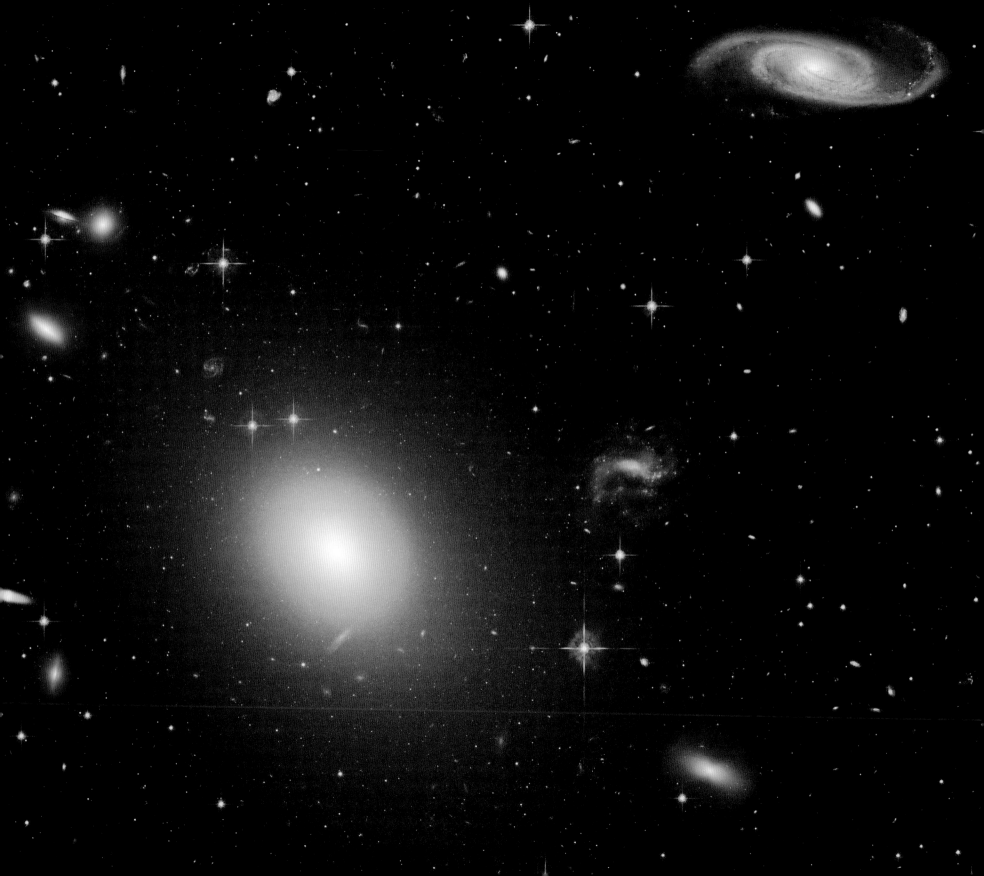

There is no end.
There is no beginning.
There is only the passion of life.

—*Federico Fellini*

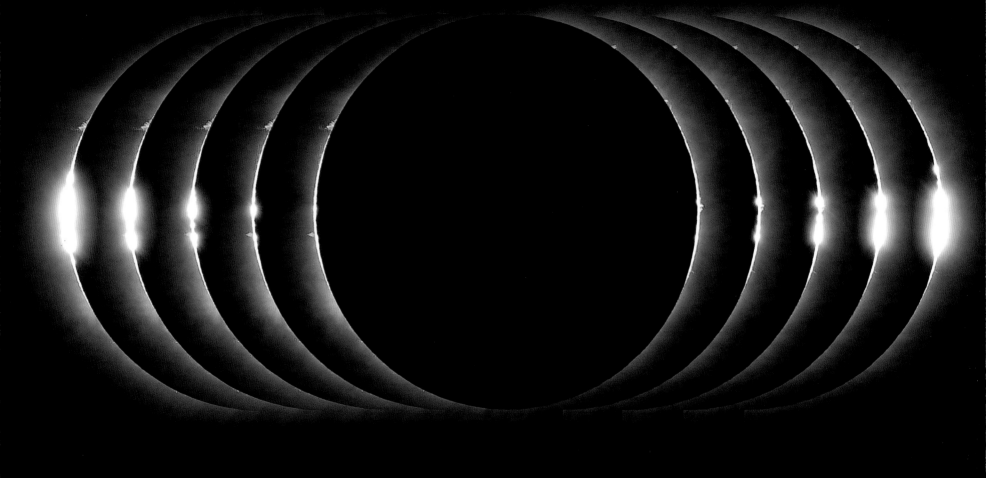

CONTENTS

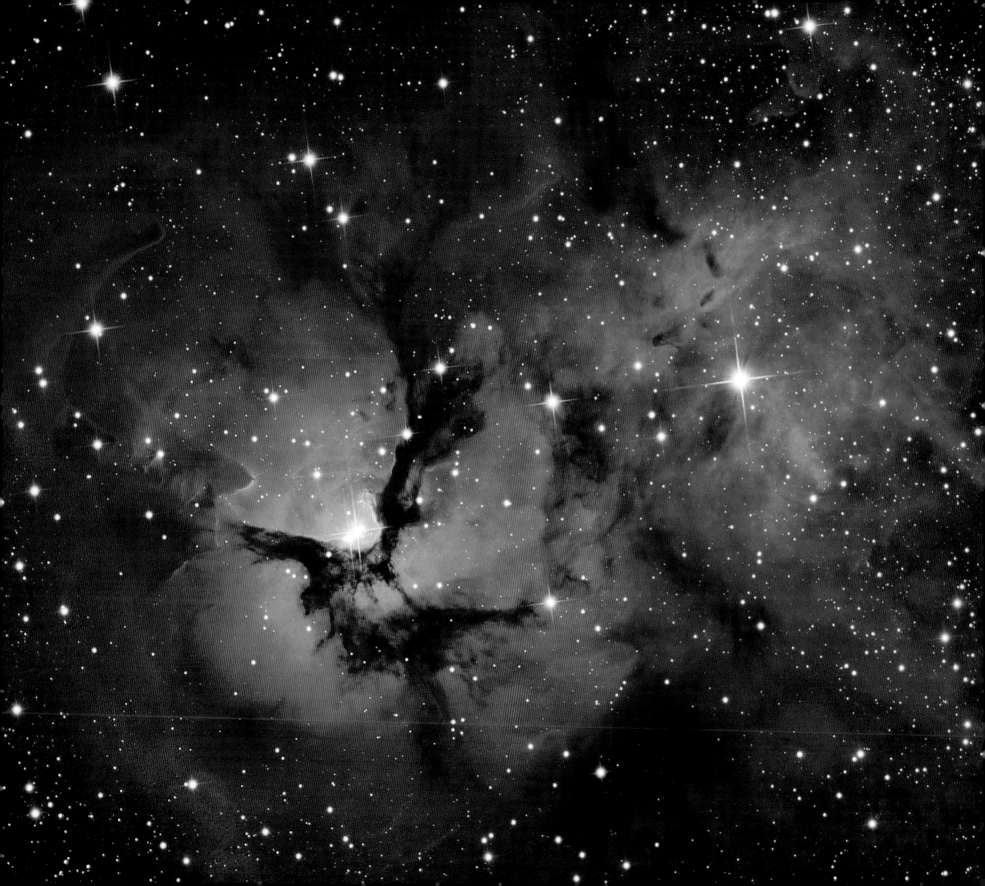

FOREWORD
BY NEIL DEGRASSE TYSON

IN ASTROPHOTOGRAPHY, unlike all other branches of this noble art, the cosmic photographer does not get to illuminate the subject or tell the subject to stand a different way to improve the angle of view. The sky above is just "there." The objects in it are just "there." Not only that, the extreme light travel time from the depths of the universe to Earth forces the photographer to view most objects not as they are but as they once were, long ago. Beyond these profound limitations, one might be further surprised to learn that the most interesting objects in the universe are so dim that the photographer does not even see in advance what the picture will become when fully exposed. Astrophotography might then be the humblest of hobbies, even while its subject draws from the most beautiful vistas there ever were.

In modern times we have no shortage of beautiful cosmic images from celebrated professional sources, such as the Hubble Space Telescope. So why turn to an atlas chock full of images taken not just by professionals but by amateur astronomers with their personal cameras from their suburban backyards? First, the era of affordable digital detectors greatly reduces the relative advantage that a professional telescope formerly had over amateur equipment. Second, the field of view of professional telescopes is generally quite small. The Hubble, for example, sees no more of the night sky than 1/100 the area of the full moon. Meanwhile, an amateur setup using a simple camera, or a camera combined with a moderate-sized telescope, can capture large swaths of sky—in some cases, entire constellations—revealing dim but large-scale features within our own Milky Way that would otherwise lay undiscovered in front of our noses.

As we have known for some time, Earth rotates continuously. As these large-scale features drift by, any attempt to expose an image for more than a few seconds blurs the stars and other light-emitting objects, just as would a time lapse of car headlights along a highway. To avoid this, one must somehow compensate precisely for Earth's rotation. Of course, the clock drive was invented long ago to solve just this problem. Some clock drives even allow you to make adjustments to follow objects, such as comets, that are themselves in motion against the drifting background sky. In all cases, the sharpness of a final image depends heavily on how well the clock drive works, especially for the longest of exposures one may require.

The camera and telescope combo operates like a light bucket. In a fraction-of-a-second exposure, such as what the brain does with human vision, you can detect only so much light. But with full control over exposure time, combined with the highly sensitive digital detectors used in modern cameras, you can fill your bucket with as much light as you like—exposing the scene for as long as you have the patience to support and as long as you trust the stability of your clock drive. A single image can take several minutes to expose. Others can take several hours; still others, the most challenging targets of the night sky, may require many nights of work.

With each added moment of exposure, the gossamer, ghostlike features of a nebula or a galaxy become brighter, more delineated, more revealed. Like the sculptor in *Pygmalion*, where each strike of the hammer and chisel brings the subject closer and closer to life, the astrophotographer exposes the detector until the subject rises from the depths of space to become a work of art unto itself. And whether or not the nebula or galaxy comes to life, what's certain is that, as in *Pygmalion*, the astrophotographer falls in love with the images themselves.

In this case, Robert Gendler's *Capturing the Stars* cannot be read and viewed without feeling that these committed photographers are smitten by the universe and hopelessly enchanted by the objects it contains, while inviting the reader to be similarly taken by their splendor.

Neil deGrasse Tyson, though a professional astrophysicist for more than two decades, continues to count himself among the ranks of amateur astronomers—an association he has held since the age of twelve, when he took his first photographs of the night sky. Tyson is director of New York City's Hayden Planetarium at the American Museum of Natural History and is the author of nine books on the universe, most recently *Death by Black Hole: And Other Cosmic Quandaries* and *The Pluto Files: The Rise and Fall of America's Favorite Planet.*

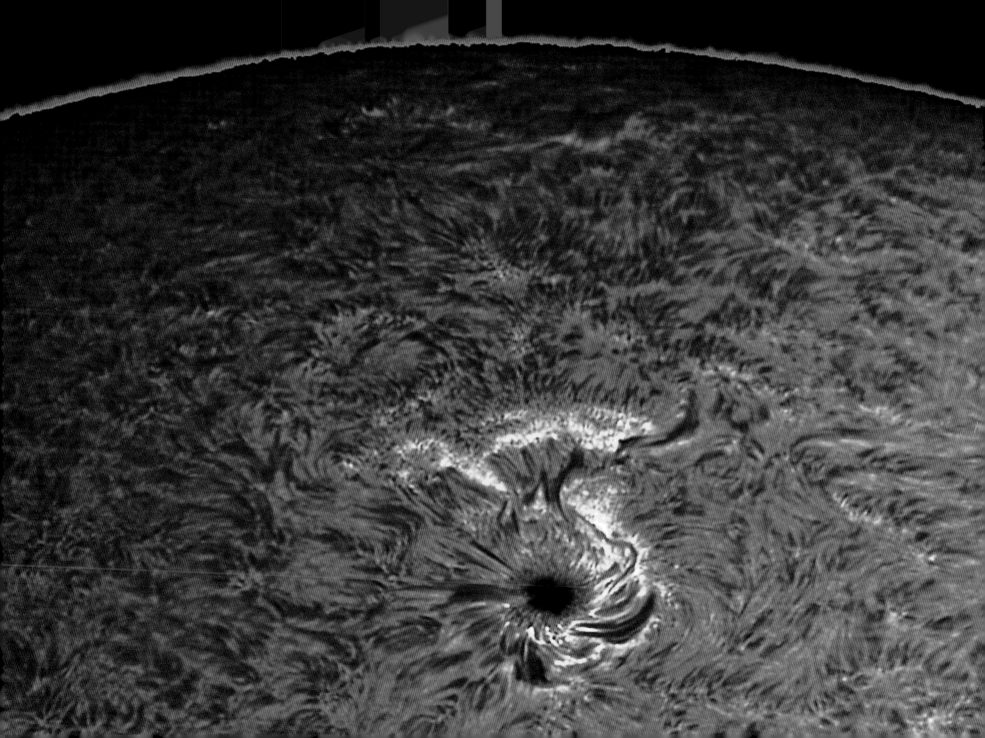

PREFACE

THE CORE OF THIS BOOK relates to astrophotographers and their art. The essence of this photographic compilation is to bring to print the most provocative and visually compelling portraits of the deep sky and of local astronomical phenomena taken by the world's most accomplished astrophotographers. The modern astrophotographic process can be broken down into the technical and the artistic. The technical aspect is substantial and requires technical precision and refinement of the highest order. It is beyond the scope of this book to list the numerous technical innovators who were so vital to establishing the enormously sophisticated state of modern astronomical imaging that we enjoy today. That said, in a few cases the successful practitioners and technical innovators were one and the same.

Capturing the Stars pays homage to the most accomplished practitioners of the art of astronomical imaging—professional and amateur, past and present—who have produced the most stunning, creative, and significant astronomical images of their time. The book features thirty-five astrophotographers from fourteen countries, a testament to the degree of international participation in astrophotography today. The one common thread among them is an obsession with recording phenomena of the night sky and a great joy in sharing their passion and spectacular results with the rest of the world. When passion exists, it often compels people to do extraordinary things. The astrophotographic masterpieces in the following anthology have already been recognized as extraordinary, but the images have not yet appeared together under the same cover until now. They were produced by an elite group of dedicated and talented people from around the world who have established original techniques, styles, and directions in astrophotography and who have set the standard for astronomical imaging in their time. The results of their dedication, creativity, and untiring labor are revealed in the pages ahead.

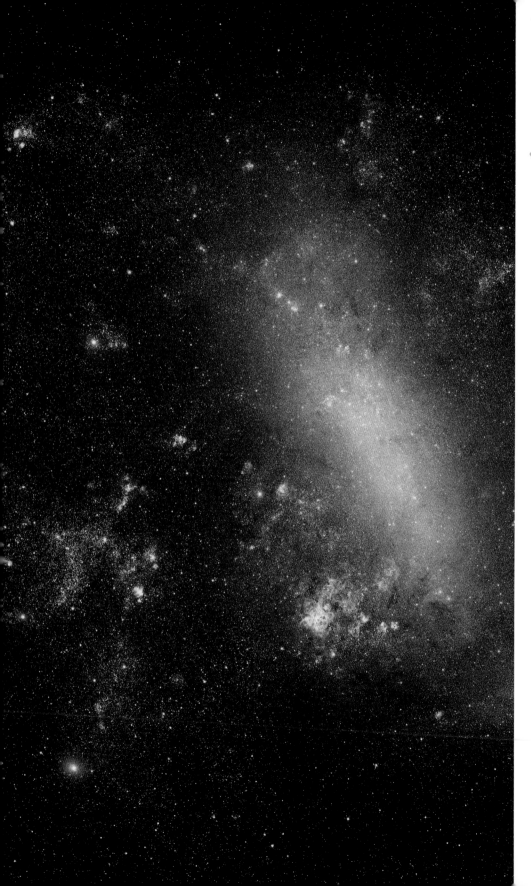

SOON AFTER THE ANNOUNCEMENT of the first photograph in 1839 by Louis Daguerre, a camera was turned toward the moon and, with the awkward snap of a primitive shutter, heralded the age of astrophotography. Photographs of the sun, planets, stars, and comets soon followed. The first long-exposure photograph of a deep-sky object—the Orion Nebula—was recorded in a fifty-one-minute exposure by Henry Draper in September 1880. It was followed by a photograph of the Andromeda Galaxy in 1884, taken by A. A. Common. In 1923, in one of the great milestones of astrophotography, Edwin Hubble made history by resolving stars in the Andromeda Galaxy using the 100-inch Hooker Telescope at Mount Wilson Observatory in California. This event defined the beginning of modern cosmology: Galaxies were now recognized as individual island universes receding from each other, formed from a common beginning.

Over the next century, innovations were directed at overcoming the chief limitation of film, known as reciprocity failure, which imposed serious limitations on recording faint celestial objects. Various techniques such as heating, cooling, baking, and, later, gas hypersensitization all achieved partial success in making film more suitable for deep-space astrophotography. In 1969, the world of astrophotography underwent an extraordinary revolution when Willard Boyle and George E. Smith of Bell Labs used a charge-coupled device to record images electronically. The charge-coupled device (CCD), a linear recorder of light, overcame the problem of reciprocity failure and propelled astrophotography into the modern age.

A series of technical advances during the next few decades transformed the early CCDs from primitive devices into highly efficient, low noise, large-format light detectors capable of pushing the limits of depth, detail, and color well beyond what was possible with film. Joined to modern telescope designs, the CCD has produced astounding cosmic images along with an explosion of new knowledge and astronomical discoveries.

The transformation of astrophotography from a technical craft to a photographic art form began only recently. For more than a century after its inception, astronomical imaging remained exclusively a technical exercise. The astrophotographer was considered a skilled technician, at most an "artisan," whose photographs made possible advancements in the science of astronomy. Between the late 1940s and the 1960s, astrophotography remained within the domain of large professional observatories, particularly the renowned Mount Wilson and Palomar observatories, whose sky surveys produced many of the most famous and inspiring astrophotographs of that era. William C. Miller produced the first color-corrected astrophotograph in 1958, but it wasn't until David Malin's work in the 1970s and '80s, at the Anglo-Australian observatory, that color astrophotography came into its own. Malin's monumental tricolor film images established astronomical photography not only as a tool of science but as "works of photographic art."

Although amateurs had always played an important role in advancing astrophotography, it is only within the last two decades that high-precision telescope and imaging equipment have become available to nonprofessionals as "off the shelf" products. Finally, a remarkable craft was accessible to those enthusiasts eager to pursue astrophotography for nothing other than pleasure. In the hands of these "amateurs," astrophotography flourished and matured. Although accepted for some time in the realm of traditional photography, the concepts of creativity and personal expression were embraced only gradually and cautiously in the world of astrophotography. Following the digital revolution, imagers increasingly adopted key concepts from traditional photography, such as composition and elements of visual impact. They integrated these traditional ideas with newer techniques for the enhancement and manipulation of light and color, ultimately applying them in new ways to produce works of extraordinary visual impact and refreshing creativity. Over time, many amateur astrophotographers began to establish their own personal styles. The last decade, in particular, has witnessed a defining transformation in the field of astrophotography. Once an arcane cousin of traditional photography, astrophotography has arrived as a valid and worthy art form in its own right. With this transformation, the term "astrophotographer" has been redefined: The "artisan" of photographic astronomy is now the "artist" of the night sky.

Astrophotography serves both art and science. The rewards are profound and exhilarating; however, the rigor of astrophotography is less well known. Over the years, the difficulties have shifted from one aspect of the process to another. Early on it was the maddening task of guiding the telescope by hand for hours on end while trying to expose an image. Early astrophotography was essentially an endurance sport that tested the limits of concentration and sleep deprivation. The photographers were often stationed outdoors, exposed to the elements, and pushed to their physical limits. Some have claimed that this practice shortened the life of the pioneer astrophotographer Edward Barnard. Later, the emphasis shifted to darkroom wizardry with the astrophotographers' time and effort focused on the task of extracting information buried within photographic emulsions. In today's electronic imaging age, the challenges have shifted once again and are now directed at mastering the myriad software tools required to extract data from millions of tiny pixels that compose the large CCD arrays in use today. The development and mastery of digital enhancement methods has lifted astrophotography into a new era, taking it to astonishing degrees of depth, detail, and color and creating endless opportunities for creativity and visual impact.

Times and techniques have surely changed, but in a fundamental sense, the essence of astrophotography has remained pure. From glass plates to film to silicon detectors, the dream of the astrophotographer has always been the same: to capture and share a moment of exalted natural beauty and to learn through imagery the truth about our cosmic world. These scenes, which we are unable to behold with our own eyes, are brought to life through the marvels of astrophotography.

EDWARD EMERSON BARNARD

EDWARD EMERSON BARNARD (1857–1923) is one of the most recognized names in the history of astronomical observation and photography. He grew up in Tennessee during the Civil War. After an impoverished childhood, Barnard followed his passion for astronomy, ultimately becoming an observer and astrophotographer at the famous Lick Observatory in California and, later, the director of the Yerkes Observatory in Chicago.

Critical to Barnard's success was an enormous capacity for work and an equally enormous determination to succeed at whatever astronomical project was placed before him. His career began at the age of nine as an errand boy for a local photographer. In his teenage years, he observed the night sky through a series of modest telescopes. When he turned twenty, he used most of his savings to purchase a high-quality 5-inch refractor and equatorial mount. With this modest instrument, he began to conduct serious observations of planets, nebulae, and comets. Before long, his keen observing skills and growing list of comet discoveries earned him a reputation as a prolific astronomical observer and successful comet discoverer.

In 1888, Barnard's accomplishments led him to an observing position at the Lick Observatory in Mount Hamilton, California, where construction of the massive 36-inch Lick refractor was nearing completion. He spent eight years at Lick and continued his comet work, which ultimately led to sixteen comet discoveries in his lifetime. At that time, he began to turn his attention to photographing the Milky Way. He honed his photographic skills using a refigured 6-inch portrait lens fitted on an equatorial mount. His photographic sessions were grueling by any standards, testifying to his determination and endurance. Typically, he made exposures lasting four to five hours, all manually guided, sometimes in subzero conditions.

In 1895, Barnard took the position of Chief Observer at the Yerkes Observatory in Chicago, home of the giant 40-inch Yerkes refractor. After ten years at Yerkes, frustrated by the poor visibility and cloudy conditions of Chicago, Barnard transported his prized photographic instrument, the 10-inch Bruce photographic telescope and equatorial mounting, to the dark skies at Mount Wilson Observatory in California. During his eight months there, Barnard completed his most legendary achievement: He exposed and developed five hundred photographs of the Milky Way, concentrating on the "dark nebulae" that so intrigued him. His work during this period became his lasting legacy. Soon after his death in 1923, Barnard's *Catalogue of 349 Dark Objects in the Sky: A Photographic Atlas of Selected Regions in the Milky Way* was published. The catalog of Barnard objects is still in popular use today by amateurs and professionals alike.

The Rho Ophiuchus Nebula

This splendid vista, beautiful even in grayscale, was one of the many wide-field portraits Barnard made of his cherished subject, the Milky Way. It focuses on the Rho Opiuchus Nebula, a hot spot of star formation in the summer Milky Way. (See page 149 for a modern color image of this same vista.)

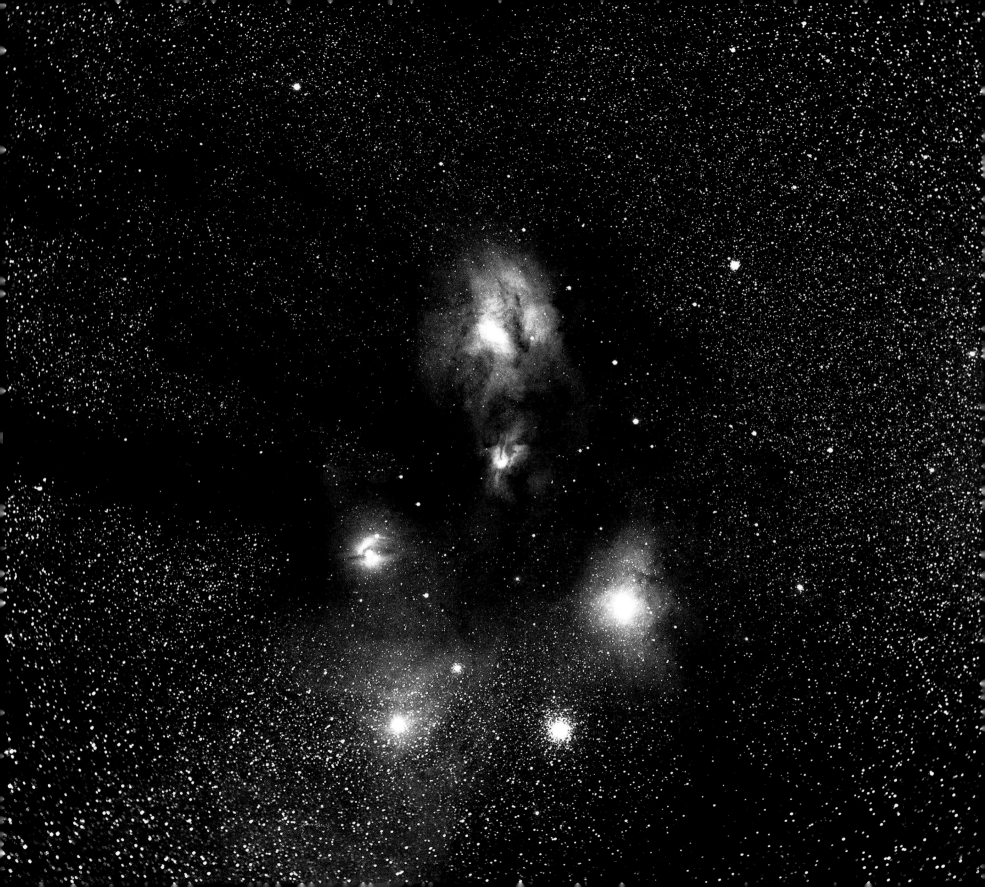

WILLIAM C. MILLER

WILLIAM C. MILLER (1910–1981) WAS A TRUE PIONEER in the field of astro-photography. Those practicing the craft today may not realize the extent to which we are indebted to Miller for his early work in producing color-corrected astronomical photographs. Miller worked for the Mount Wilson and Palomar observatories from 1948 to 1975 as a photographic engineer. He originated or refined many of the photographic techniques used by the large professional observatories of that time. Like many astrophotographers before and since, Miller had no formal training in astronomical photography. He had diverse backgrounds in optics, physics, engineering, and astronomy and used these to expand the techniques of astrophotography practiced at that time. Miller did most of his work using the 200-inch Hale and 48-inch Schmidt telescopes at the Mount Wilson and Palomar observatories. Specific contributions made by Miller include the development of hypersensitizing methods such as baking and immersion of photographic emulsions in forming gas to make them more sensitive to low light levels. Miller also produced some of the first realistic color-corrected astronomical photographs, which helped pave the way for the modern era of color film and, later, CCD imaging.

Courtesy of David Malin

The Andromeda Galaxy

This image of the Andromeda Galaxy (M31), originally exposed in 1958 by William C. Miller and later digitally remastered by David Malin, represents one of the first true-color astronomical images ever produced. It heralded a new era of color astrophotography.

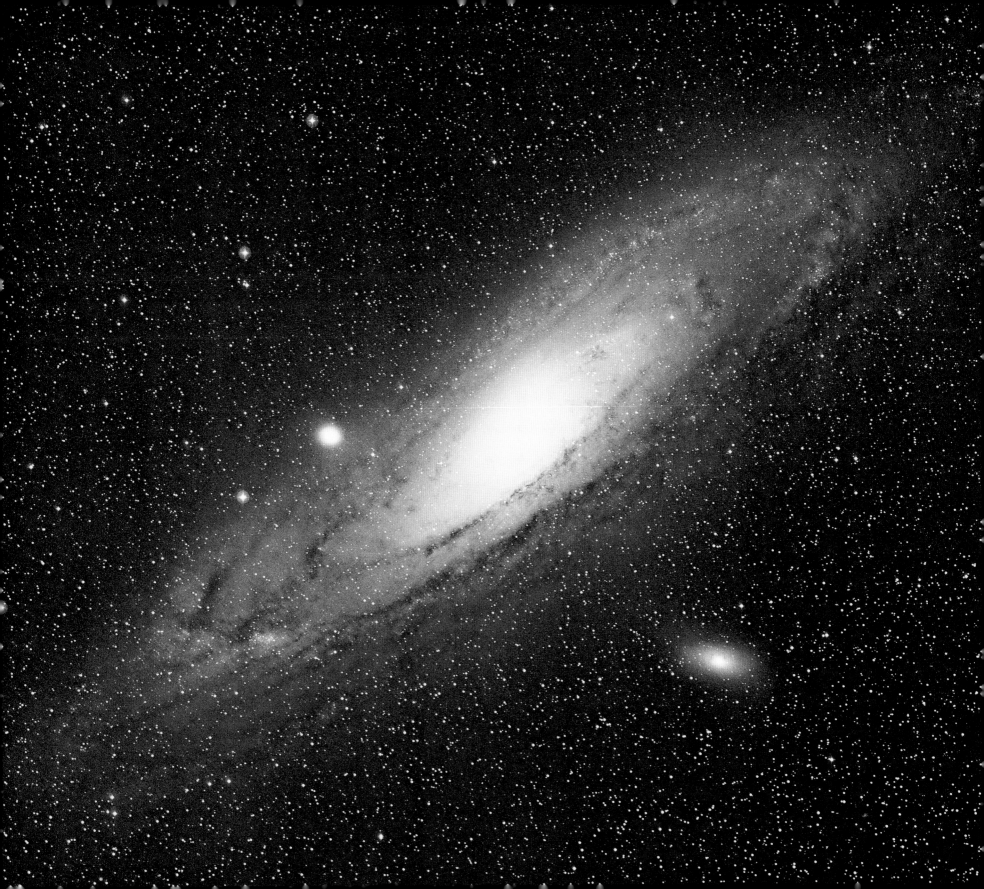

\mathcal{P}ER-MAGNUS HEDÉN

Courtesy of Per-Magnus Hedén

SWEDISH ASTROPHOTOGRAPHER PER-MAGNUS HEDÉN GREW UP OBSERVING the wonders of the night sky. He specializes in photography that integrates astronomical scenes with terrestrial landscapes or manmade structures such as historic buildings. His wide variety of sky subjects includes galaxies, nebulae, northern lights, solar imaging, and high clouds that are luminescent at night, called noctilucent clouds. His particular brand of astrophotography allows him mobility and the freedom to explore new and creative ways to photographically capture many aspects of nature during day and night.

Northern Lights and the Milky Way

In this surreal scene, a light show in the uppermost layer of the atmosphere casts fantastic colors onto the horizon, its hues merging with the star clouds of the Milky Way.

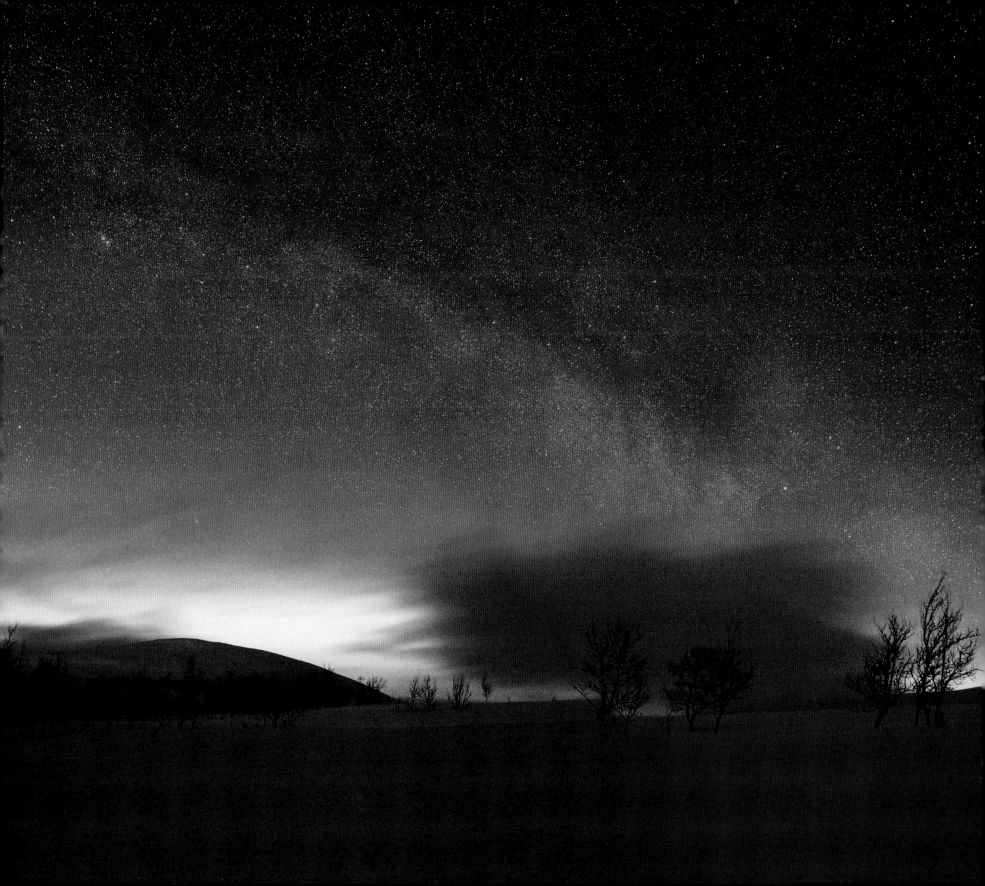

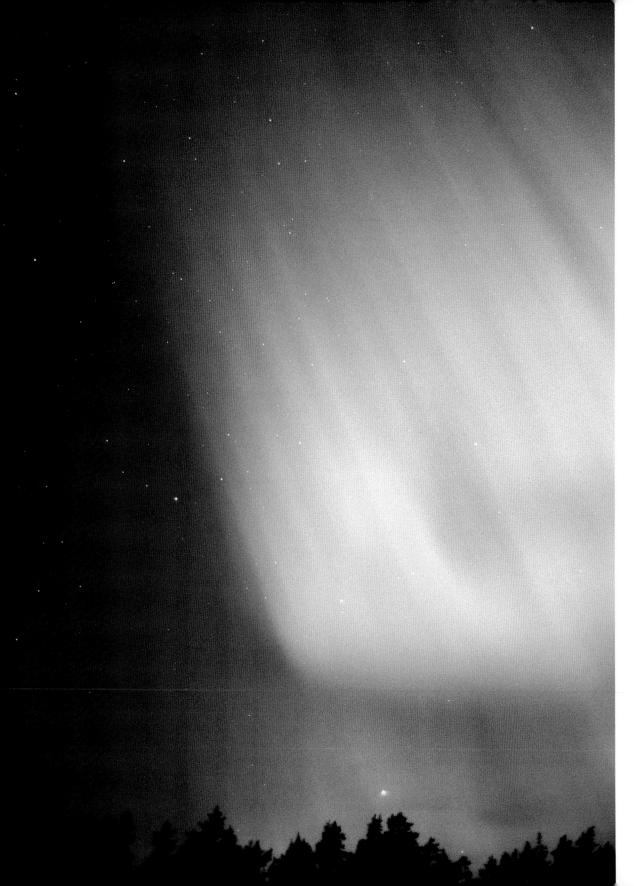

The Wall

In a magnificent example of northern lights, broad curtains of colorful light appear to point skyward.

Blue Aurora ▷

This blue aurora has its origin in a collision of charged particles. The particles are ejected by the sun and carried by the low-energy solar wind to Earth, where they interact with molecules in the upper atmosphere, creating the light show known as an aurora.

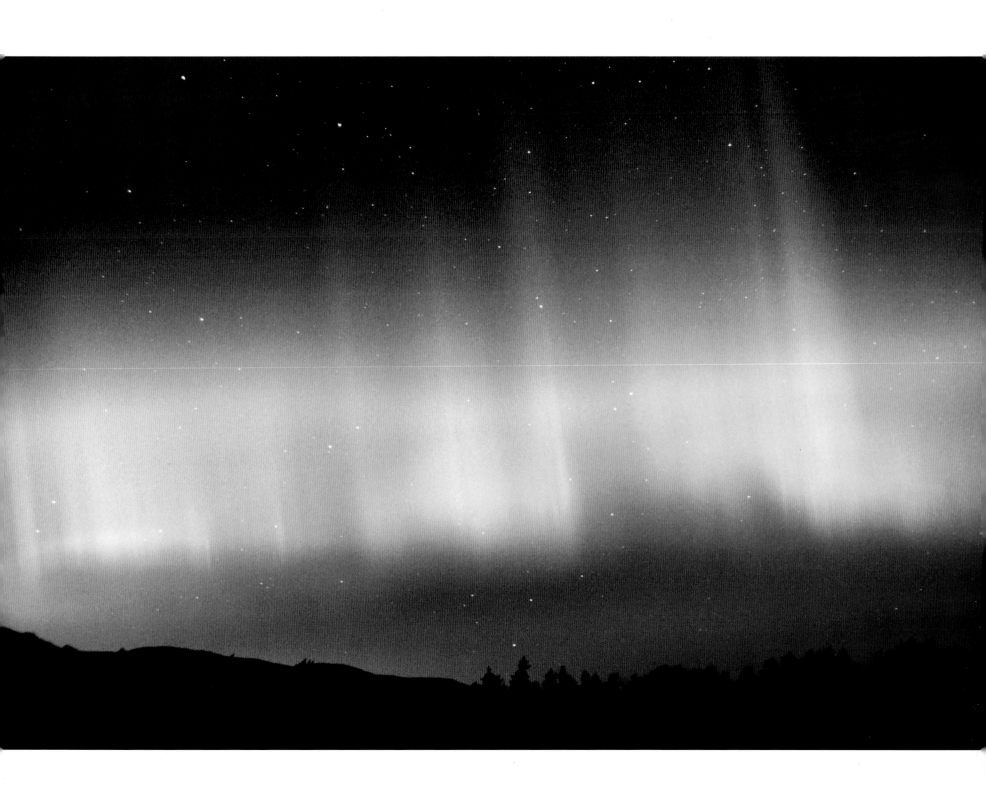

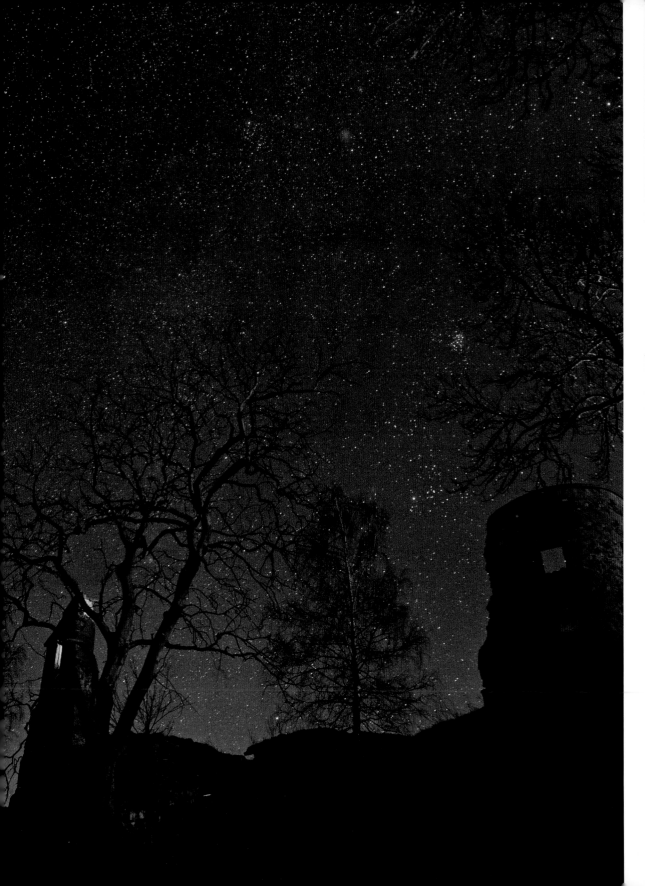

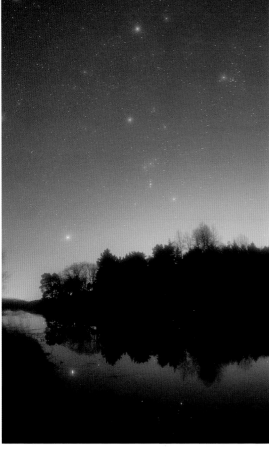

▲ Stars of Orion

The blue and red supergiant stars of the constellation Orion rise above a lake and trees in this dreamy winter evening composition. Below the bright stars of Orion's belt lies the Orion Nebula (M42), one of the great telescopic showpieces of the winter sky. (See page 150 for a closer view of M42.)

◄ Castle Ruins and Comet Holmes

Comet Holmes, faintly visible in the sky, is framed by castle ruins and tentacle-like tree branches in this hauntingly beautiful winter skyscape.

The Big Dipper over Ancient Rocks ▶

The Big Dipper rises over a fossilized coral reef on the island of Gotland in Sweden. The scene is softly illuminated by the glow of the setting moon.

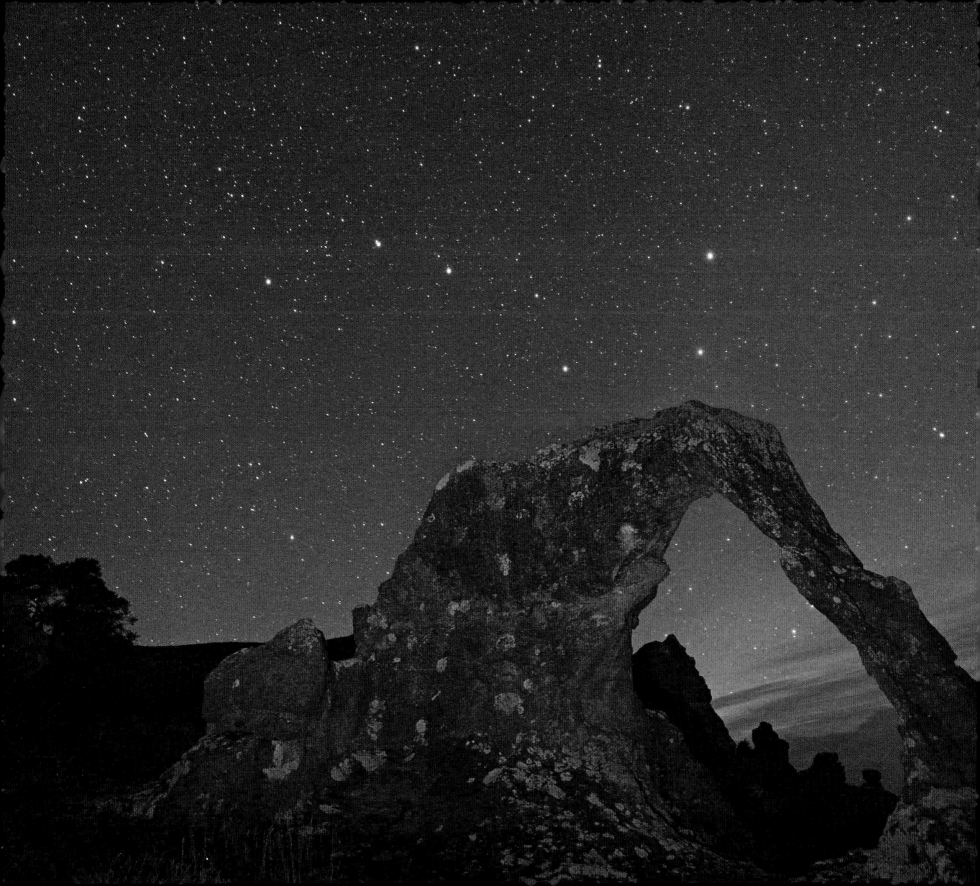

ARNE DANIELSEN

Courtesy of Thrond Falch Danielsen

ARNE DANIELSEN IS A COMPUTER SOFTWARE ENGINEER living in Norway. He grew up on a small farm in the countryside, which gave him easy access to dark skies. He recalls "learning about astronomy in the fourth grade and feeling immediately hooked." After attending college, Danielson moved to Oslo and began to fulfill his dream of pursuing amateur astrophotography. He bought his first CCD camera and constructed his own observatory near his home. His interest in imaging came just in time to enjoy Comets Hyakutake and Hale-Bopp and five years of spectacular activity from the Leonid meteor shower (1998–2003). Danielson photographs a diverse variety of atmospheric events. He says, "With the ever-changing weather in Norway, I have the opportunity to photograph all types of atmospheric phenomena, such as aurora borealis, noctilucent clouds, nacreous clouds, halos, etcetera, which has expanded my definition of astrophotography. In this way, I can pursue astrophotography even when the sky is not clear and during the bright Nordic summer nights."

Leonid Fireball

An exceptionally bright Leonid meteor lights up the sky from the mountains of southern Norway on November 18, 1999.

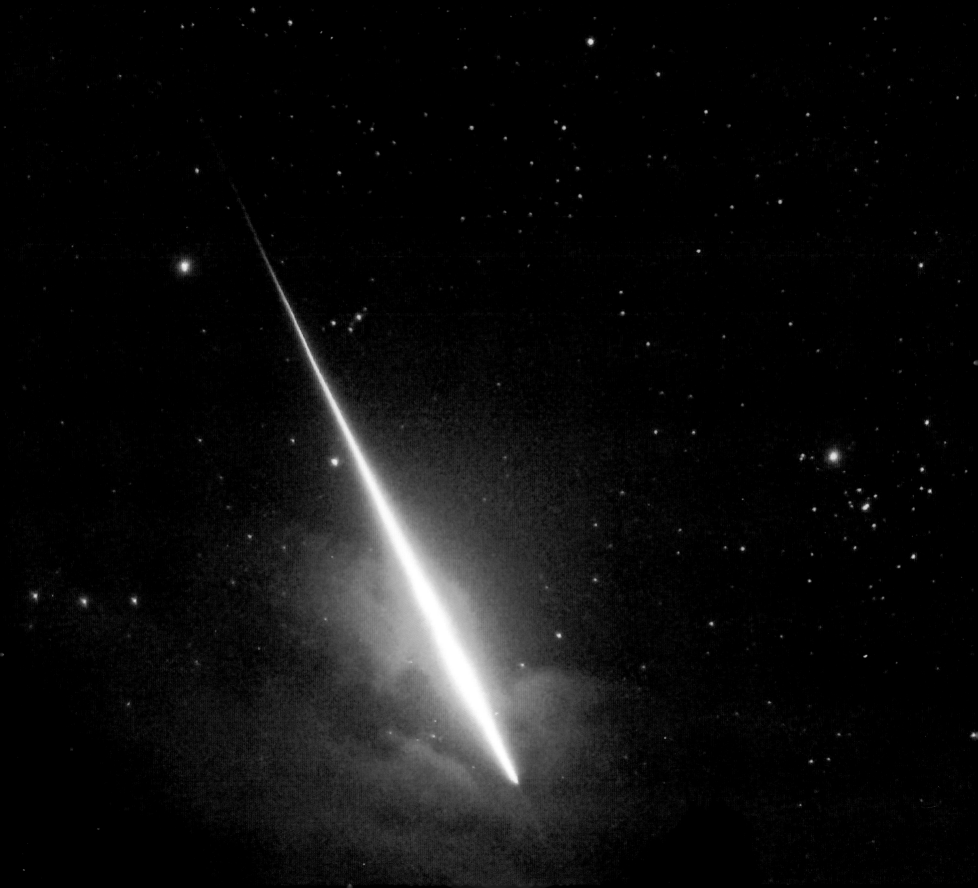

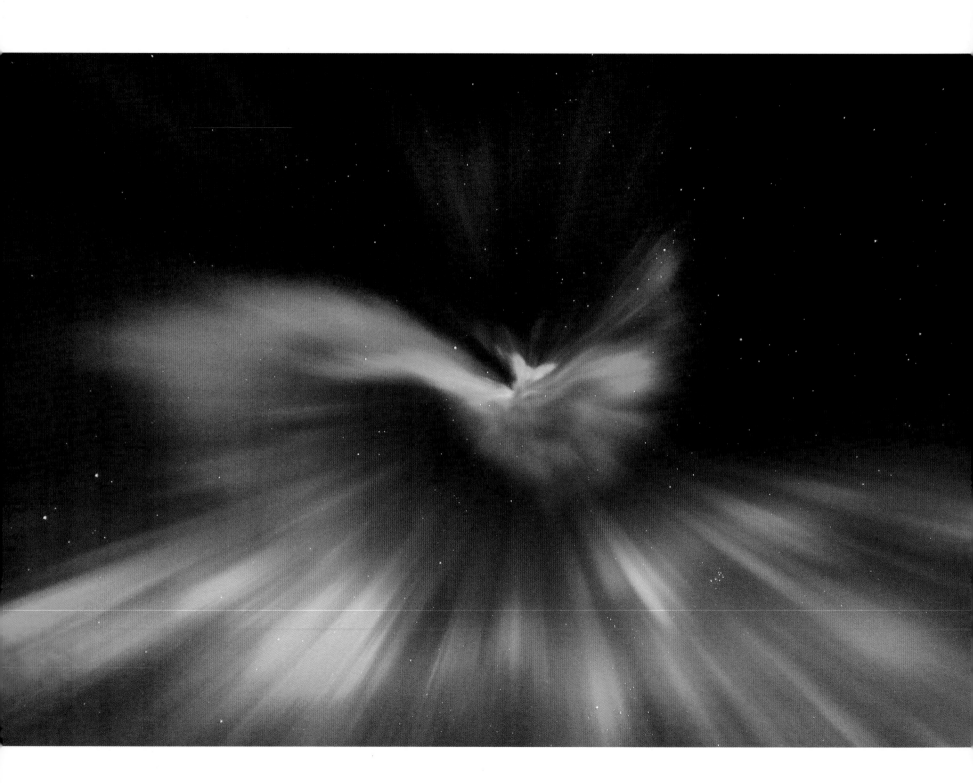

ARNE DANIELSEN

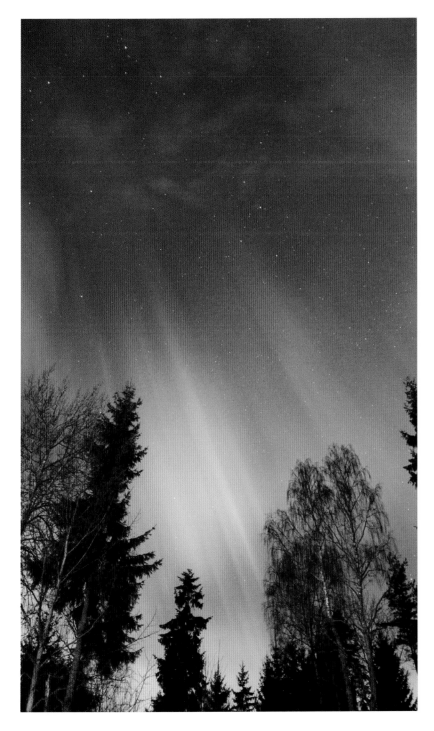

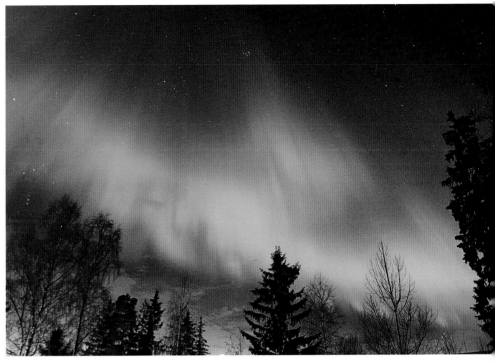

Aurora Borealis on November 8, 2004, Langhus, Norway

These three images were taken the same night during an exceptionally bright display of northern lights. Glowing modulations of light form a variety of rays, arcs, and curtains. Each ray lines up along the direction of Earth's magnetic field as excited molecules in Earth's upper atmosphere collide and release their energy in the form of visible light. Green and red hues are produced by excited oxygen, while blue auroras are produced by nitrogen in the earth's atmosphere.

BILL AND SALLY FLETCHER

Courtesy of Bill and Sally Fletcher

BILL AND SALLY FLETCHER MOVED TO THE SADDLE PEAK AREA of southern California's Santa Monica Mountains in the early 1980s after leaving a career in the music recording business. The dark skies of the mountain-top compelled them to purchase their first telescope in 1983 and to learn the complex techniques of "through-the-telescope" photography. They are now avid astrophotographers and go anywhere dark skies lead them. Their images have appeared in books and magazines around the world. Beginning in 1998, they perfected a technique for photographing constellations utilizing controlled fogging of the brightest stars, which succeeded in scattering the light and enhancing the true colors. The technique leaves the background stars and objects unaltered, creating evocative, richly colored portraits of the constellations.

Cygnus and Lyra

This rich wide-field image showcases not only the bright stars of the constellations Cygnus and Lyra but also the summer Milky Way and several notable summer nebulae such as the North American, Gamma Cygni, and Veil nebula complexes.

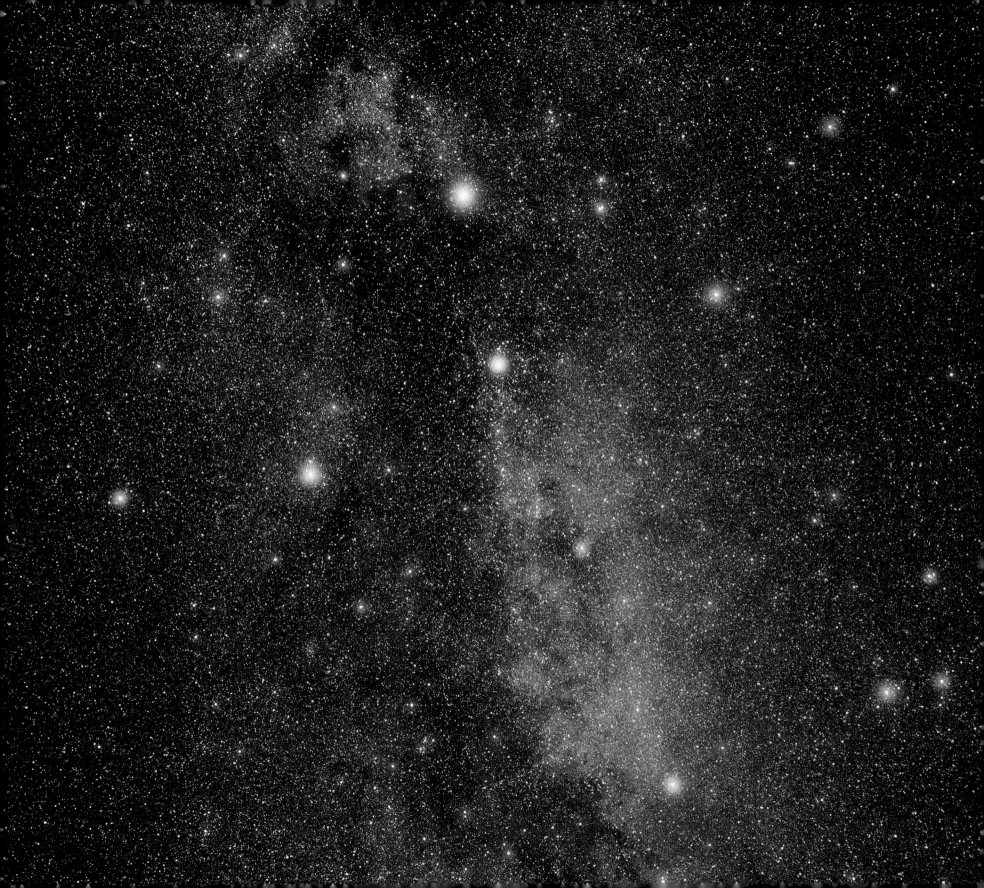

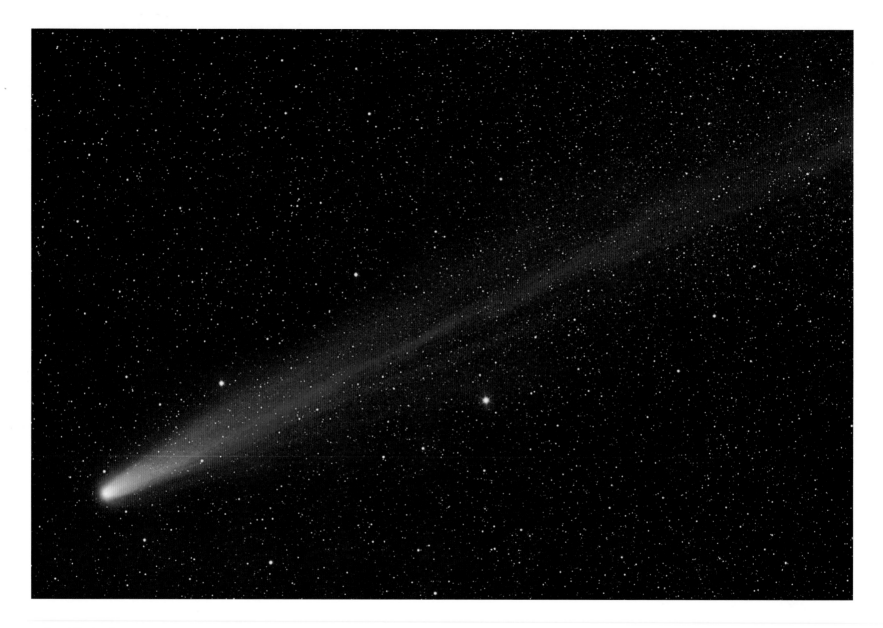

▲ Comet Hyakutake

Discovered by amateur astronomer Yuji Hyakutake in January 1996, Comet Hyakutake made a close approach to earth in March 1996. Highly visible even in daylight, the comet put on an amazing visual and photographic spectacle. The comet's remarkable tail is 360 million miles long, the longest known for any comet.

Capricorn ▶

Known in mythology as the tenth astrological sign of the zodiac, the brilliant constellation stars of Capricorn form a celestial triangle to create this enchanting composition.

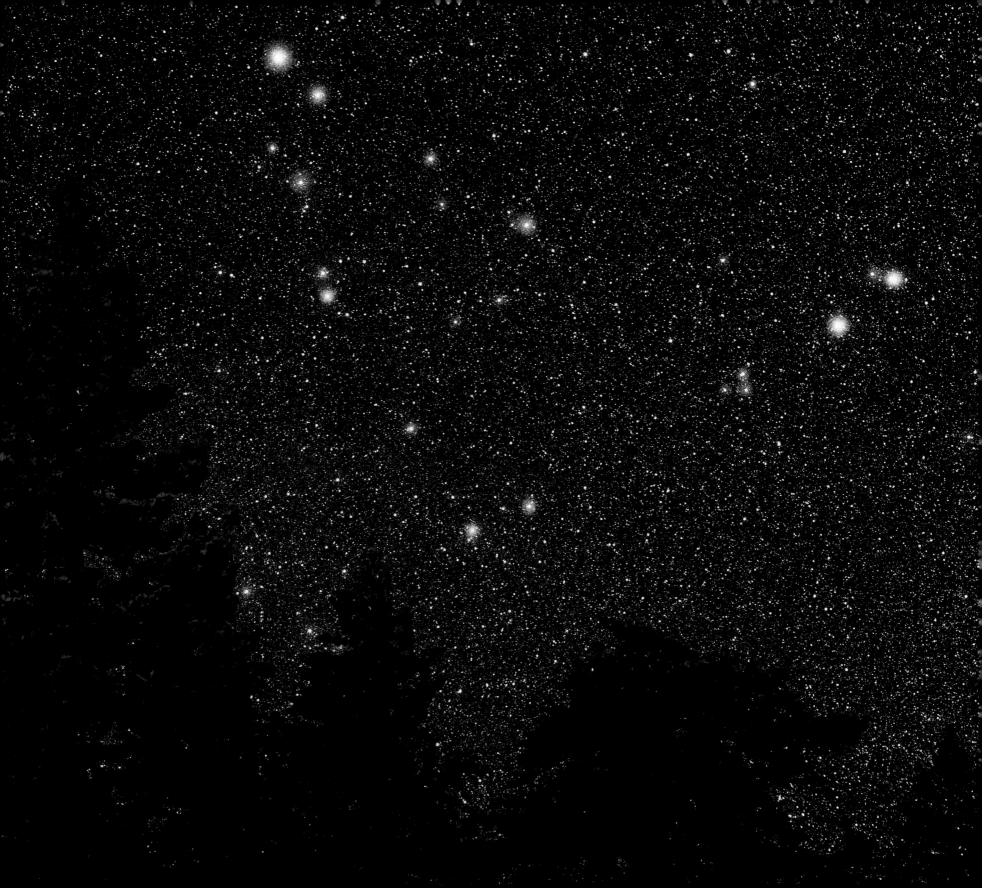

MILOSLAV DRUCKMÜLLER

Courtesy of Hana Druckmüllerova

MILOSLAV DRUCKMÜLLER IS A PROFESSOR OF APPLIED MATHEMATICS at the Institute of Mathematics, Brno University of Technology, in the Czech Republic. His specialty is numerical methods of image processing. For Druckmüller, mathematics and programming are not only a job but a hobby, too. His interest in astrophotography is closely related to his work. Druckmüller is known for his amazing high-resolution images of eclipses. Since the total solar eclipse of 1999, he has been developing specialized software for eclipse image processing that employs a mathematical theory inspired by the principles of human vision. His images reveal unparalleled details within the sun's faint outer atmosphere known as the corona.

High-Resolution Close-Up of Solar Corona

Small- and large-scale details of the sun's corona or "plasma atmosphere," including immense "coronal loops," are strikingly apparent in this remarkable high-resolution image. Many times hotter than its surface, the sun's corona extends millions of kilometers into space.

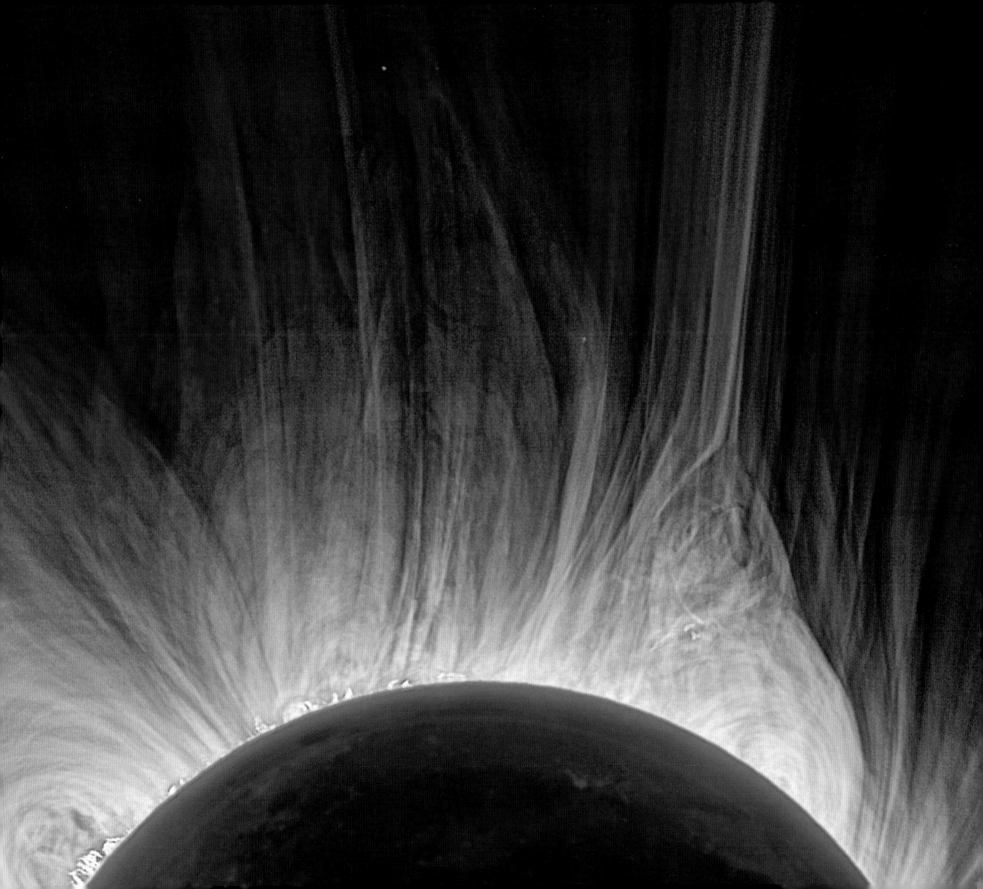

Full Extent of Solar Corona

Composed of fifty-five separate images taken by two different cameras, this composite ranks as one of the most elaborate eclipse images ever created. Taken from the Mongolian desert during the total solar eclipse of 2008, this enormous field shows the extended solar corona out to 20 solar radii (12 degrees). As the eclipse reaches totality, many stars can be seen in the midday sky, including the open cluster M44, known as Praesepae.

MILOSLAV DRUCKMÜLLER

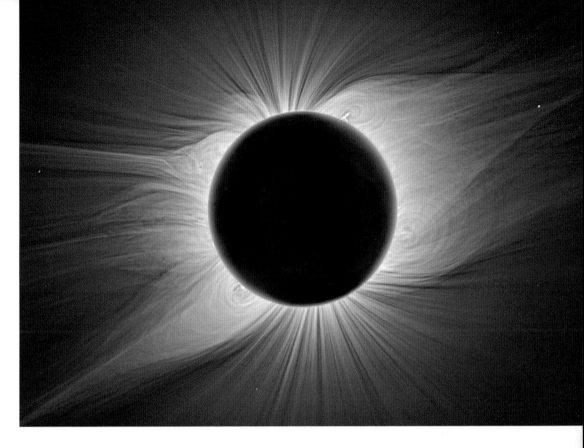

High-Resolution Image of Solar Corona, Mongolia 2008

A composite of twenty-three frames taken during totality shows the sun's hot corona. Its temperature is several million degrees Kelvin. As the moon covers the sun's disk, its exceedingly dim outer atmosphere becomes visible in exquisite detail. Huge Earth-sized flares of superhot plasma leap off the solar surface at the upper right.

The True Color of the Solar Corona

This extraordinary image displays the range of true coronal colors. The blue sky has been artificially removed close to the sun's surface, revealing the green hues dominant in the innermost corona (1.8 million degrees Kelvin), caused by the presence of the element Fe XIV, known as coronium. The corona becomes progressively redder farther from the sun's surface as dust particles scatter the shorter wavelengths of light.

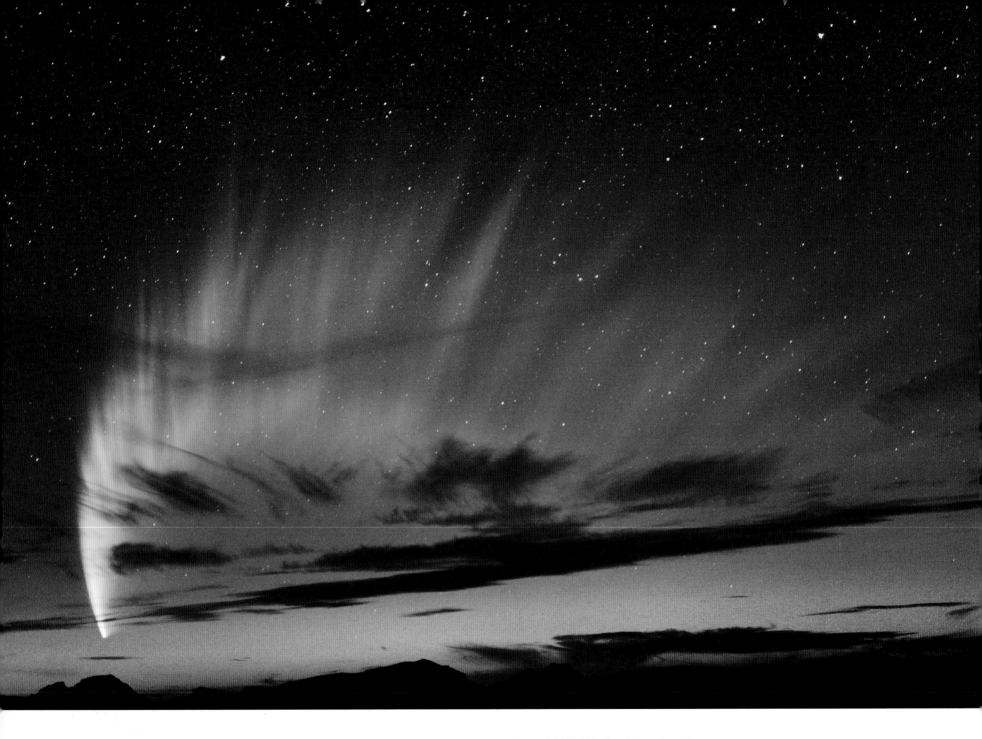

▲ Comet C/2006 P1 McNaught over Chile

As day fades to night, the remarkable tail of Comet McNaught stretches across a picturesque scene of mountains, evening clouds, and Milky Way stars.

Comet C/2006 P1 McNaught over Argentina ▷

A study in cosmic perspectives, the interloper Comet McNaught is flanked at bottom by planet Earth, on its left by the Milky Way, and on its right by the extragalactic Magellanic Clouds, which are a pair of dwarf galaxies that orbit the Milky Way.

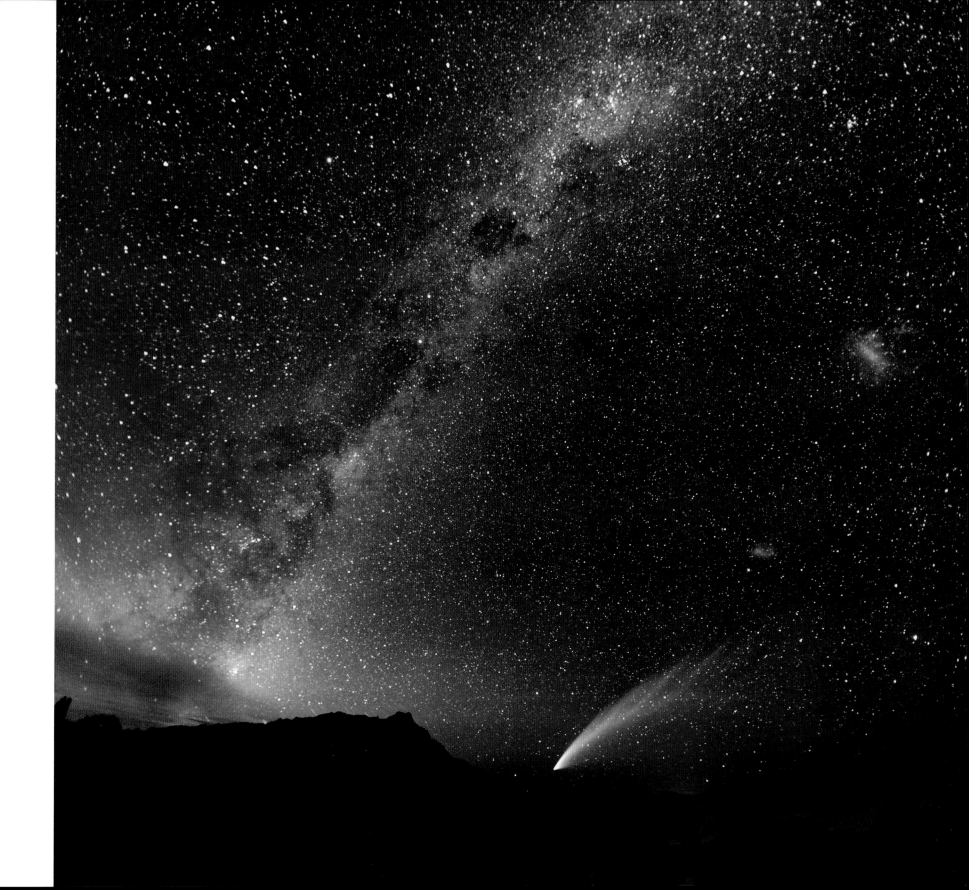

\mathcal{T}HIERRY LEGAULT

Courtesy of Thierry Legault

FRENCH ASTROPHOTOGRAPHER THIERRY LEGAULT became interested in astronomy as a boy. He recalls viewing Saturn through a 2-inch refractor at the age of thirteen and finding himself "stuck at the eyepiece." He began CCD astrophotography in 1993 and started serious high-resolution imaging the next year after photographing the crash of Comet Shoemaker-Levy 9 on Jupiter. For the past decade, Legault has led an annual digital astrophotography workshop at the Festival d'Astronomie de Haute Maurienne in France. He emphasizes the importance of precise focus and alignment when creating raw images and is known for his "exquisite attention to details." Legault's imaging philosophy is to acquire the highest resolution data possible within the limits of his equipment. He enjoys the challenge of photographing rare events such as eclipses and solar transits.

Lunar Crescent

Earth's shadow transforms the lunar surface into a stark and desolate landscape of mountains, valleys, and craters.

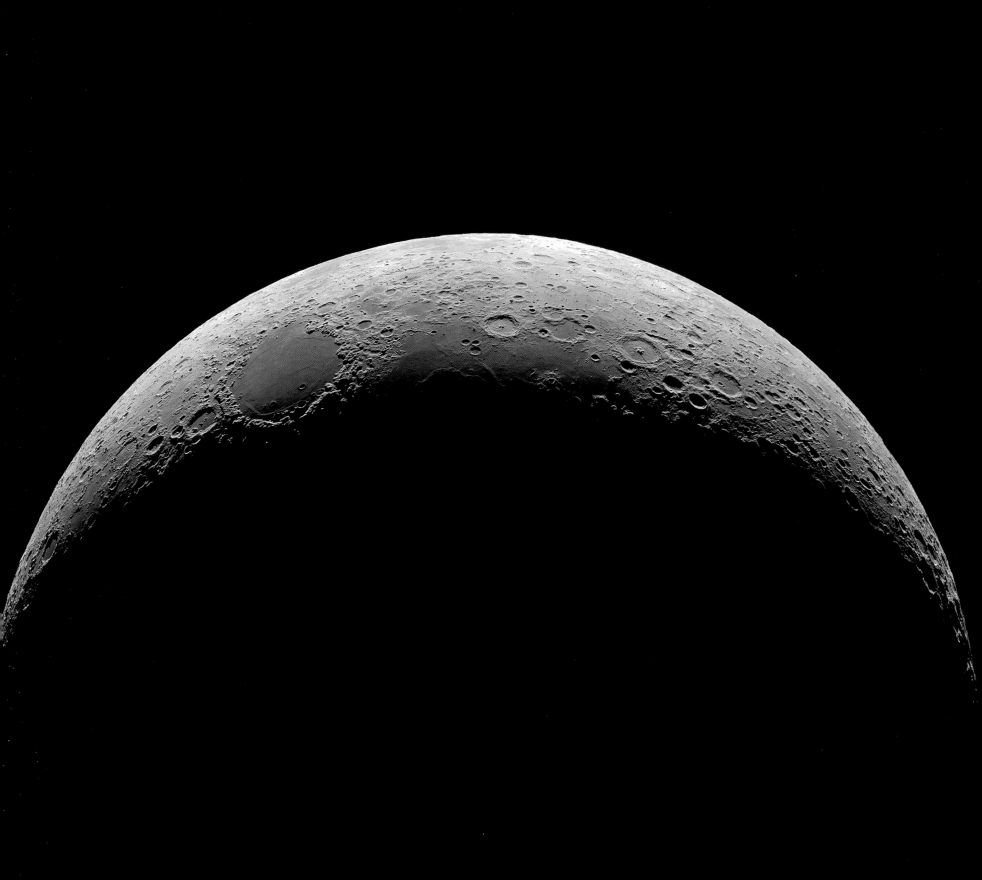

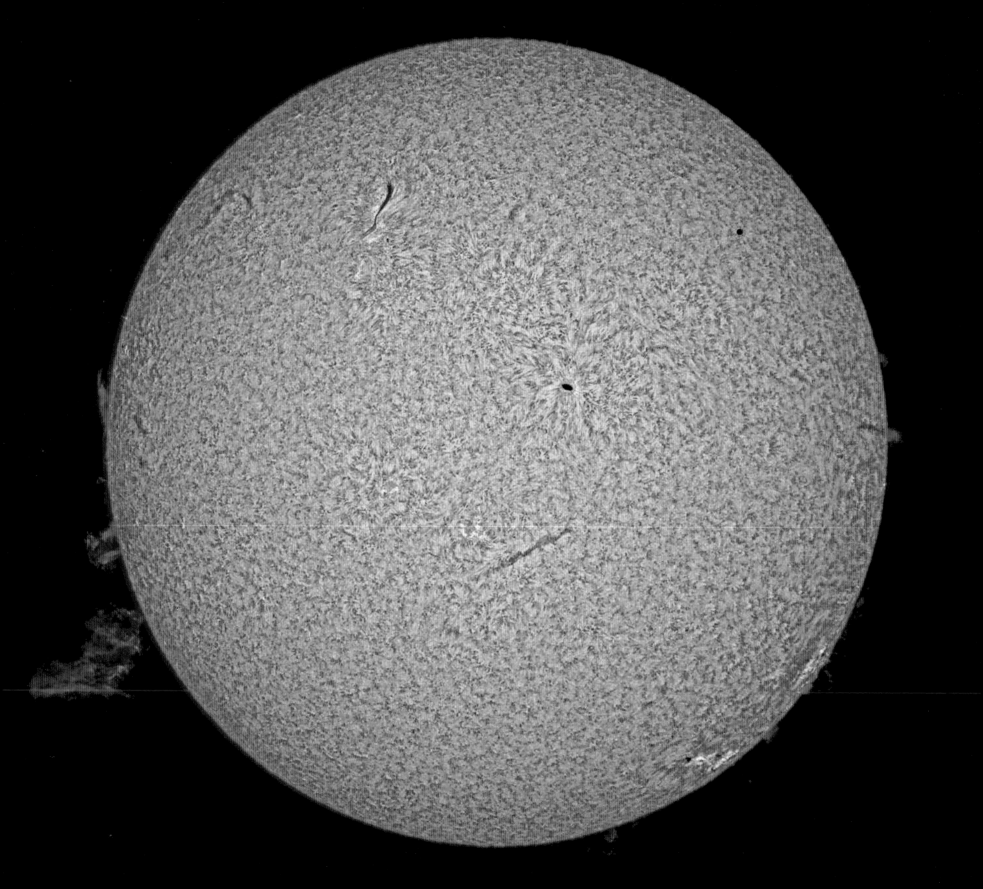

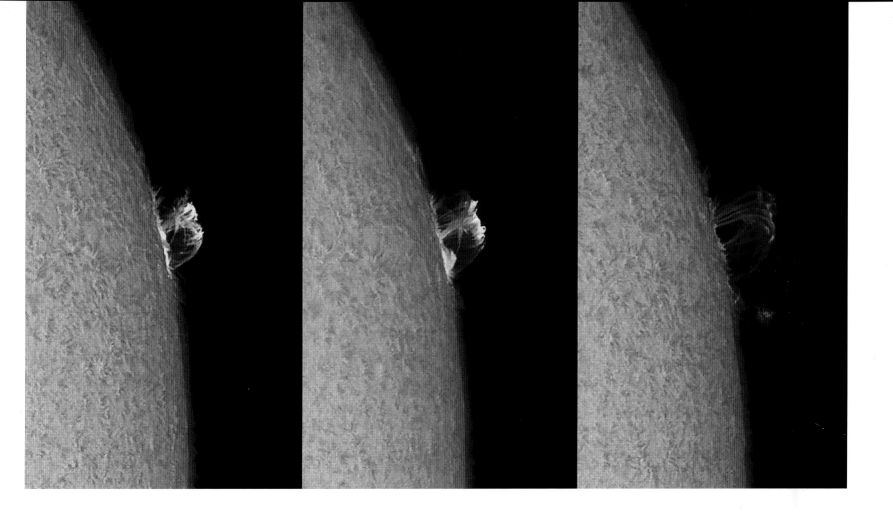

▲ Solar Prominences

Hot gaseous matter ejected from the sun is returned to its surface by powerful magnetic fields, forming immense arc-like prominences.

Sunspot ▷

Sunspots are formed by transient interactions of temperature and magnetic fields over the sun's surface. They expand and contract, often in predictable cycles, over time.

◁ Mercury Transit

A transit is the passage of a smaller celestial body or its shadow across the disk of a larger celestial body—in this case, the passage of the shadow of planet Mercury across the sun. The planet's small round shadow is visible in the upper right as it crosses the solar disk, but it is almost a sideshow compared to the enormous activity occurring over the solar surface. The various solar features include a giant flare in the lower left and several sunspots.

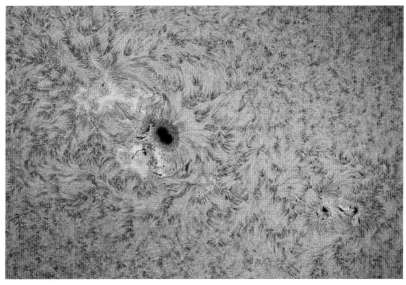

FRED ESPENAK

Courtesy of Patricia Totten Espenak

FRED ESPENAK IS AN ASTROPHYSICIST at NASA's Goddard Space Flight Center in Greenbelt, Maryland. His research has helped monitor the ozone in Mars' atmosphere, detect the winds on Venus, Mars, and Titan, and measure the hydrocarbons in the stratospheres of Jupiter and Saturn. Espenak is best known for his astroimages and his predictions of solar and lunar eclipses. His two books, *Fifty Year Canon of Solar Eclipses: 1986–2035* and *Fifty Year Canon of Lunar Eclipses: 1986–2035*, published by NASA, have become standard references on the subjects. Espenak's interest in eclipses was first sparked after witnessing the total solar eclipse of 1970. Since then, he has taken expeditions to view more than twenty eclipses around the world and has experimented with a number of photographic techniques in order to capture the incredible beauty of the sun's corona.

Solar Crescent and Baily's Beads

Lasting only a few seconds during the early and late stages of eclipse totality, the rugged lunar topography allows "beads" of sunlight to peek through. The effect is named in honor of English astronomer Francis Baily, who observed the phenomenon in 1836. Planet-sized flares are visible on the solar surface.

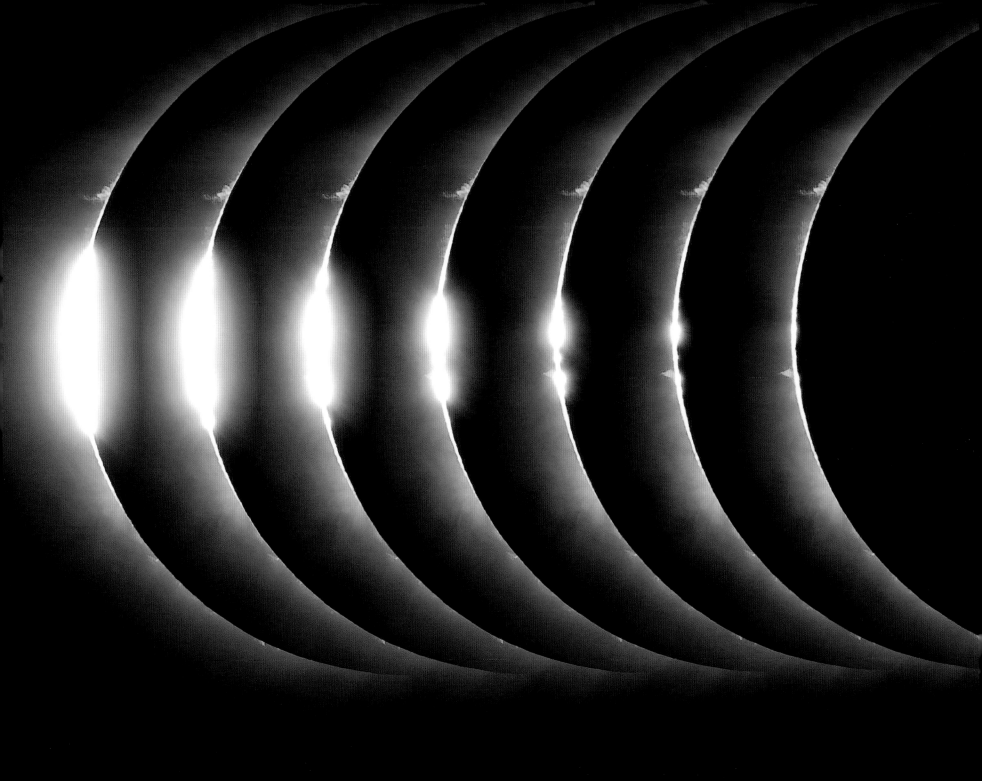

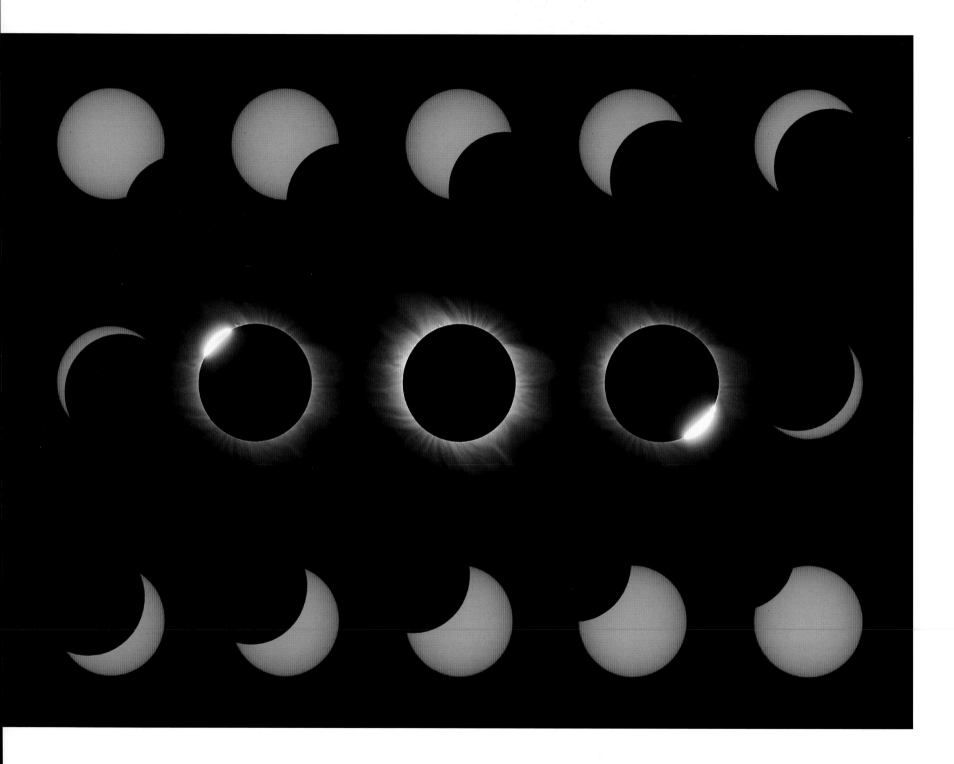

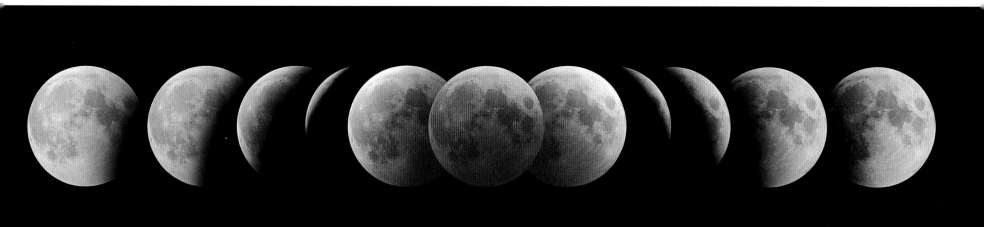

▲ **Lunar Eclipse**

This sequence captures the total lunar eclipse of October 28, 2004, from start to finish. Highly refracted rays of light from the sun cast a ruddy complexion onto the moon's surface during totality.

◀ **Entire Total Eclipse**

The entire solar eclipse of 2006 was captured in a matrix of fifteen images taken every twelve minutes. The central image marks totality, when the faint corona becomes visible against the darkened sky. Flanking the central image, the "diamond ring effect" occurs immediately before and after totality.

9

GREG PIEPOL

Courtesy of Greg Piepol

GREG PIEPOL WORKED AS AN ELECTRONICS TECHNICIAN on Air Force One in the U.S. Air Force and retired after twenty years of active duty in 2002. He lives in Maryland. An advisor for the NASA/JPL Solar System program, Piepol's passion is imaging the dynamic surface of the sun. He says, "Unlike other astronomical objects, every time I turn the camera to the sun, it puts on a different show." Piepol enjoys providing the viewer with a sense of the highly dynamic and rapidly changing nature of the sun's surface. Visible in Piepol's high-resolution solar images are spectacular ephemeral events occurring on the sun's surface over periods as short as a few minutes. His images give us a vision of the fascinating and dynamic star located in our celestial backyard.

Sunspot 875 and Prominence

Captured in a fortuitous composition, Sunspot 875 appears in the foreground along with a huge prominence. Each feature, several times the size of our planet, is a transient phenomenon that speaks to the highly dynamic and violent nature of the sun's surface.

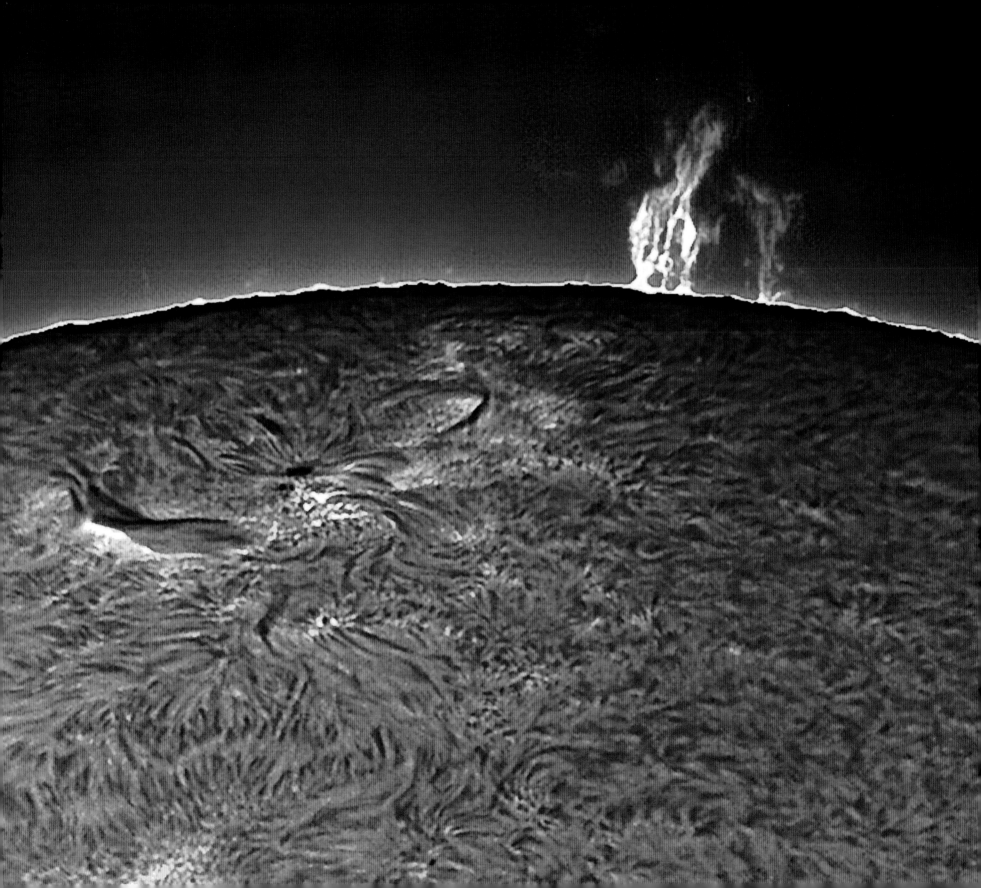

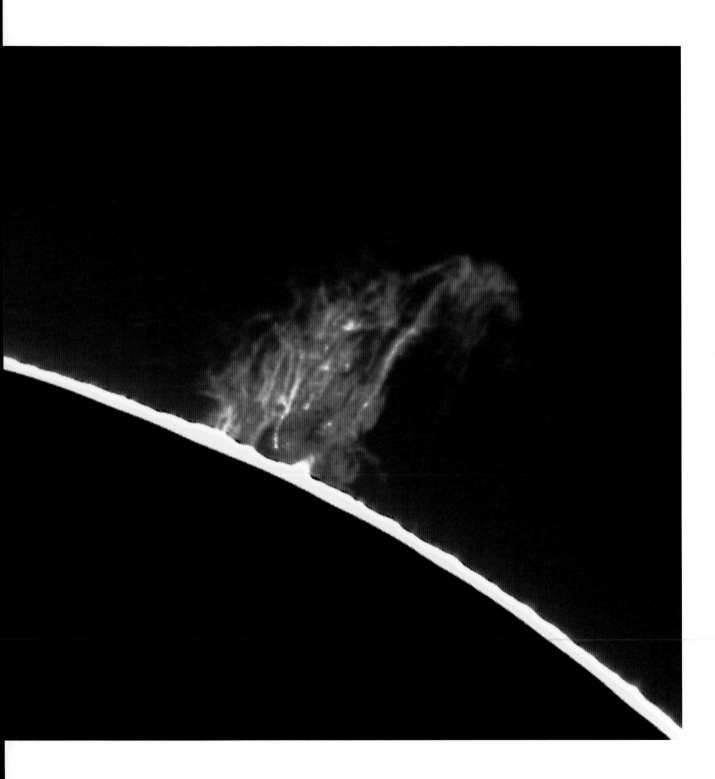

◄ **Solar Prominence**

Enormous dancing towers of hot plasma, known as prominences, span almost five times the Earth's diameter and testify to the power and scale of solar surface phenomena.

Full Solar Disk in Hydrogen Alpha Light ▷

Using a special filter that captures a very narrow bandwidth of light allows the sun's surface features to become visible. Dynamic features such as filaments, prominences, and sunspots can be found over the entire disk.

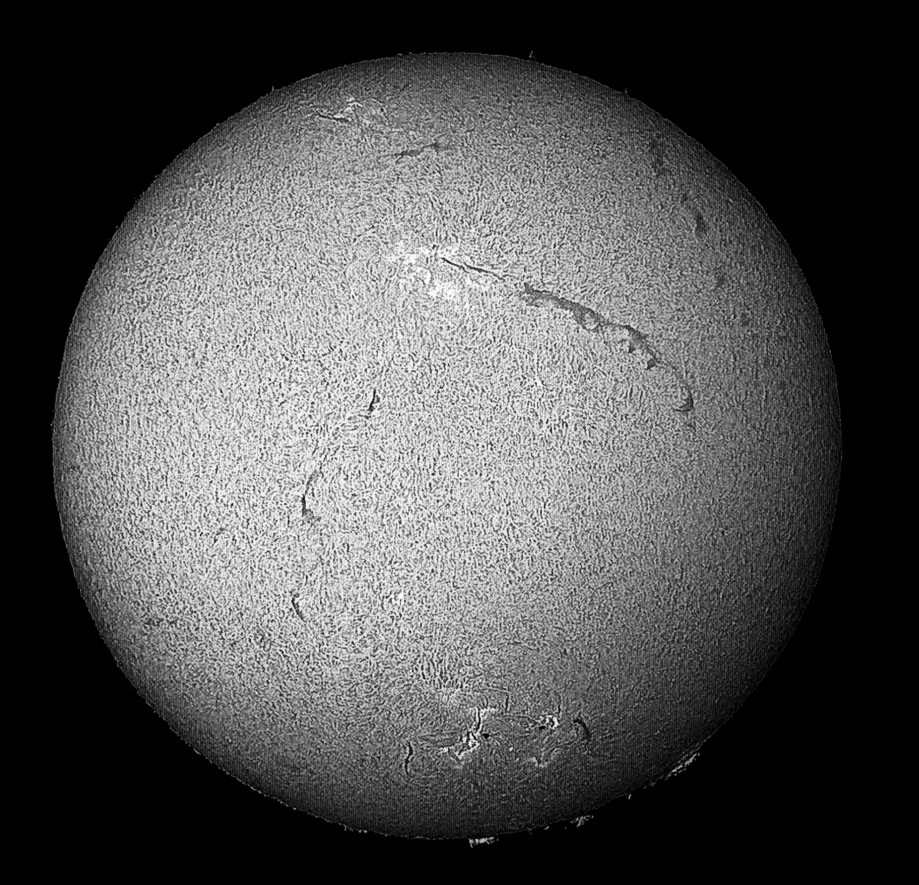

\mathscr{W}ES HIGGINS

ON MAY 5, 1961, NASA SENT THE FIRST American, Alan Shepard, into space. On that day, Wes Higgins' fascination with astronomy began. Although he's been active in astronomical observing for a long time, Higgins only started taking astroimages eight years ago. He lives in Oklahoma, where he enjoys the process and says, "There is something very special about being out under the stars early in the morning between 3 a.m. and dawn, when everything is quiet and peaceful." Higgins limits his imaging to high-resolution lunar and planetary imaging, the former being his favorite. He uses current video and software technology to extract the highest resolution data possible to make his breathtaking lunar images. His images reveal unprecedented details of the lunar landscape reminiscent of the *Apollo* "flyby" images that inspired his original fascination with the cosmos.

Moretus-Curtius Mosaic

Reminiscent of an *Apollo* flyby, this mosaic photograph shows two dominant craters in the foreground: Moretus (*left*) and Curtius (*right*). They represent two large meteor impact sites in the heavily cratered southern highland region.

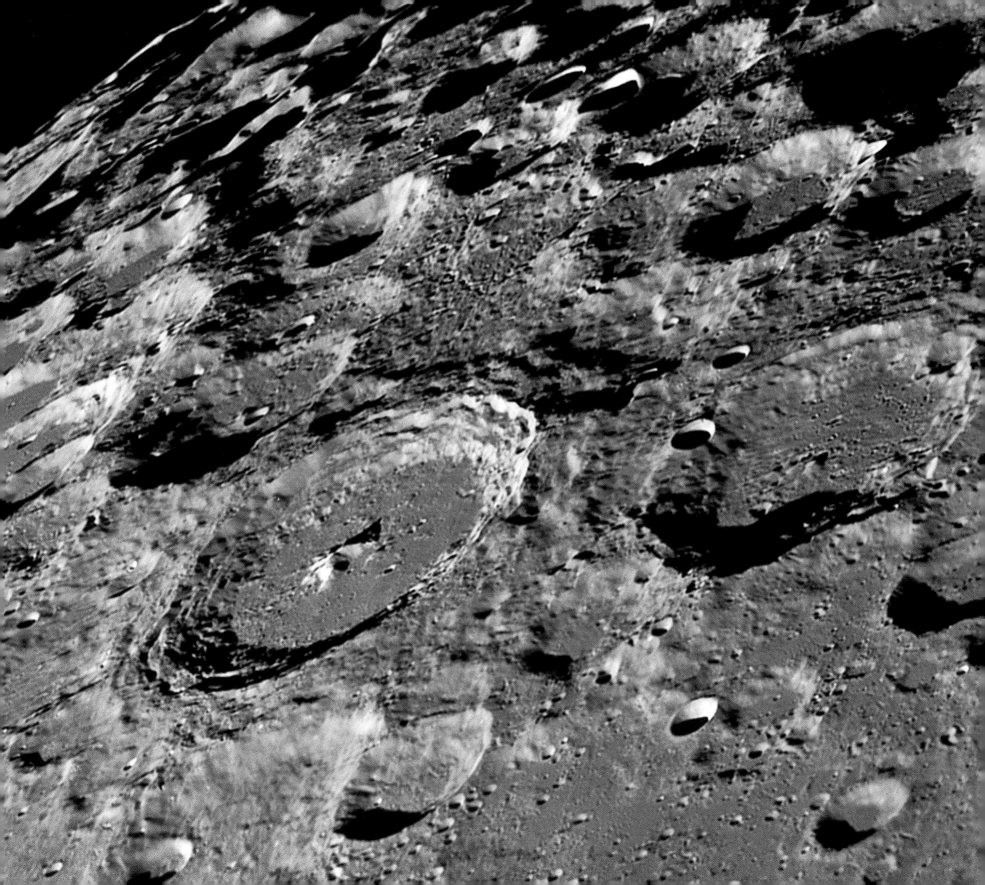

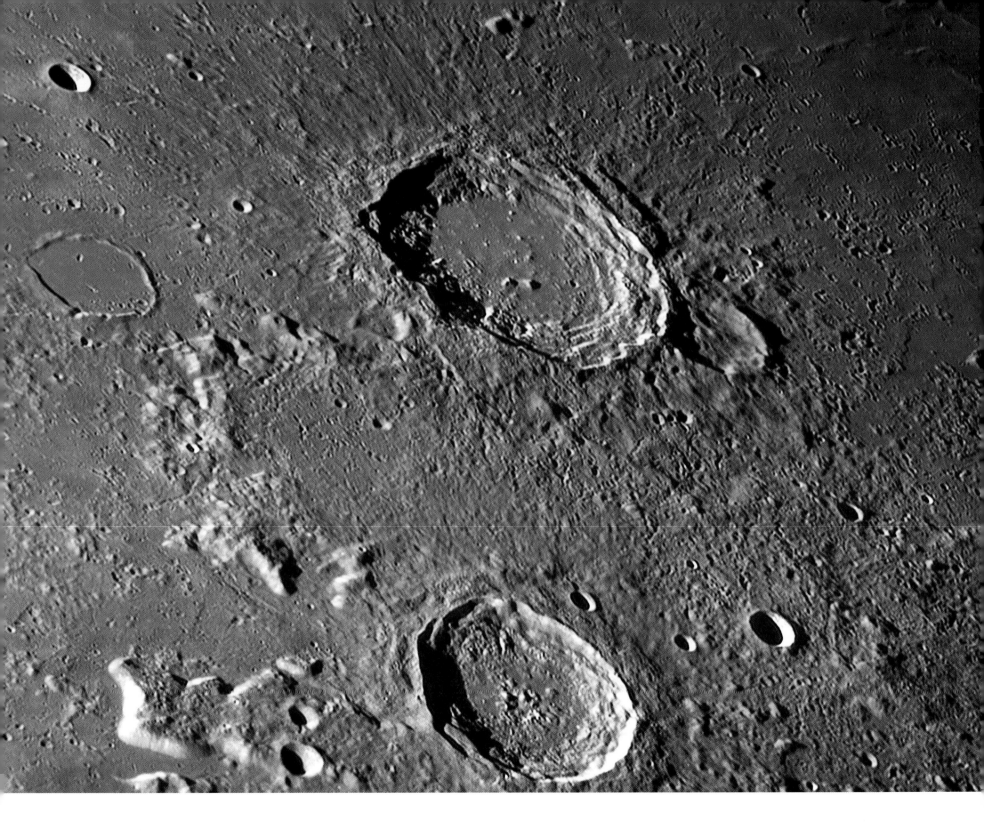

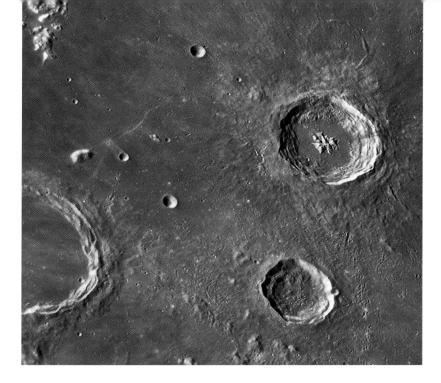

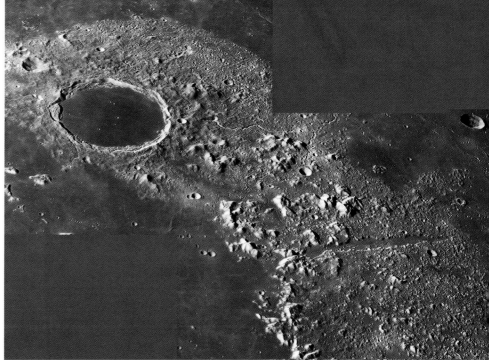

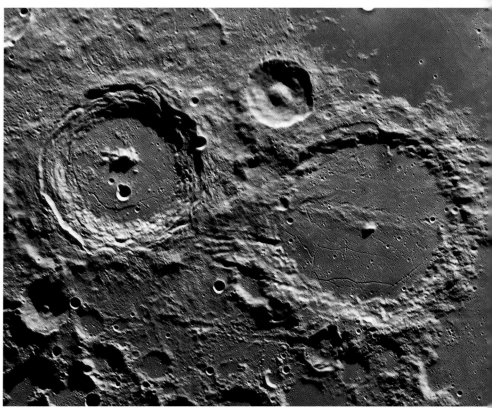

▲ Aristillus

The huge impact that formed the crater Aristillus created rays of debris that ejected outward more than six hundred kilometers. In the center of the crater are three clustered peaks that rise almost one kilometer above the crater floor.

Plato-Alpine Valley Region Mosaic ◥

Similar to other lunar impact craters, Plato (*left*) is ancient at 3.84 billion years old. It formed during the torrential bombardment of material that occurred in the early formation of our solar system. An ancient lava flood created the bottom of the Alpine Valley (*right*). The clarity of the central rift in the valley is a tribute to superb conditions, quality optics, and, above all, the skills of the operator.

Alphonsus and Arzachel ▶

Alphonsus (*right*) was the impact site of the *Ranger 9* probe and the alternate landing site for *Apollo 16* and *17*. Arzachel (*left*) has a central peak that rises 1.5 kilometers and a complex rile system with small craters at its base. A rile system is a series of rocks that rises up from the lunar surface.

◀ Aristoteles and Eudoxus

A radial array of ejecta surrounds the finely terraced inner walls of Aristoteles (*upper*). Just south of Aristoteles is the impact crater Eudoxus (*lower*).

DAMIAN PEACH

Courtesy of Robin Scagell

BRITISH ASTROPHOTOGRAPHER DAMIAN PEACH first became interested in astronomy in 1988 at the age of ten. He used a pair of binoculars and a small spotting telescope to learn his way around the sky. Peach says, "I recall vividly my first views of M31, Jupiter, and the Jovian moons." Three years later, he acquired his first real telescope, a 50mm refractor that he used to view everything "from double stars to the belts of Jupiter, the rings of Saturn and phases of Venus."

Beginning in 1992, Peach began serious planetary observation using larger, high-quality reflecting telescopes. "I was finally able to see the kinds of details in the planets about which I read," he says. "I spent many nights during my early teens observing the planets through these telescopes, with a special fascination for Jupiter." Today, Peach is known throughout the astronomical community for his spectacular images of the planets, amazingly taken with relatively modest equipment. His images frequently grace the pages of magazines and books, and he is one of the premier planetary photographers in the world.

Saturn

This razor-sharp image of the majestic ringed planet was captured not by an orbiting space probe but by the amateur astrophotographer Damian Peach using a small Earth-based telescope during exquisite viewing conditions.

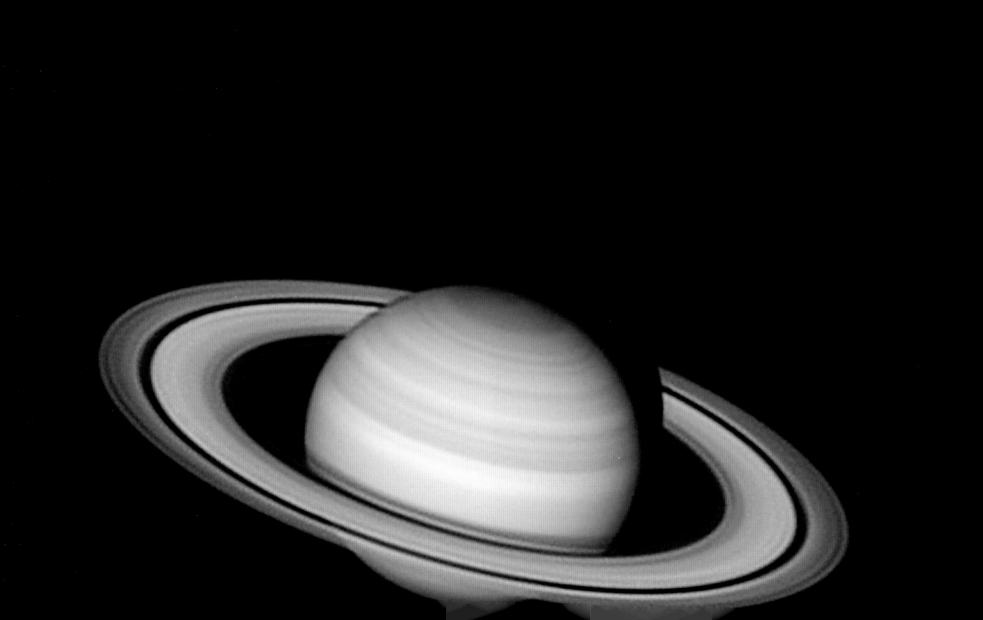

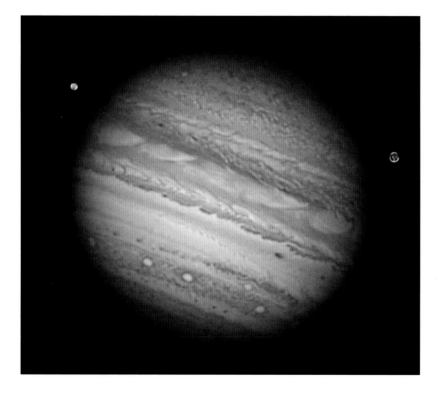

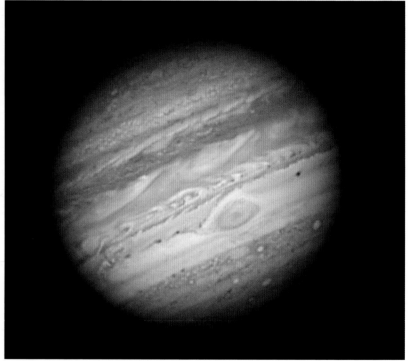

Jupiter with Io and Ganymede

The gas giant Jupiter is seen along with two of its largest moons, Io and Ganymede. Exquisite details of Jupiter's undulating cloud tops are amazingly clear in this spectacular image.

The Great Red Spot on Jupiter

The Great Red Spot is a peculiar feature located 22 degrees south of Jupiter's equator. It represents a persistent and complex storm within the turbulent cloud tops of the gas giant planet. The Great Red Spot varies in size and color, and has persisted for more than 340 years.

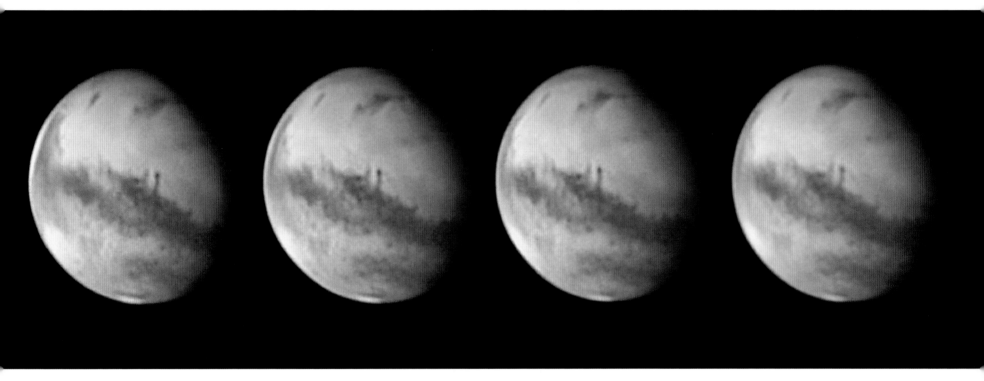

Mars

This sequence of four images shows the Eastern Hemisphere of Mars, where Elysium Mons, a Martian volcano, is located. Also visible are the south polar ice cap and Syrtis Major Panum, a dark spot located in the boundary between the northern lowlands and the southern highlands.

\mathcal{D}ONALD C. PARKER

Courtesy of Maureen Parker

DONALD C. PARKER, A RETIRED PHYSICIAN living in Florida, has had a life-long interest in astronomy. Since 1953, he has built a number of precision telescopes that he uses for high-resolution planetary astrophotography. Dr. Parker specializes in solar system research and planetary photography. He has taken more than twenty thousand images of Mars and Jupiter as support for professional astronomers at NASA, JPL, and various observatories. He has been observing Mars for longer than half a century. Parker has authored or coauthored more than 150 papers on astronomy, and his work has been published in both amateur and professional journals, including *Science, Nature, Icarus, The Astronomical Journal*, and *The Journal of Geophysical Research*. In recognition of his contributions to planetary astronomy, Dr. Parker was honored by the International Astronomical Union in 1994, when an asteroid was given the name 5392 Parker.

Jupiter–SL9 Impacts

In July 1994, fragments of Comet Shoemaker-Levy 9 descended from their orbit around Jupiter and crashed into the Jovian cloud tops, creating an unprecedented visual and photographic spectacle of a large planetary impact.

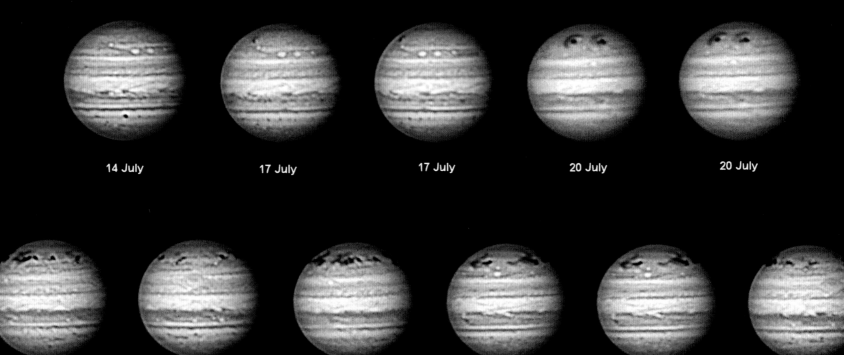

JUPITER - SL9 IMPACTS, 1994

D. Parker

14 July 17 July 17 July 20 July 20 July

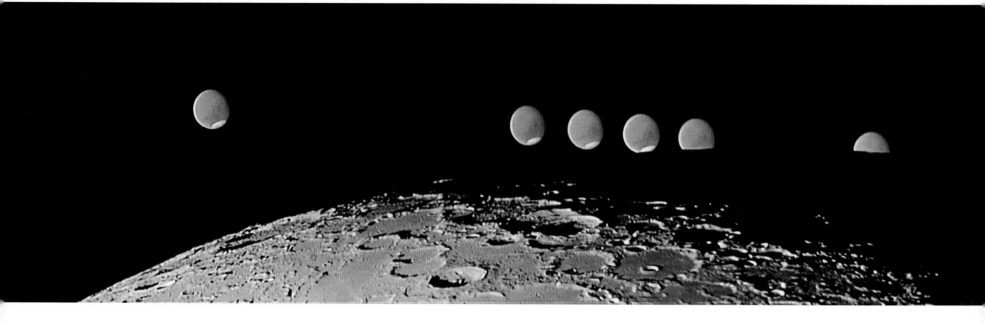

Lunar Grazing Occultation of Mars

Mars disappears behind the rugged lunar terrain during the grazing occultation of July 17, 2003. During a grazing occultation, one celestial body appears to just touch, or graze, another, rather than being completely hidden from view.

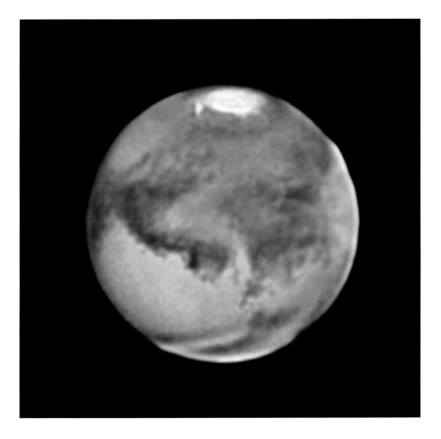

Fog on Mars

This impressive image (*south side up*) shows the southern polar ice cap with unusual clarity. Haze and fog can be seen along the right side, and misty clouds are visible coming off the north polar hood at the bottom of the image.

Uranus, September 8, 2006

The blue cloud tops of Uranus are caused by the presence of methane, which absorbs all but the shorter wavelengths of light. The subtle brightening at the bottom indicates the south polar region of the gas giant.

DAVID MALIN

Courtesy of Andrew T. Warman

DAVID MALIN'S NAME IS SYNONYMOUS WITH stunning astrophotography. Malin served as photographic scientist-astronomer for the Anglo-Australian Observatory in southeastern Australia from 1975 to 2001. Malin's contributions to astrophotography are many and his images legendary. Most noteworthy of his many technical innovations are his work with tricolor imaging and his development of image enhancement techniques, such as unsharp masking and multi-image addition. Malin did most of his work in the film era of astrophotography using the 4-meter Anglo-Australian telescope and the UK Schmidt camera. Although applied primarily to film astrophotography, his methods and innovations have paved the way for current techniques considered essential in the digital era of CCD imaging. David Malin's images are considered works of art and are published in countless venues around the world.

Nebulosity Surrounding Antares

Glowing with the luminosity of 40,000 suns, the red supergiant star Antares is an imposing sight. Matter ejected by the aging star scatters its starlight, forming the vast yellow cloud that appears to engulf the star.

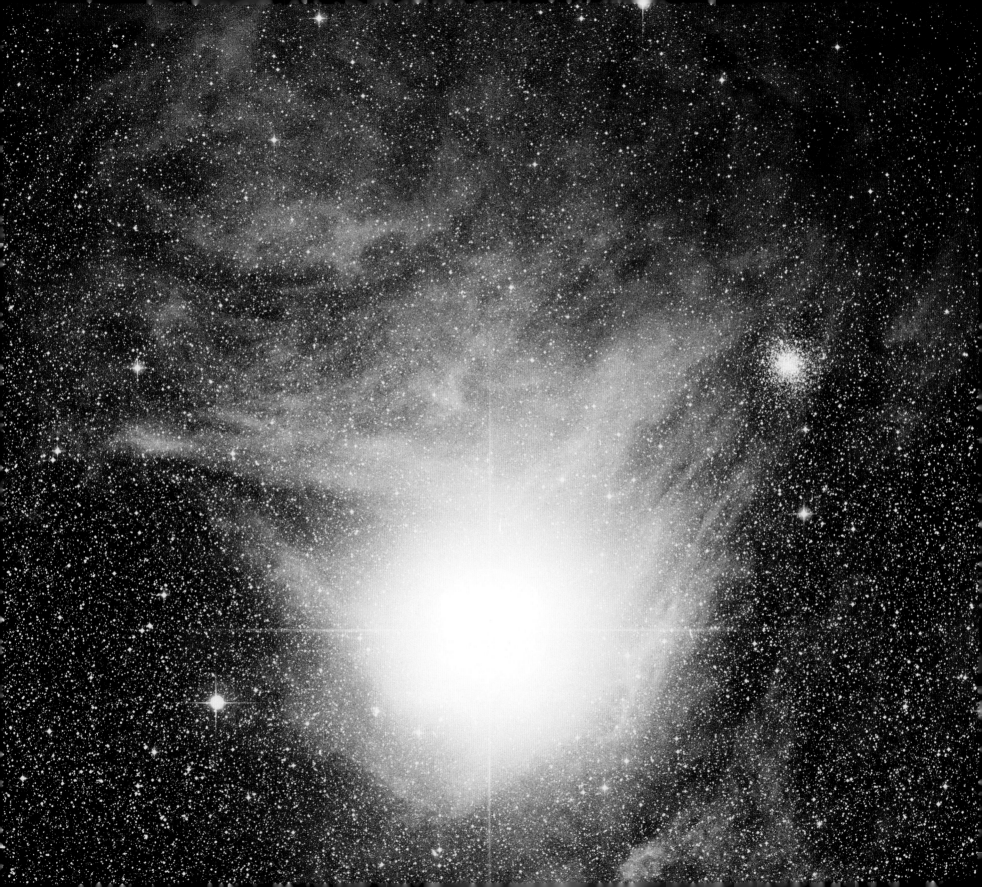

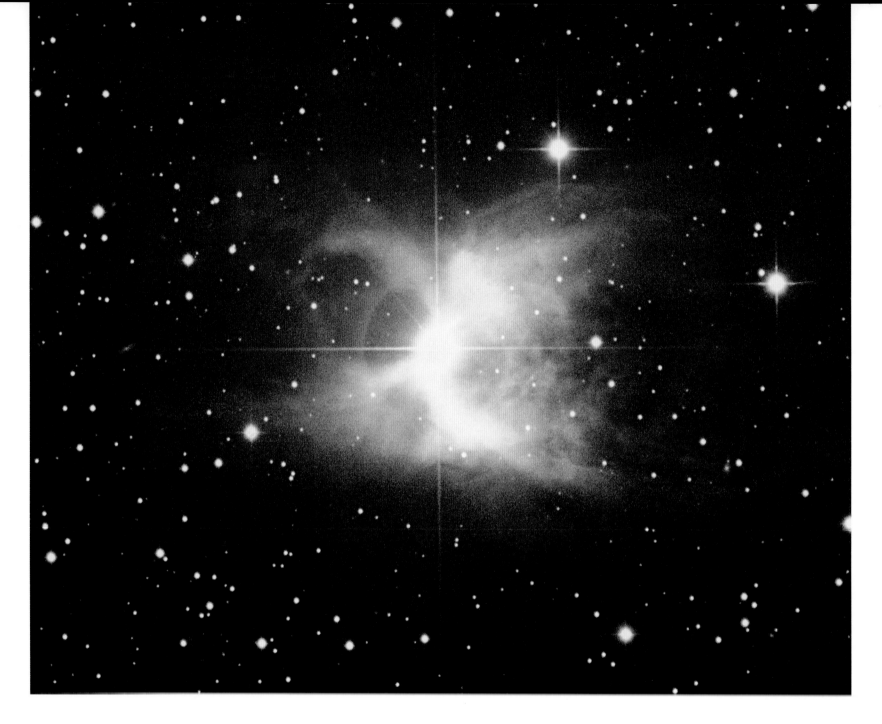

▲ IC 2220

Also known as the Toby Jug Nebula, this delicate cloud was formed by matter ejected from the unstable star HD 65750.

Baade's Window ▶

The opaque clouds of countless suns lie in the direction of our galaxy's center. A small area of relative transparency, originally found by the astronomer Walter Baade in the 1940s, was used to calculate the distance to the galactic center, now known to be 25,000 light years.

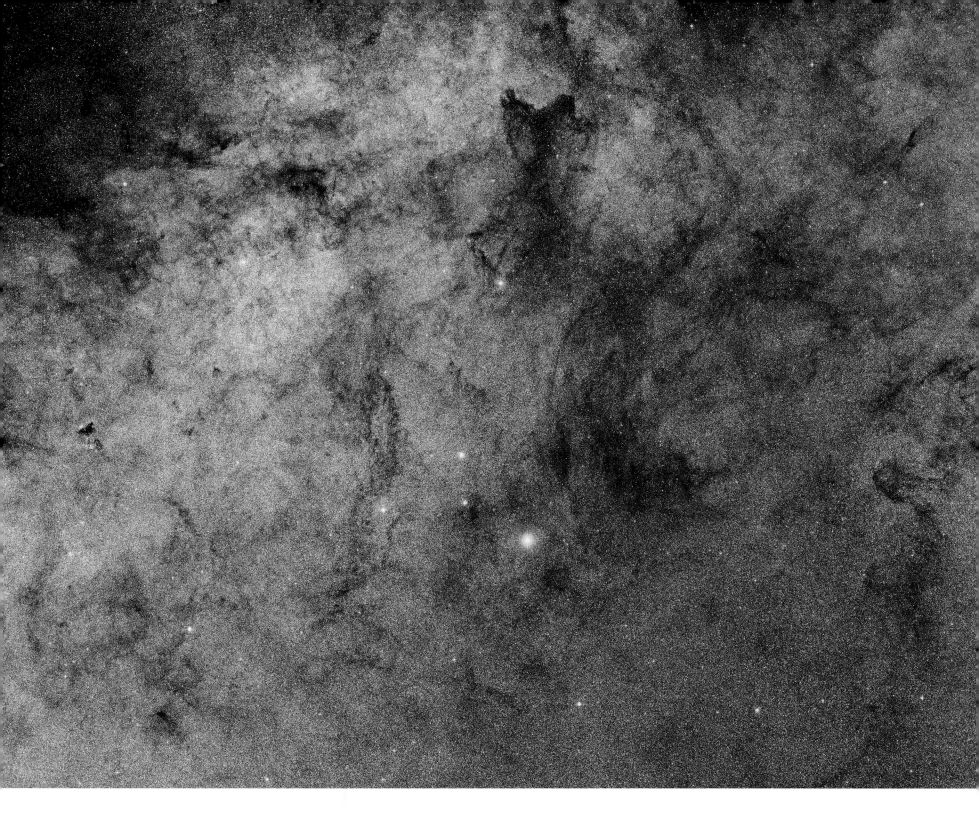

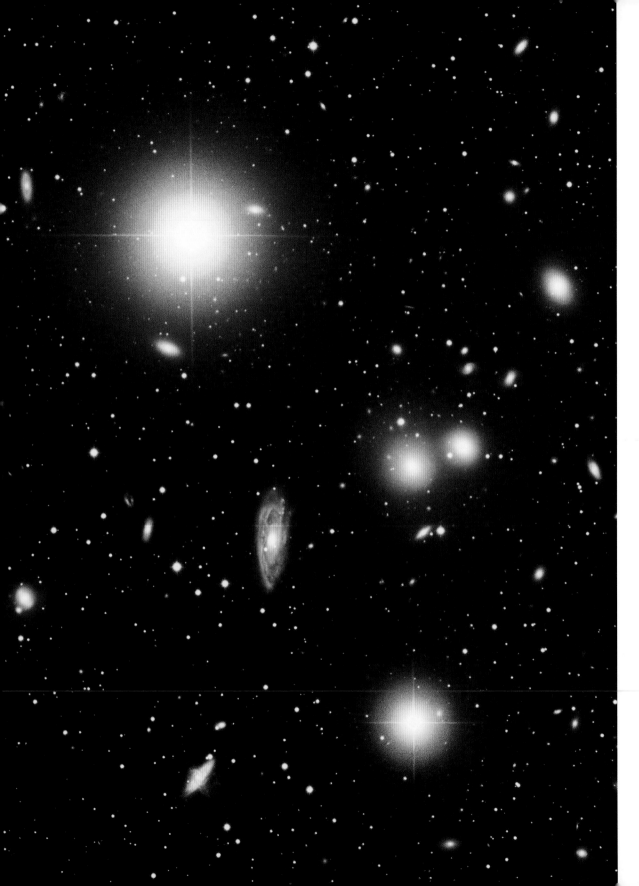

◀ Abell 1060, Cluster of Galaxies

Nearly outshined by two brilliant Milky Way stars, this assemblage of magnificent spiral and elliptical galaxies is stunning even at a distance of 165 million light years.

Vela Supernova Remnant ▶

This remnant of a once-massive star is now an expanding shell that shocks all interstellar matter in its path. The excited gases release their energy partly in the form of visible light.

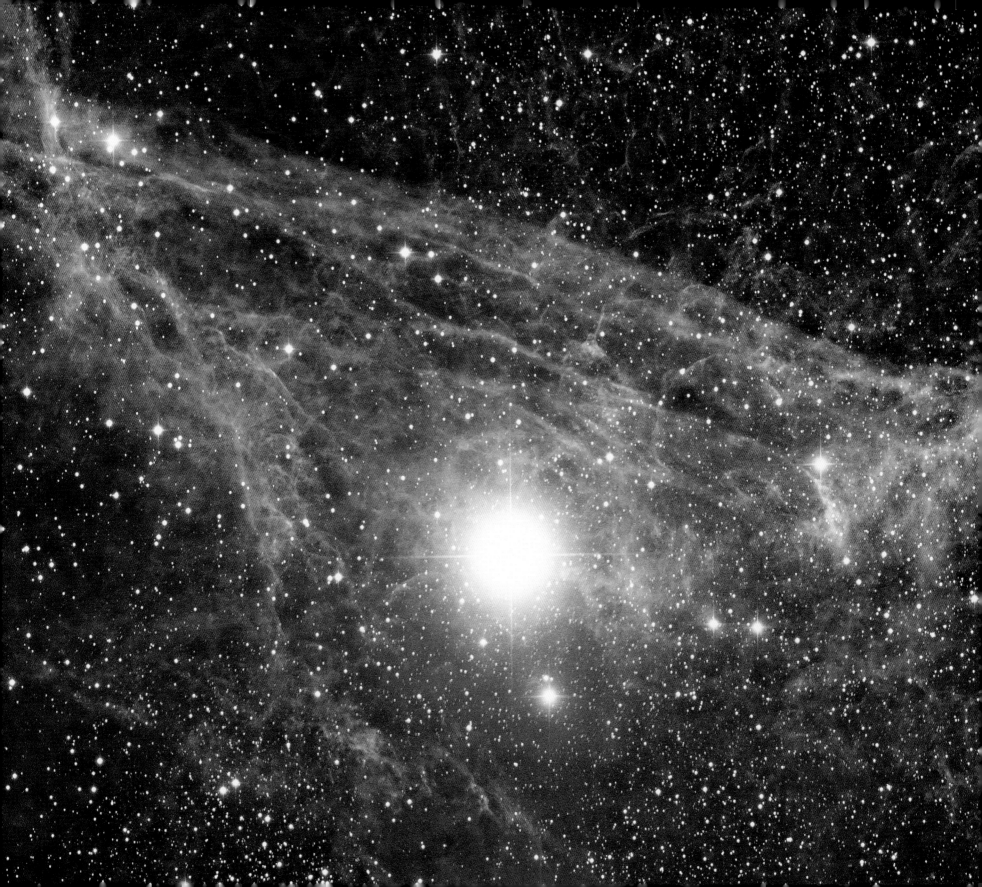

\mathcal{T}ONY HALLAS

Courtesy of Daphne Hallas

FOR CALIFORNIA PHOTOGRAPHER TONY HALLAS, a lifetime passion for astronomy started with a chance sighting of Saturn through a small 8-inch telescope. Tony recalls, "Although the image of Saturn was extremely small, I could make out the rings, which left an indelible impression." Over the next several years, his enthusiasm grew and he honed his observation skills by turning a variety of small telescopes skyward. It wasn't long before Hallas, a professionally trained photographer, had the urge to try his hand at astrophotography. After several early failures, he found that he not only had a great passion for astronomical imaging but considerable talent as well. Hallas has gone on to become one of the premier deep-sky astrophotographers in the world. His reputation was established during the film era of the 1980s and has continued to grow with later accomplishments in the CCD era. His images are known for vibrant color and extraordinary depth. His history is exceptional in that he is one of only a few astrophotographers active in all three of the modern "eras" of amateur astrophotography: film, film plus computer enhancement, and CCD. For Tony, "Each era required mastering new techniques that built on the foundation of the previous era."

Milky Way over Sugar Pine Reservoir

An artistic fusion of day and nighttime imagery produced this fanciful view of the summer Milky Way and its reflection on the still waters of Sugar Pine Reservoir in northern California.

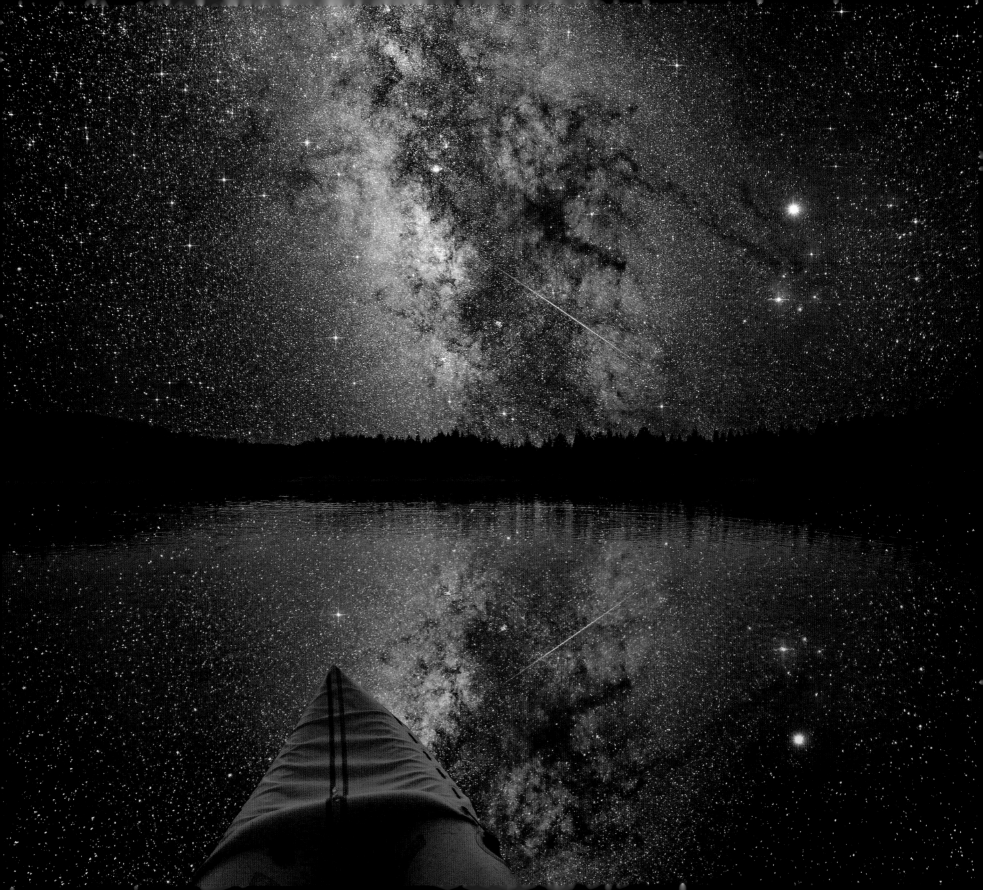

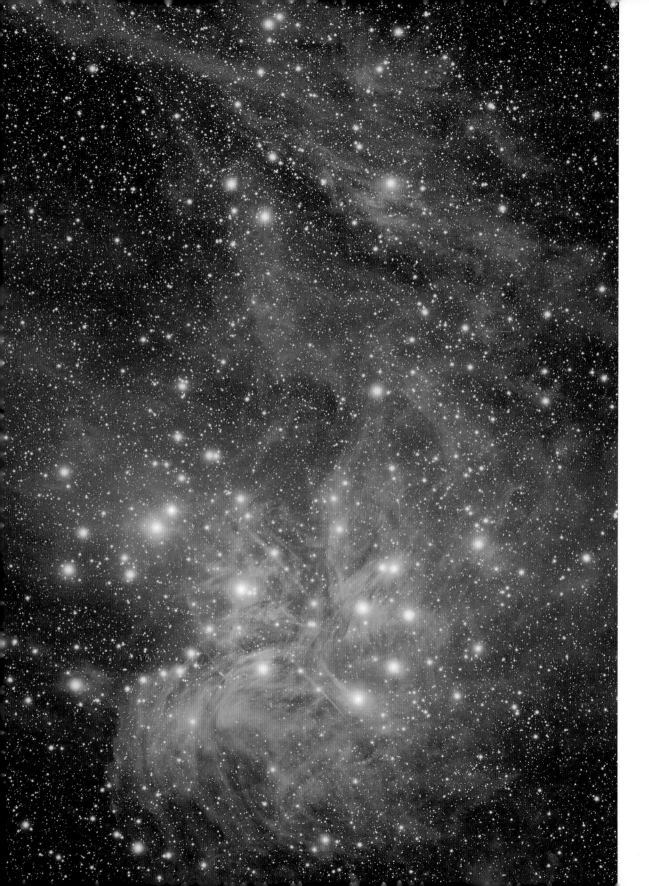

◄ The Pleiades

The rich blue clouds and delicate tendrils of the Pleiades (M45) formed serendipitously after a moving cluster of young stars encountered an unrelated molecular cloud.

The Andromeda Galaxy ▶

The Andromeda Galaxy (M31) and our Milky Way represent the two dominant giant galaxies of our Local Group. This complex photo mosaic required several months to assemble and is one of the richest views of our galactic neighbor ever produced.

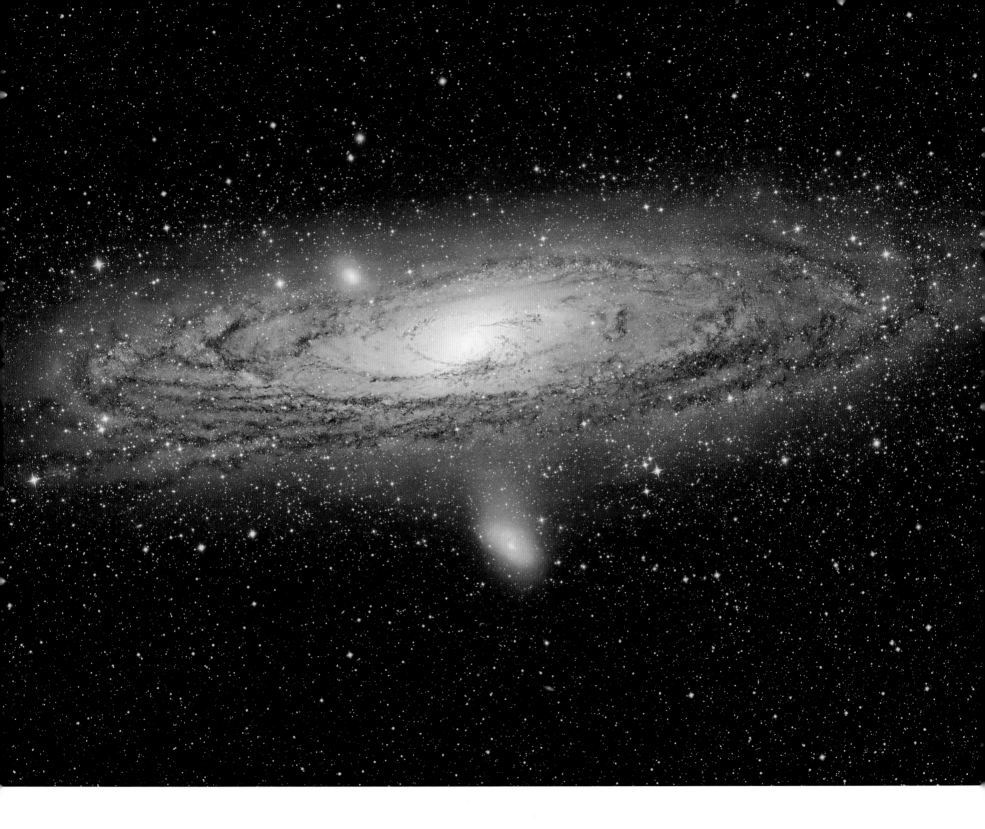

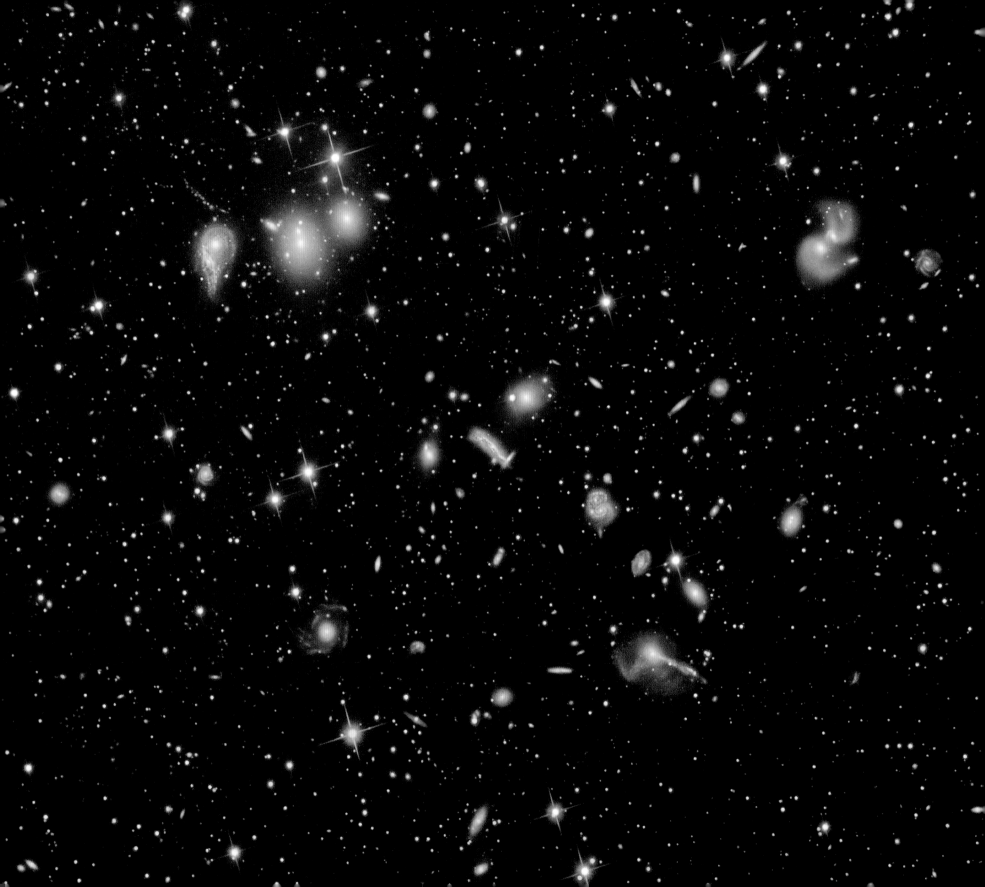

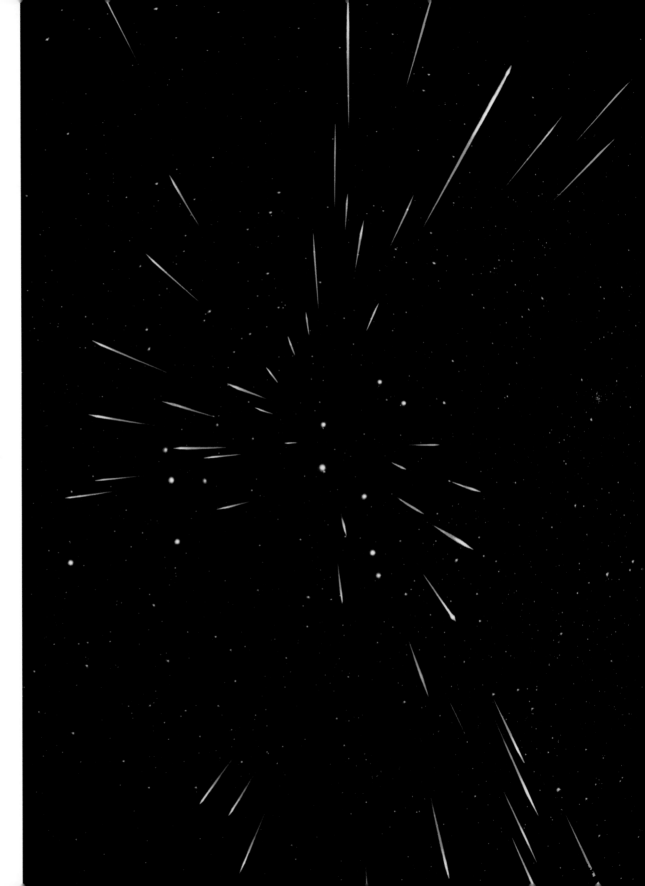

◄ Abell 2151

We now understand that galaxies exist within megastructures known as clusters. Even at a distance of 500 million light years, the cluster Abell 2151 reveals an astounding variety of island universes, each one a vast rotating system of stars, gas, and dust like our Milky Way.

Leonid Radiant ▶

Observable each year in mid-November, the Leonid meteor shower occurs when dust-sized particles, formed in the wake of Comet Tempel-Tuttle, disintegrate while entering our atmosphere. The meteors appear to radiate from the constellation Leo, apparent in this long-exposure composite image.

RUSSELL CROMAN

Courtesy of Stephanie Croman

WHILE STUDYING ENGINEERING at Washington State University, Russell Croman served as the sports photographer for the student newspaper. He recalls, "It was there that I got my feet wet in photography and gained a sense for composition and the various other elements that go into making a good photograph." Later, working in Austin, Texas, as an electrical engineer, Croman began taking astronomical images from his backyard. This practice was rewarding, but the ever-growing light pollution from the thriving city placed severe limits on the quality of his images. In 2004, Croman built an observatory in the mountains of New Mexico, which he operates remotely over the Internet. He was one of the first amateurs to successfully venture into the realm of remote imaging. Croman explains his imaging philosophy: "My engineering background has contributed greatly to my work in astrophotography. Being a technical art, there are a million little details, all of which need to be right for a session to be successful." His philosophy is evident in his work, and his images have received world-wide recognition for their striking beauty and unparalleled precision.

NGC 2170

A web-like complex of iridescent clouds and mysterious dark structures converges onto a central mass of embryonic stars within this magnificent stellar nursery in the constellation Monoceros.

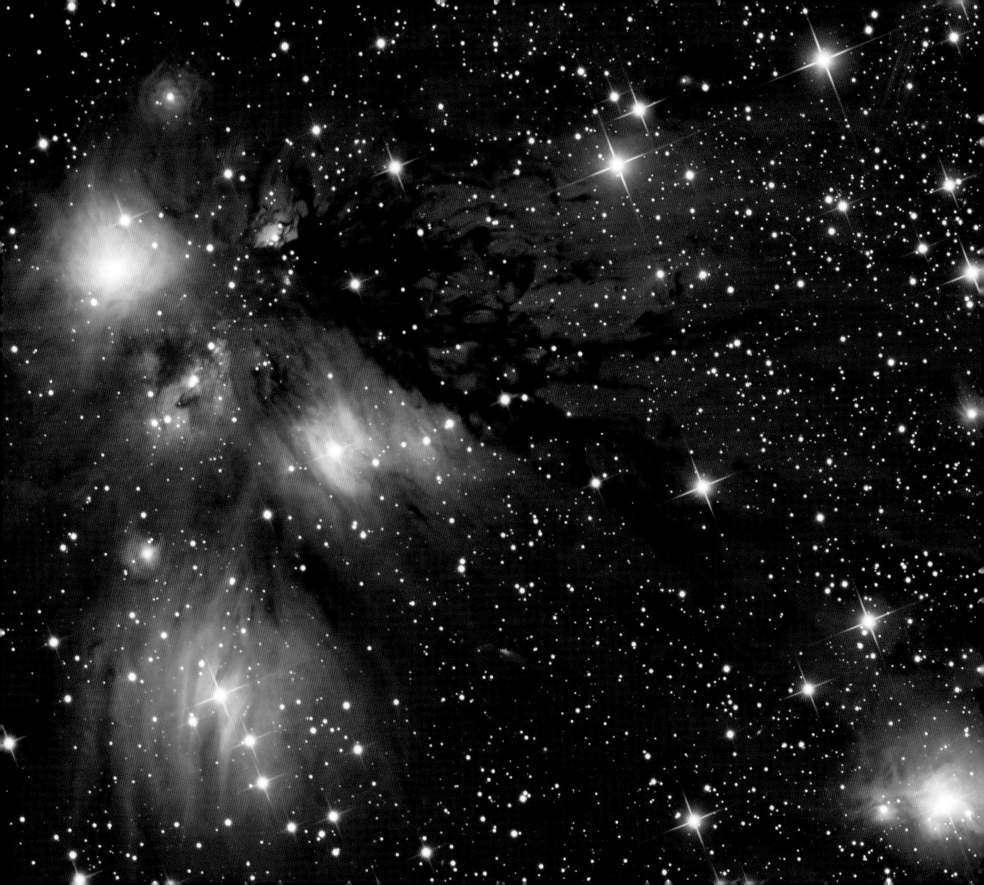

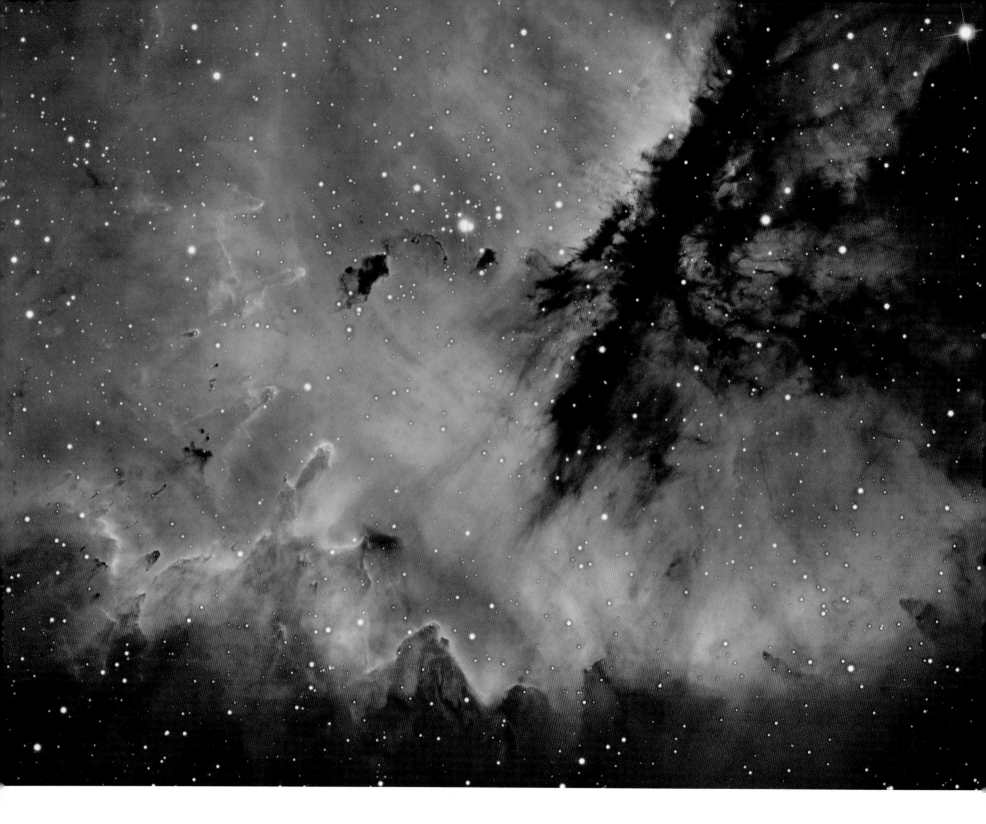

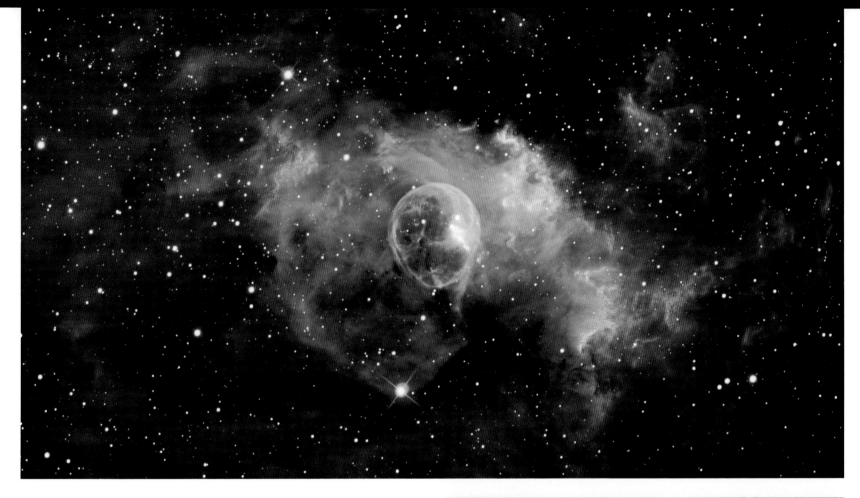

▲ The Bubble Nebula

A cosmic bubble of titanic proportions called the Bubble Nebula (NGC 7635), six light years wide, was formed by violent winds blown out by the hot central supergiant star, several hundred thousand times more luminous than our sun.

The Pelican Nebula ▷

A torrential flood of ultraviolet radiation released from embedded stars wreaks havoc on the Pelican Nebula (IC 5067). The radiation illuminates the cloud but also erodes and evaporates it, chiseling the surface into long, convoluted pillars of gas and dust.

◁ The Pacman Nebula

Translucent pillars of gas point toward the hot stars that power the Pacman Nebula (NGC 281). Radiation emitted by the stars illuminates the gas clouds but also continually erodes their structure. Among the huge dark clouds are compact globules of dust known as Bok globules. These are places of low-mass star formation, first described by the Dutch-American astronomer Bart Bok.

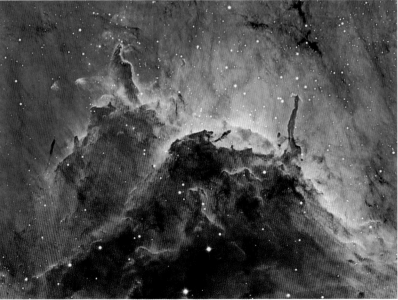

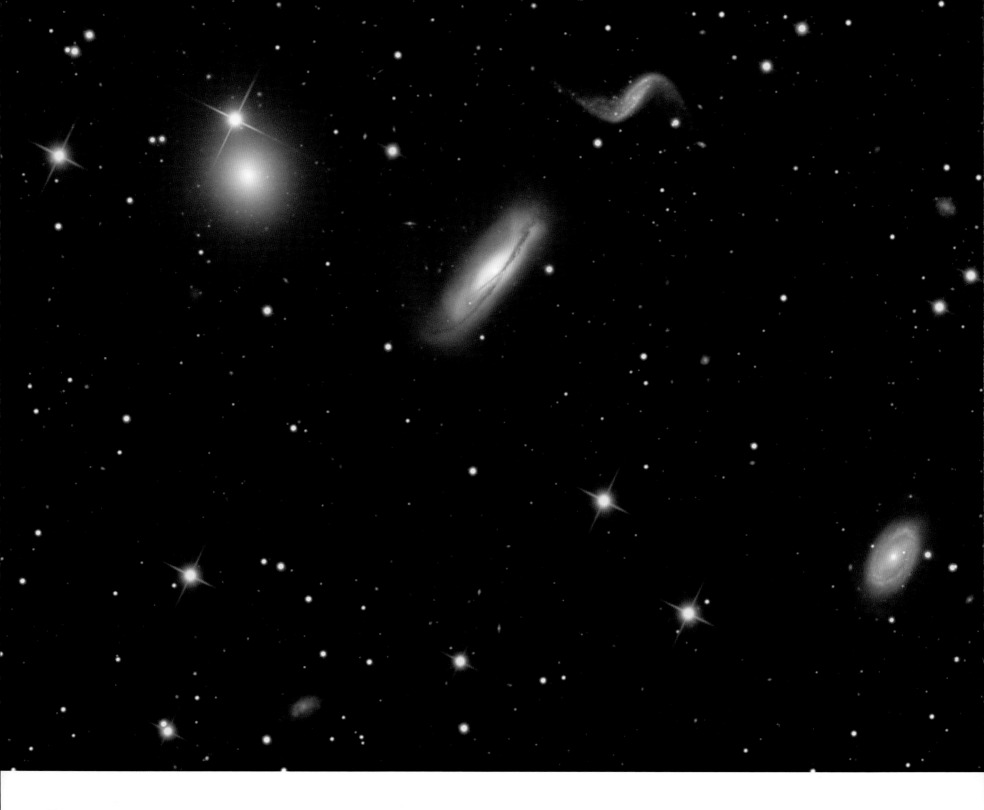

RUSSELL CROMAN

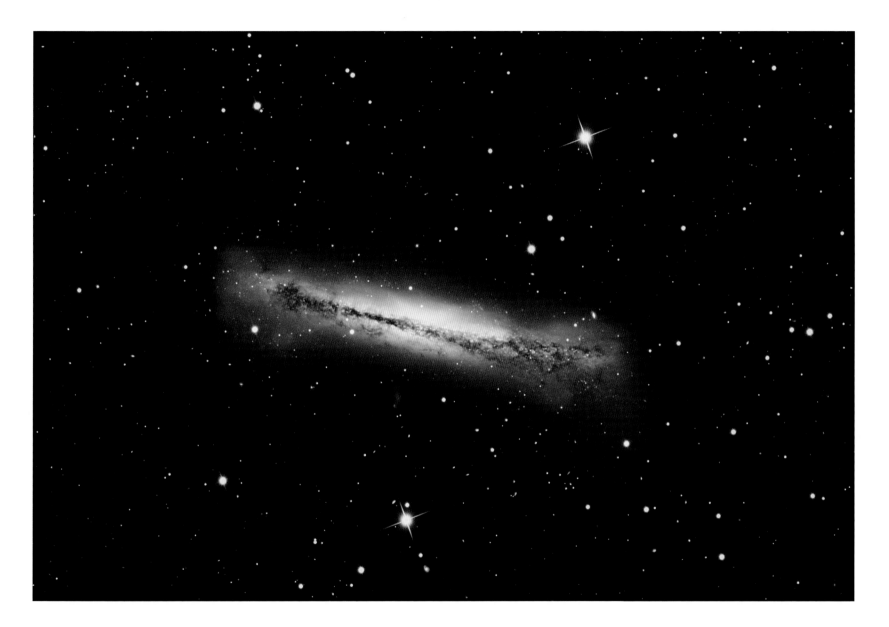

◄ **Hickson 44 Compact Galaxy Group**

These diverse galaxies are 100 million light years away and constitute number 44 of 462 compact groups identified by the Canadian astronomer Paul Hickson. Hickson and others believe these compact groups represent a stage in galactic evolution leading to the eventual fusion of all members of the group into one massive galaxy.

▲ **NGC 3628**

NGC 328 belongs to the Leo group, a grouping of three galaxies in the constellation Leo. Peculiar features on this galaxy, including a tidal plume of stars and gas that extends for thousands of light years and a curiously shaped disk, tell the tale of past gravitational encounters with other galactic members of the Leo group.

SEAN WALKER AND SHELDON FAWORSKI

Courtesy of Pat Faworski

WHAT DO AMATEUR ASTRONOMERS DO WHEN they live in locations less than ideal for astrophotography? Sean Walker of Chester, New Hampshire, and Sheldon Faworski of Elizabeth, Illinois, have combined their abilities and locations to form one of the elite imaging teams in astrophotography today. Faworski is a master at telescope making and digital image data acquisition, while Walker lives in a light-polluted town but enjoys and excels at image processing. Faworski takes the images from a dark sky site in Illinois, and Walker processes them. As a team, they produce a range of outstanding portraits of the universe from deep sky to high-resolution planetary imaging.

The Monkey Head Nebula

A stellar nursery is any celestial region where stars are born. Here, a gracefully shaped cloud of ionized gases known as the Monkey Head Nebula (NGC 2174–2175) is illuminated by its young brood of stars in the stellar nursery of Orion.

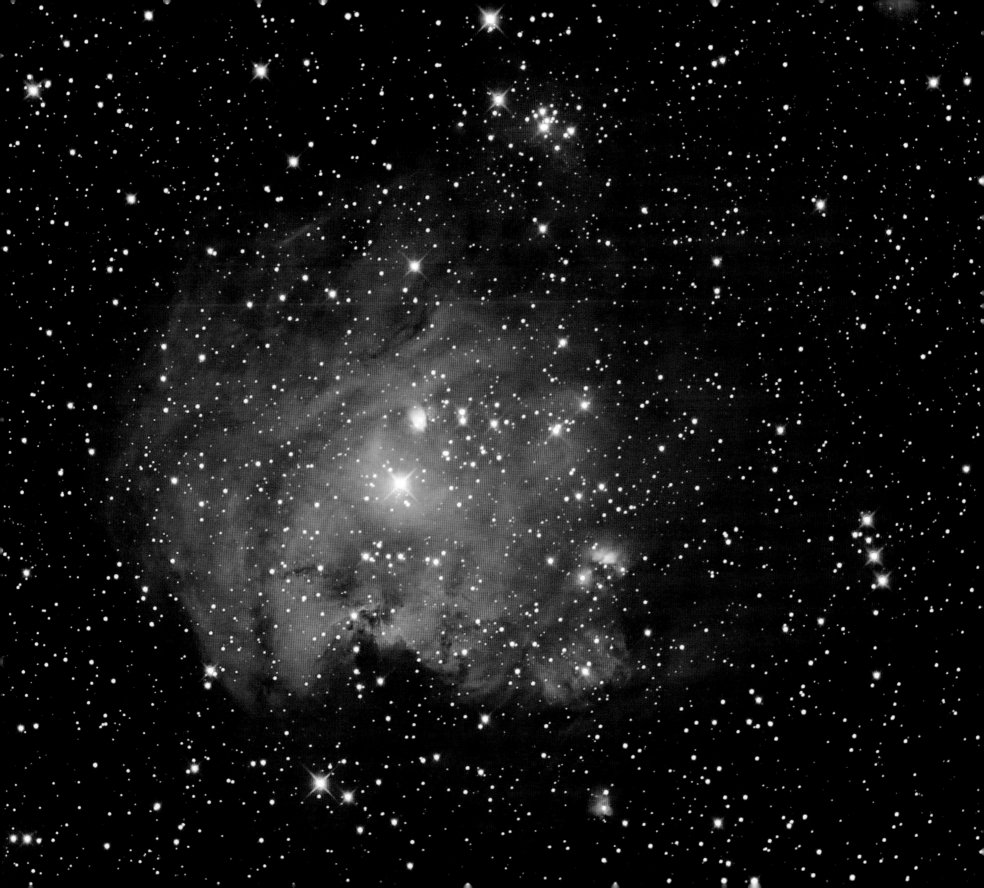

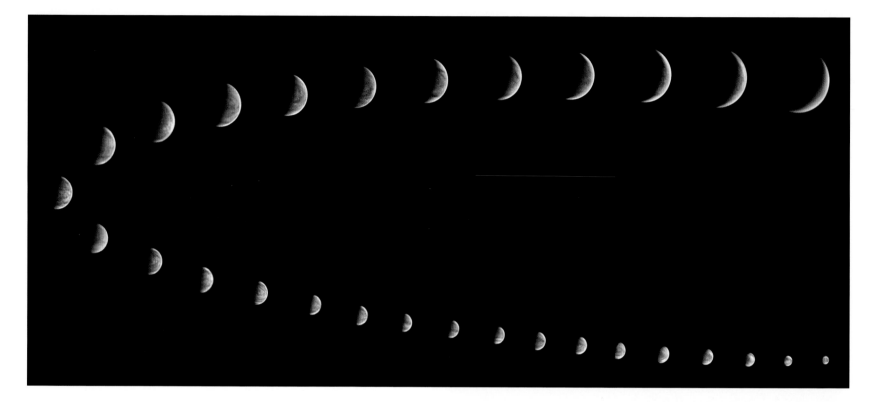

▲ Venus in Ultraviolet Light

The phases of Earth's sister planet, Venus, were captured in ultraviolet light during its appearances in our night sky in 2007. Only large features of the opaque sulfuric acid cloud tops are visible, concealing the planet's complex but unseen terrestrial surface.

Mars ▶

The southern ice cap of Mars is the foremost feature in this highly detailed image. Formed by layers of frozen carbon dioxide and water, it expands and contracts with the Martian seasons, much like Earth's polar regions.

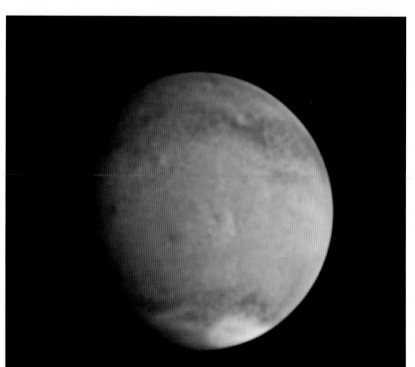

SEAN WALKER AND SHELDON FAWORSKI

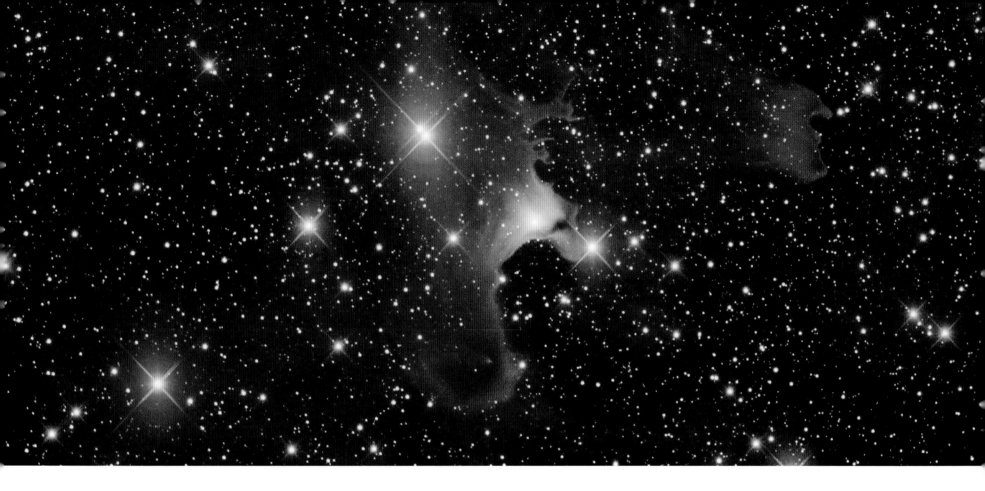

▲ Reflection Nebula in Cepheus, vdB 141

Large sweeping dust clouds gently illuminated by nearby stars form curious branching patterns and ghostly shapes as they scatter the starlight of the young nearby suns.

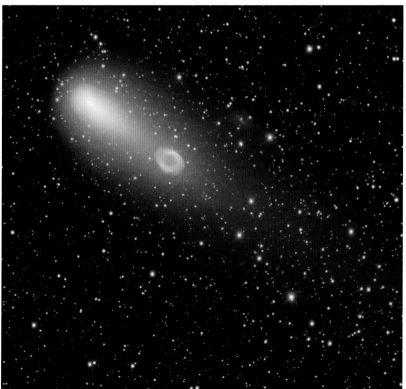

◀ Comet P73/Schwassmann-Wachmann

In a serendipitous study of cosmic perspectives, Comet P73/Schwassmann-Wachmann, 6 million miles from Earth, passes along the line of site of planetary nebula M57 and the faint distant galaxy IC 1296, located 20,000 light years and 200 million light years away, respectively.

JOHN GLEASON

Courtesy of Pam Lee

JOHN GLEASON, A PRODUCT MANAGER FOR HEWLETT-PACKARD in California, has been practicing amateur astrophotography since 1974. He is well known for his narrowband grayscale images of the night sky, inspired by the pioneering work of Hans Vehrenberg in *Atlas of Deep-Sky Splendors* (1967) and Shigemi Numazawa in *The Deep Sky* (1993). Narrowband photography isolates specific wavelengths of light. Gleason is particularly interested in capturing the beauty of the Milky Way. He regularly takes imaging trips to the Southern Hemisphere for this purpose. "The real treat on these trips is the grand sweep of the galactic center of our Milky Way galaxy overhead on late fall mornings," Gleason says. "The integrated starlight of a billion suns cast a faint glow across the observing field. . . . I've never seen a more spectacular sky."

Simeis 147

Relentlessly expanding, the supernova remnant Simeis 147 (Sh2-240) is currently 100 light years wide. The structure of glowing arcs and bubbles is what remains of the cataclysmic end of a stellar giant some 30,000 years before.

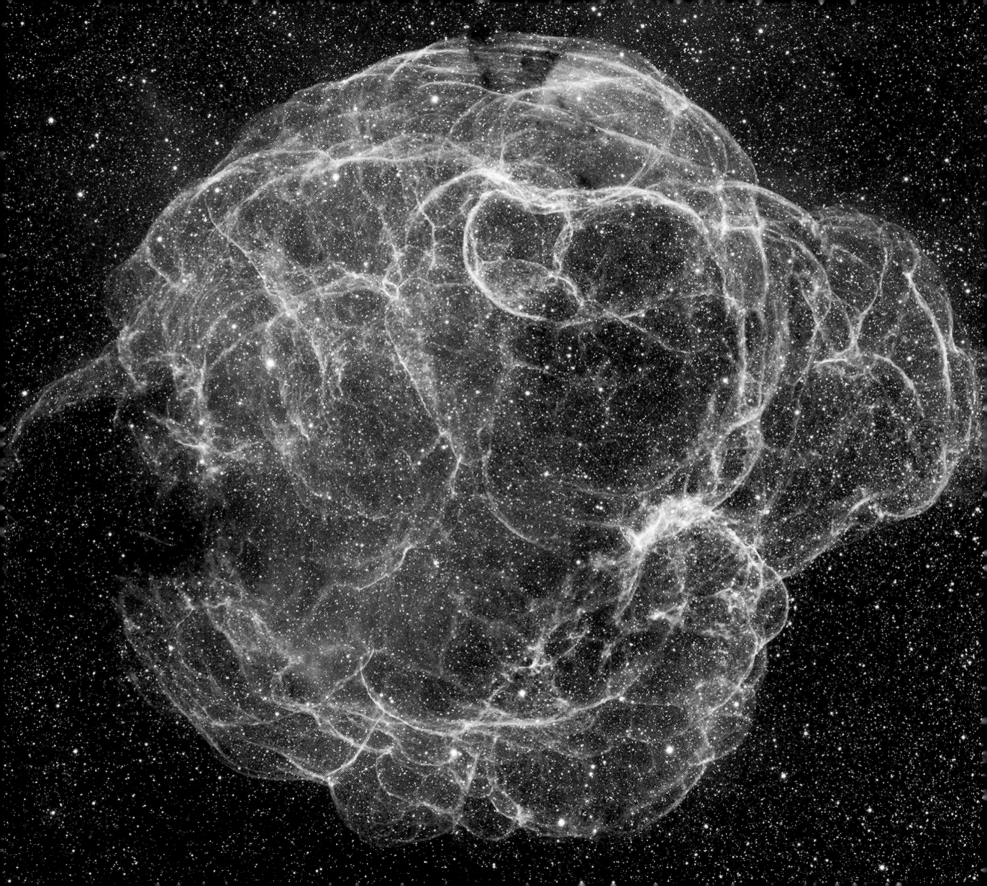

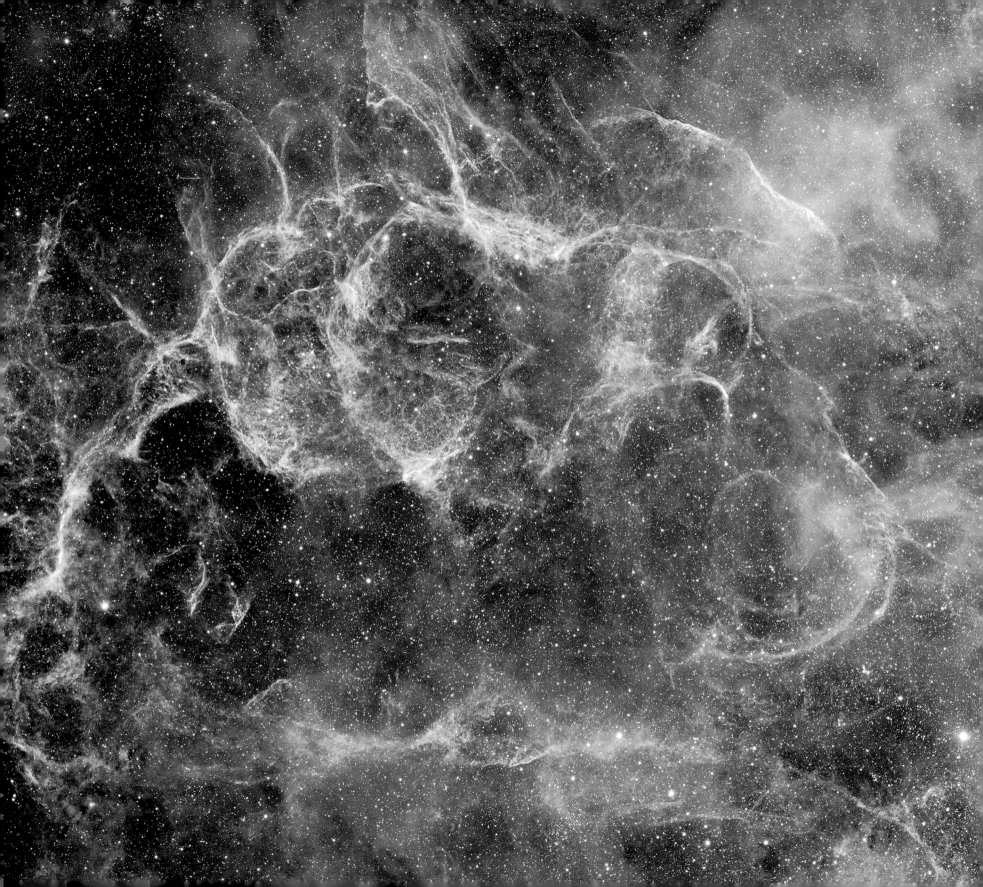

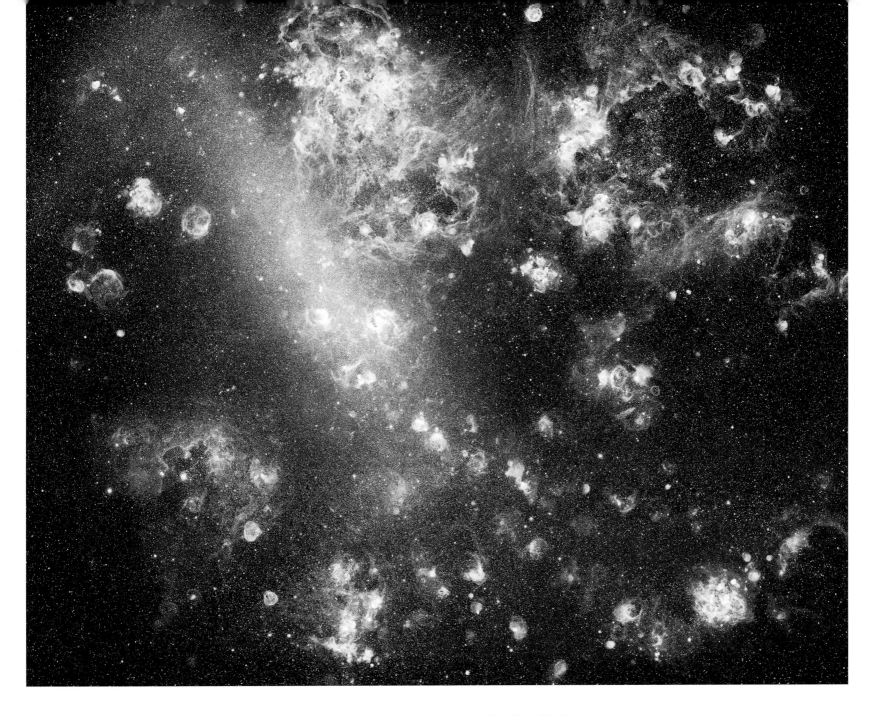

◀ **Vela Supernova Remnant**

In the southern constellation of Vela, expanding clouds and filaments of visible light will continue to shine for thousands of years as the contents of a once-massive sun become recycled into a new generation of young stars.

▲ **Large Magellanic Cloud**

Cavities and shells abound in this expansive photo mosaic of one of the major companion galaxies orbiting the Milky Way. Hints of a barred spiral structure suggest its origin as a spiral galaxy captured in a close encounter with the larger Milky Way billions of years before.

LISA FRATTARE AND ZOLT LEVAY

Courtesy of STScI

Courtesy of Michael DiBari Jr.

ZOLT LEVAY AND LISA FRATTARE WORK FOR THE OFFICE OF PUBLIC OUTREACH at the Space Telescope Science Institute (STScI) in Baltimore, Maryland. Their main responsibility is to produce and publicize images taken by the Hubble Space Telescope. As team members of the Hubble Heritage project, they have helped assemble many of the Hubble images into breathtaking masterpieces for the benefit of public enjoyment and education.

Frattare was educated at Oswego State, Arizona State University, and Wesleyan University before coming to the STScI in 1996. Some of her earliest memories are celestial in nature: "I loved staying up late, having the shades open at night to watch the stars and moon traverse my bedroom window." Frattare has a deep passion for amateur and professional astronomical observation. She is the project coordinator and an image processor for the Hubble Heritage project, and she also has the privilege of working on science release images for space and ground-based observatories. Along with Levay, she creates stunning full-color pictures from Hubble's black-and-white raw data.

Levay was born in Rawalpindi, Pakistan, and came to the United States when he was four years old. He became interested in astronomy in high school. Levay recalls being "particularly fascinated by the magnificent photographs made by the world's great telescopes. I tried to make photos with my own home-built telescope and this fueled an interest in all things technical and a growing passion for photography." Levay joined the STScI in 1983 and is now the imaging resource lead for the Heritage project. He says, "I started this phase of my career just when the first remarkable data emerged from the repaired telescope and found myself helping to produce and publicize the first images."

The Cigar Galaxy

Bursts of star formation have produced dramatic effects on the Cigar Galaxy (M82). A collective outgassing of stellar winds from thousands of new stars and supernovae has caused superheated filaments of gas to extend out from the galactic core several thousand light years. The superheated gases that arise from the combined particle winds of new stars and supernovae are collectively known as a galactic "super wind."

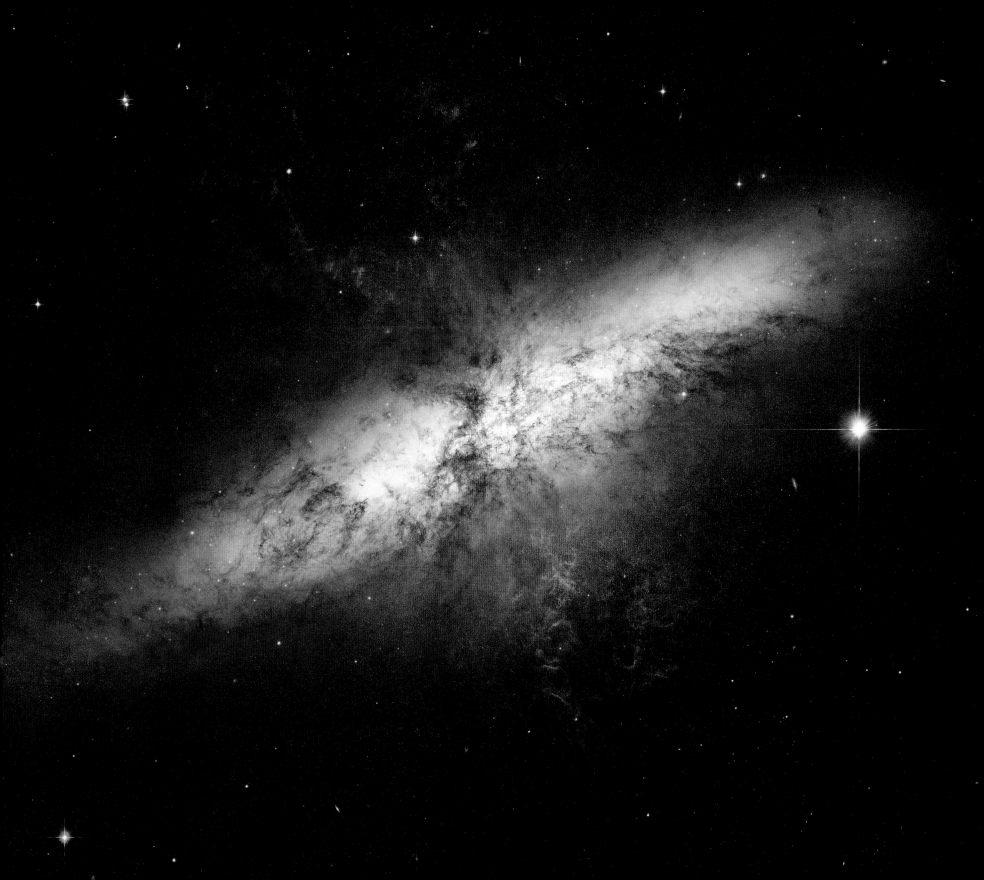

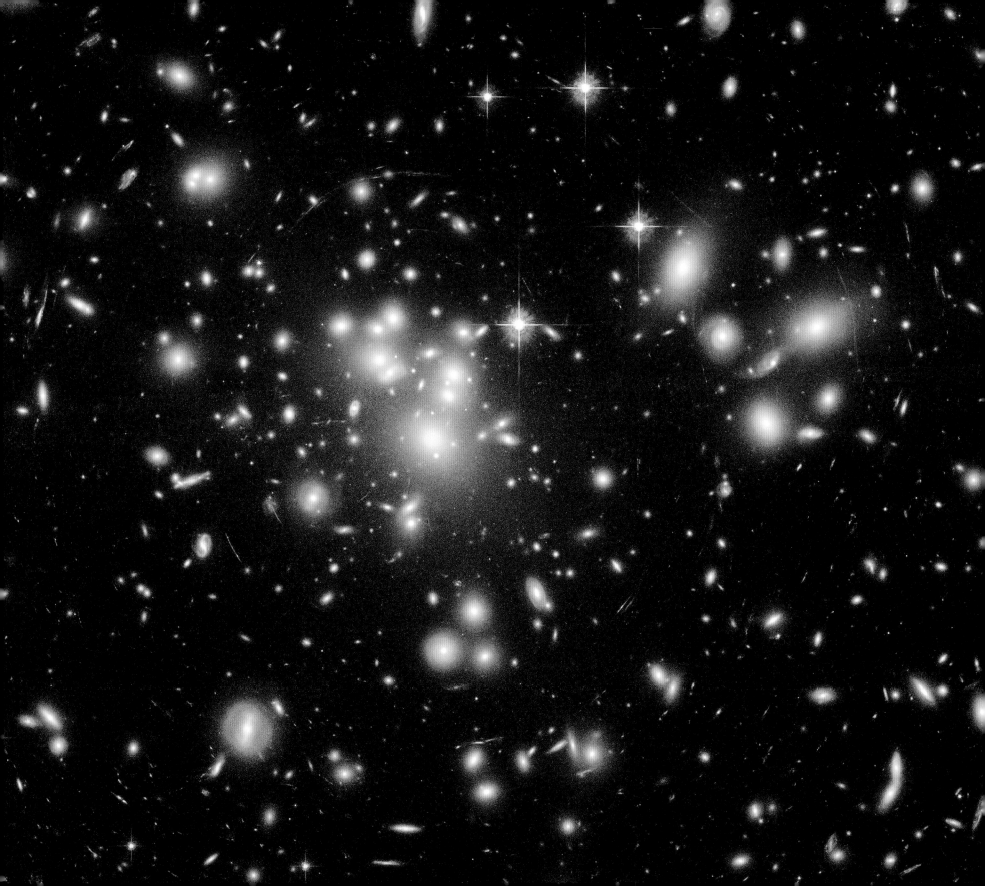

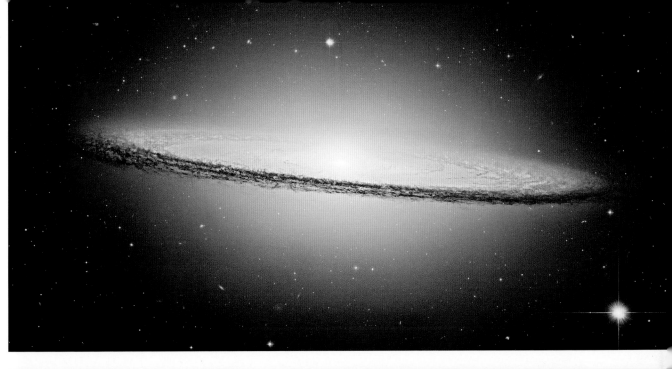

Abell 1689

Scattered throughout this vortex of galactic forms are the yellowish members of galaxy cluster Abell 1689, some 2.2 billion light years distant. The enormous mass of the cluster serves as a gravitational lens, distorting and magnifying the light of far more distant galaxies and morphing their shapes into arcs and spindles. Several of the arc-like forms represent galaxies as distant as 12 billion light years away, imaged as they existed during the formative era of our universe.

The Sombrero Galaxy

An imposing form with its dark disk transecting a colossal bulge, the Sombrero Galaxy (M104) is a highly luminous and truly substantial galaxy having a mass of 800 billion suns. It is one of a growing list of galaxies known to possess a super massive black hole within its center.

NGC 1300

This remarkably detailed image of the classic barred spiral galaxy NGC 1300 shows the two dominant spiral arms joining the enormous central bar at each end. A myriad of other small-scale structures such as star-forming nebulae, red and blue giant stars, and numerous background galaxies are visible in the image.

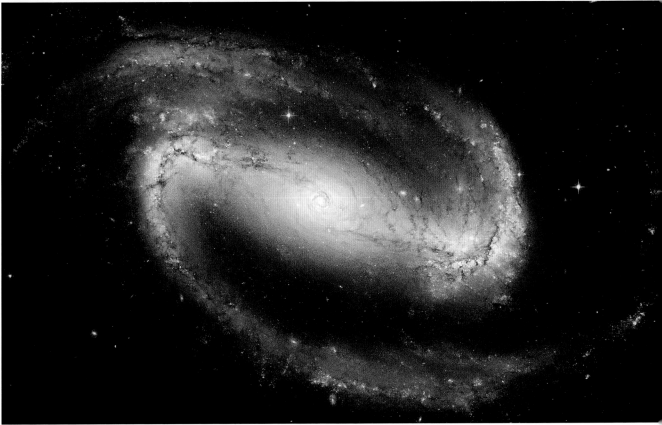

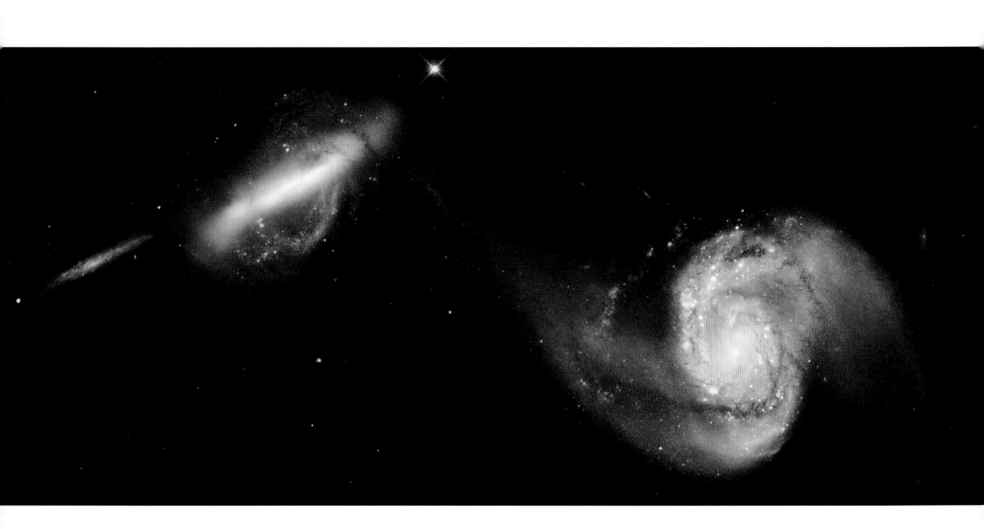

Arp 87

Collectively known as Arp 87, two distorted galaxies appear engaged in a cosmic waltz as the gravitational pull of NGC 3808A (*left*), a polar ring galaxy, strips gas and stars from the disk of its neighbor, NGC 3808 (*right*). As a consequence, a new generation of young blue stars has formed in the bridge of material shared by the two galaxies.

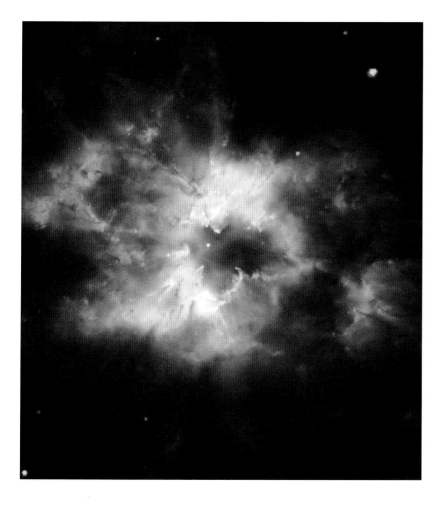

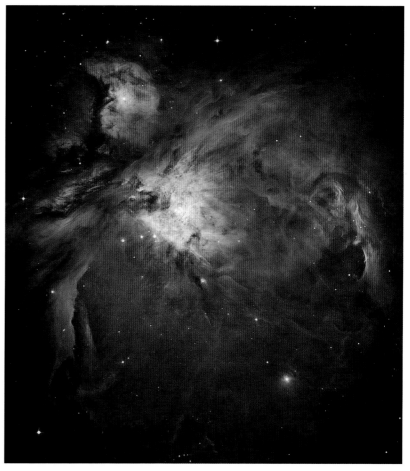

NGC 2440

The final stage in the lifetime of a sunlike star, the planetary nebula stage lasts only 10,000 to 30,000 years, an astronomical instant in the overall life of a star. The dying central star of NGC 2440 is one of the hottest known, with a surface temperature near 200,000 degrees Kelvin.

The Orion Nebula

Spanning forty light years, the legendary Orion Nebula (M42) is one of the most inspiring cosmic structures visible from our location within the Milky Way. With a gaseous repository of ten thousand suns, the clouds of M42 glow with fantastic colors and shapes, giving us a bird's-eye view of one of the greatest star-forming nurseries in our part of the galaxy.

DANIEL VERSCHATSE

Courtesy of Peter-Gerhard Seitz

BELGIUM NATIVE DANIEL VERSCHATSE works as a telecommunication component manufacturer in Santiago, Chile. He has been fascinated by astronomy since the age of ten. As a boy, he dabbled in making telescopes, experimenting with different types of lenses and mirrors. He purchased his first commercial telescope during his college years, a 102-millimeter refractor on a motor-driven equatorial mount: "This was a turning point and gave me my first quality views of the moon and planets and enabled my first excursions into astrophotography." Verschatse progressed from film photography to CCD imaging. In 1999, he moved from Belgium to Chile: "I grabbed the opportunity to make a childhood dream come true by building my own observatory under the pristine Chilean skies." The observatory saw first light in 2001, and with it he has produced many stunning celestial portraits from southern latitudes.

M78

Young stars reveal their presence in both subtle and spectacular ways. The bright young stars of the nebulae M78 and NGC 2071 give rise to great blue clouds of scattered starlight that emerge from the vast and dark Orion molecular cloud. A molecular cloud comprises vast cold and dark clouds of mostly molecular hydrogen and dust that collapse under gravity to form infant stars, which in turn illuminate those clouds to form glowing nebulae.

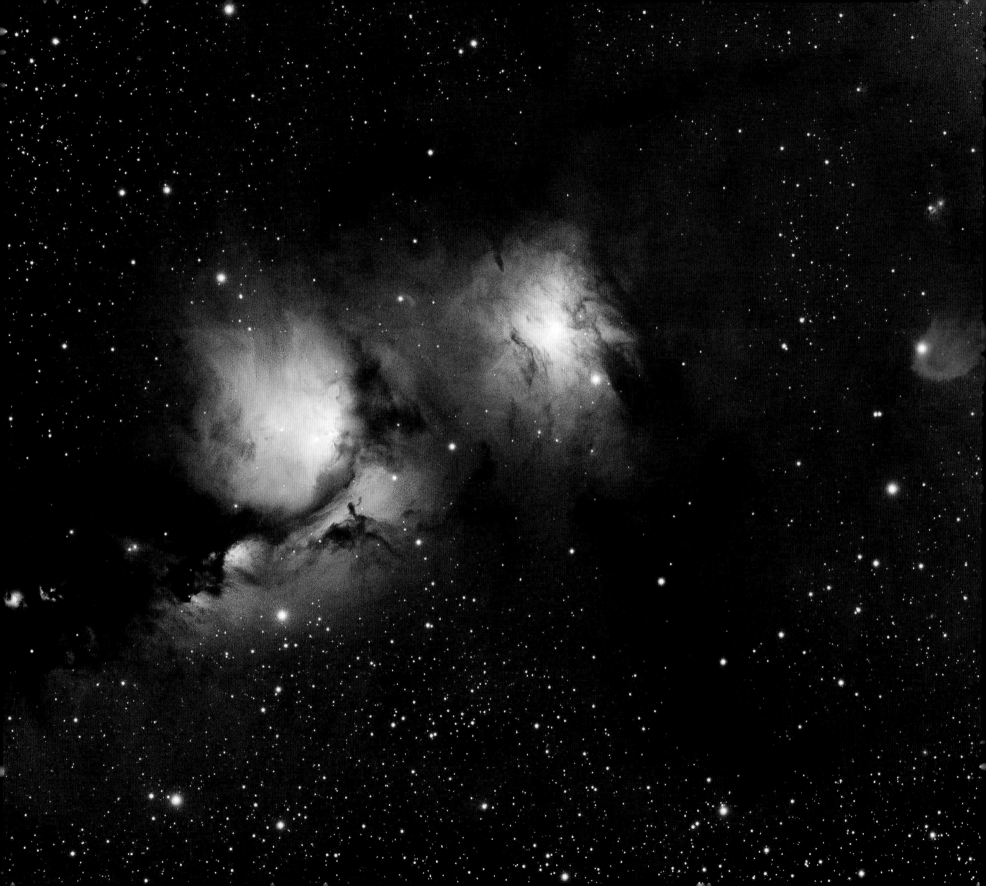

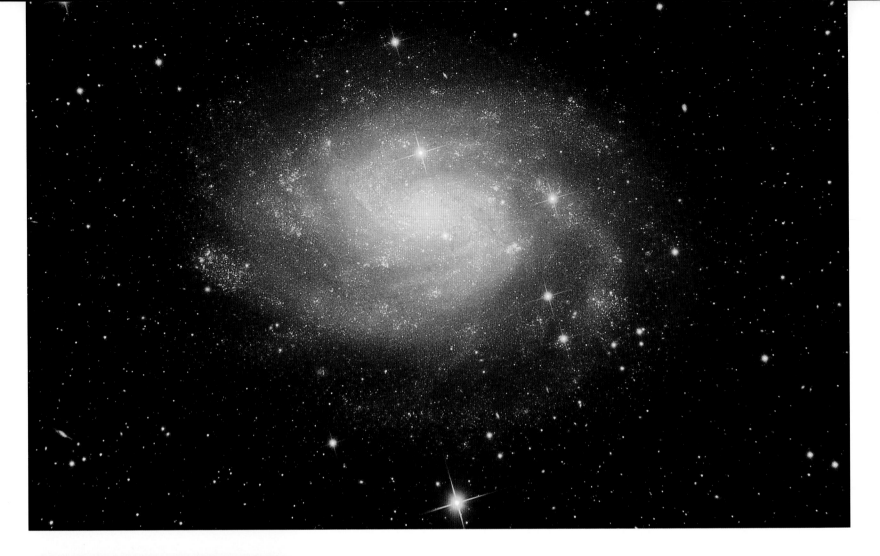

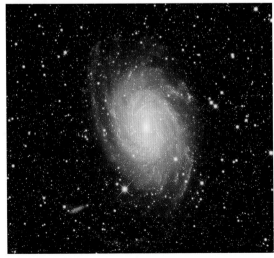

▲ NGC 300

A member of the famous Sculptor Group, NGC 300 is one of the most stunningly beautiful galaxies in the Southern Hemisphere. Populations of young blue stars occupy its rich, radially symmetric spiral arms.

◄ NGC 6744

A magnificent spiral galaxy in the constellation Pavo, NGC 6744 is thought to have great similarities to the Milky Way. At its northern tip (*lower left*), an anomalous spiral arm interacts with a dwarf companion galaxy, similar to the Milky Way's relationship with the Large Magellanic Cloud.

The Antennae ▶

The merging galactic systems NGC 4038 and NGC 4039 are known as the Antennae. Surprisingly commonplace in the universe, galactic mergers can take hundreds of millions of years to run their course. These two galaxies began their union between 300 million and 450 million years ago and will likely complete the merger in some 300 million years, forming a single galaxy.

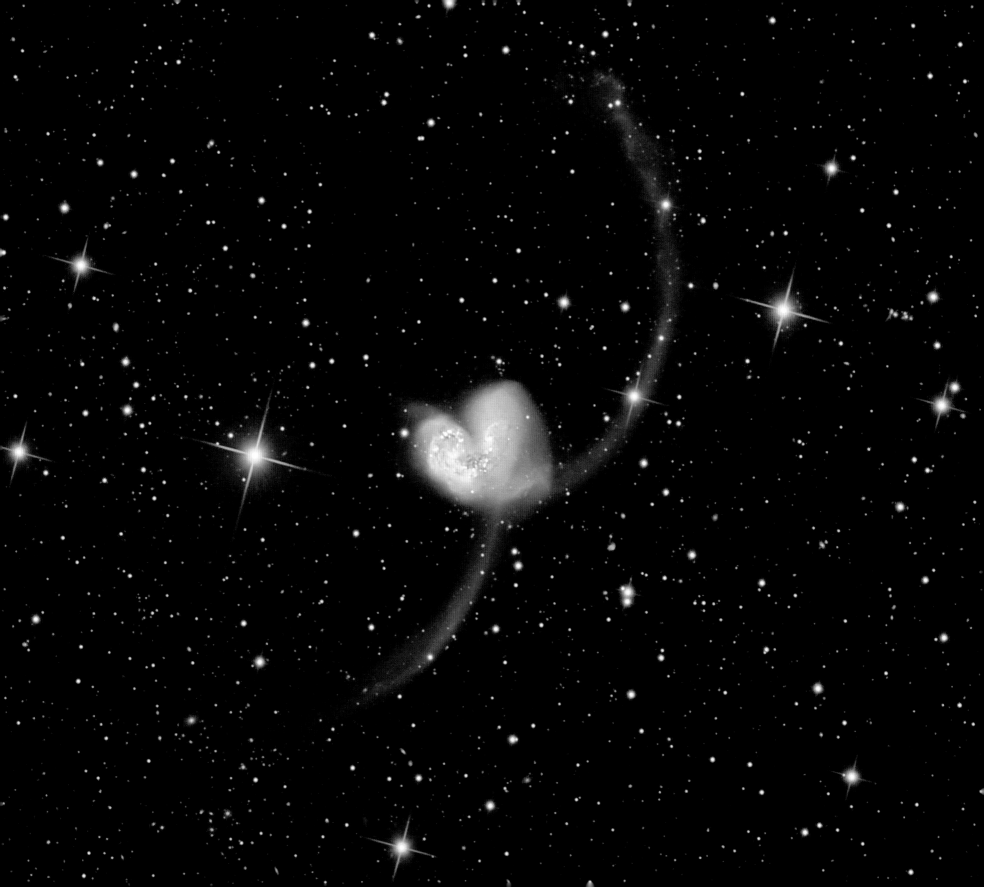

TRAVIS RECTOR

Courtesy of Peter Michaud

DR. TRAVIS RECTOR IS A PROFESSIONAL ASTRONOMER at the University of Alaska Anchorage. He earned his doctorate in astrophysics at the University of Colorado in 1998. While doing a postdoctoral fellowship at the Kitt Peak National Observatory, he began creating color composite images using large observatory telescopes. Originally intended to show the capabilities of the Kitt Peak instruments, the images soon became popular with the public. Rector continues to make images for the National Optical Astronomy Observatory and the Gemini Observatory.

The vibrant color and strange beauty of his photographs often lead viewers to ask if that is what the objects really look like. Rector explains, "The telescope can see objects that our eyes cannot. The objects are too faint to experience directly and the light we record may be beyond the spectrum of human vision. . . . Our images therefore translate telescopic vision into human vision."

IC 342

Serendipitously framed by a grouping of colorful Milky Way stars, this galaxy would be one of the brightest in the sky if it wasn't obscured by interstellar dust from the disk of our own galaxy.

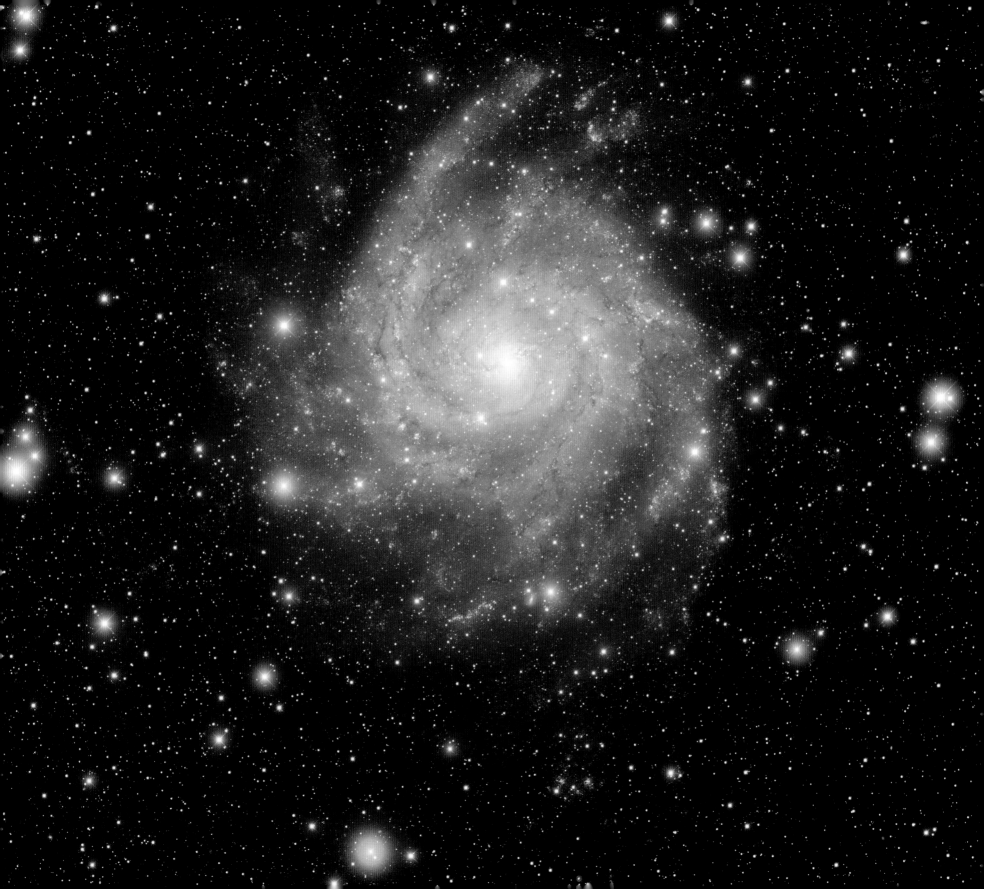

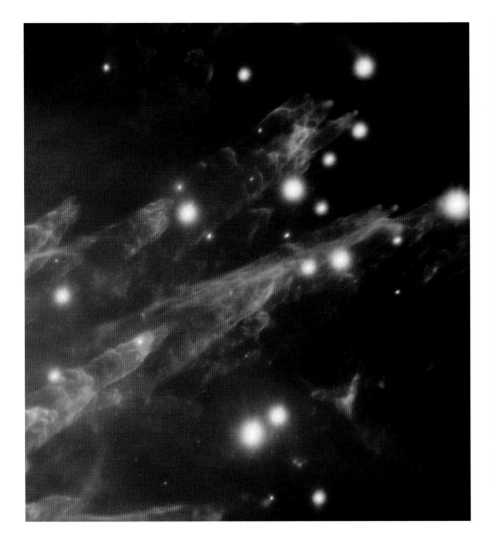

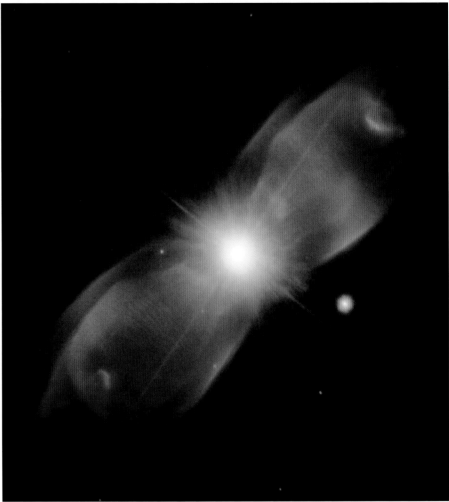

Orion Bullets

In a surreal scene, supersonic "bullets" of superheated gas pierce the cold molecular clouds in the Orion stellar nursery.

The Butterfly Nebula

The gaseous remains of a dying sunlike star have formed the Butterfly Nebula (M2-9), an object of distinctive symmetry and astonishing beauty. Our own sun will likely meet a similar fate in a few billion years.

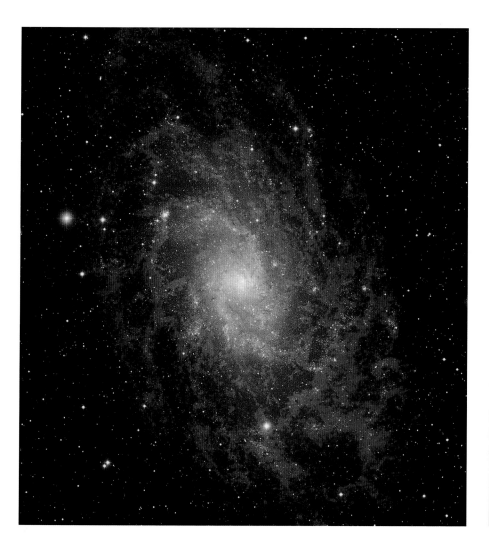

The Triangulum Galaxy

This remarkable montage of the Triangulum Galaxy (M33) was made by combining visual light data (*center*) with radio wave data (*outer blue arms*). The radio data reveals the true extent of otherwise invisible cold hydrogen gas in the outer reaches of the galaxy.

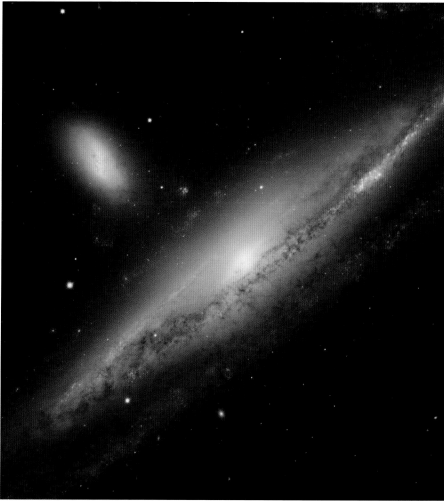

Galactic Collision

No single event in the universe is as physically altering as a galactic collision. This image captures the fateful interaction of two cosmic giants, galaxies NGC 1531 and NGC 1532.

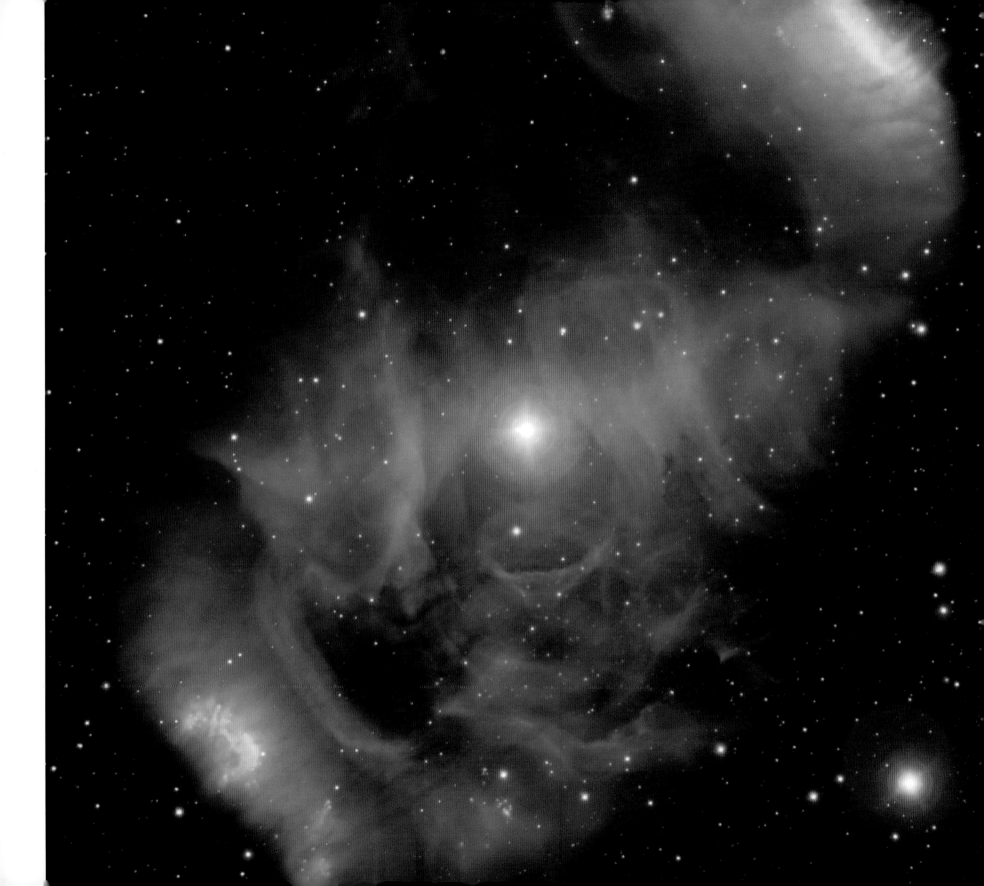

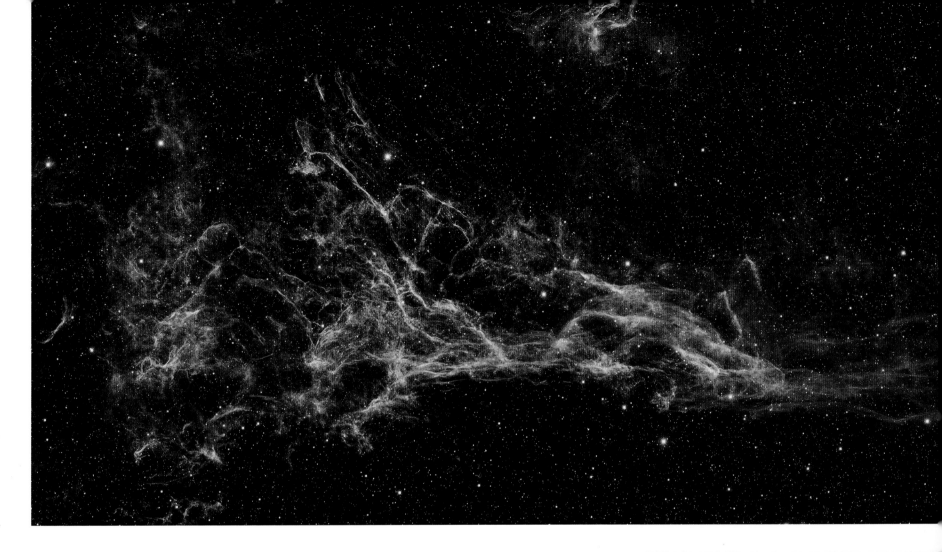

▲ Pickering's Triangle

These delicate tendrils and filaments of shocked interstellar gas were named Pickering's Triangle in honor of American astronomer Edward Charles Pickering. They make up part of the larger Cygnus Loop, an 80-light-year-wide shock front formed by the cataclysmic destruction of a massive star several thousand years ago.

Jupiter in Infrared Light ▷

The turbulent rolling cloud tops of the gas giant Jupiter take on an almost magical appearance when photographed in infrared light. Visible in the forefront is the Great Red Spot, which appears white in the infrared light.

◁ NGC 6164-5

This rare object, known as an ejected nebula, was formed by the powerful winds of its young central star. The star is an O-type supergiant, the hottest and most massive of stars. The symmetric bipolar nebula is an unusual object formed from a series of gaseous ejections by the central star over a period of several thousand years.

BERNHARD HUBL

Courtesy of Andreas Hubl

BERNHARD HUBL IS AN ENGINEER LIVING IN AUSTRIA. As a boy, he was captivated by the images of Jupiter and Saturn that were transmitted to earth by the Voyager Probes. Soon he was observing planets and deep-sky objects on his own, first through binoculars and later through a simple Dobsonian telescope. For the last fifteen years, Hubl has been imaging deep-sky objects using a variety of instruments; however, he is most known for his magical images of star fields amid bright and dark nebulae.

Hubl says, "There is one object type which is my favorite and which can be found in almost every deep sky image: stars." Hubl does not consider stars to be ancillary objects but an essential contribution to the visual impact of an astronomical image. With that philosophy in mind, his images highlight the colorful and aesthetic nature of stars.

Leo 1 Dwarf Galaxy

Subdued by the brilliant light of the blue supergiant star Regulus (*right*) in the constellation Leo, the diminutive-appearing Leo 1 Dwarf galaxy (*left*) is one of many strange satellite galaxies known to orbit (and occasionally be consumed by) our Milky Way.

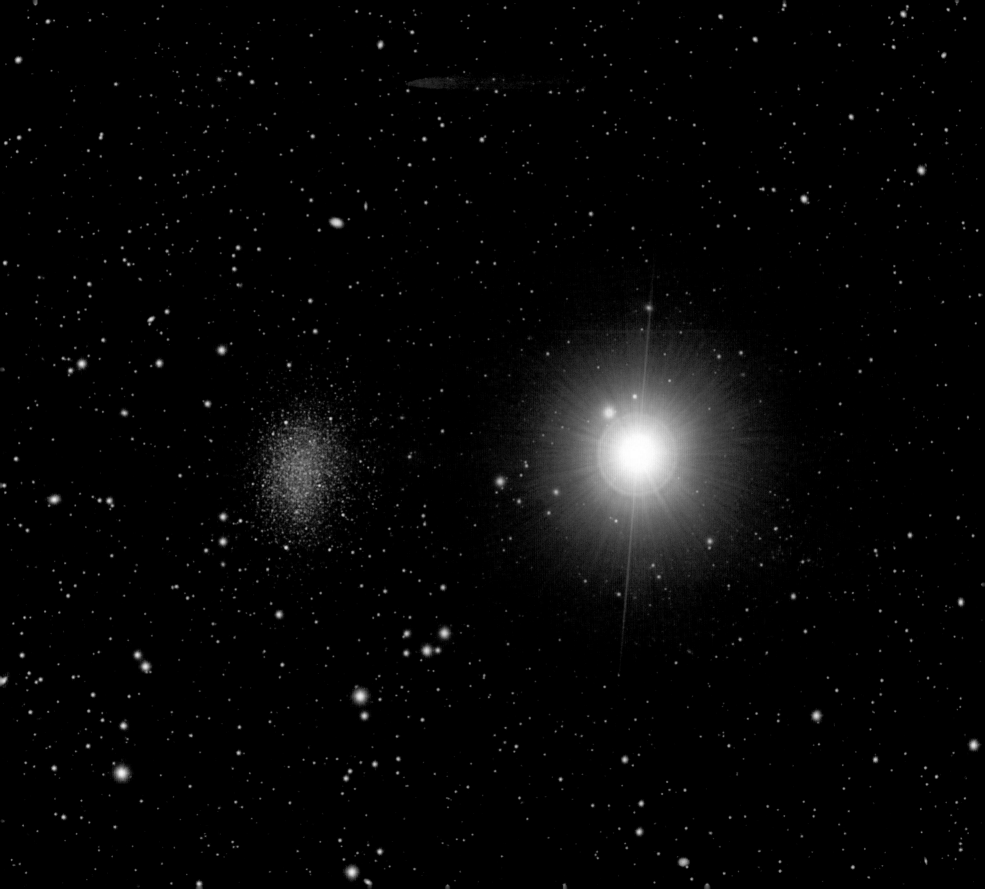

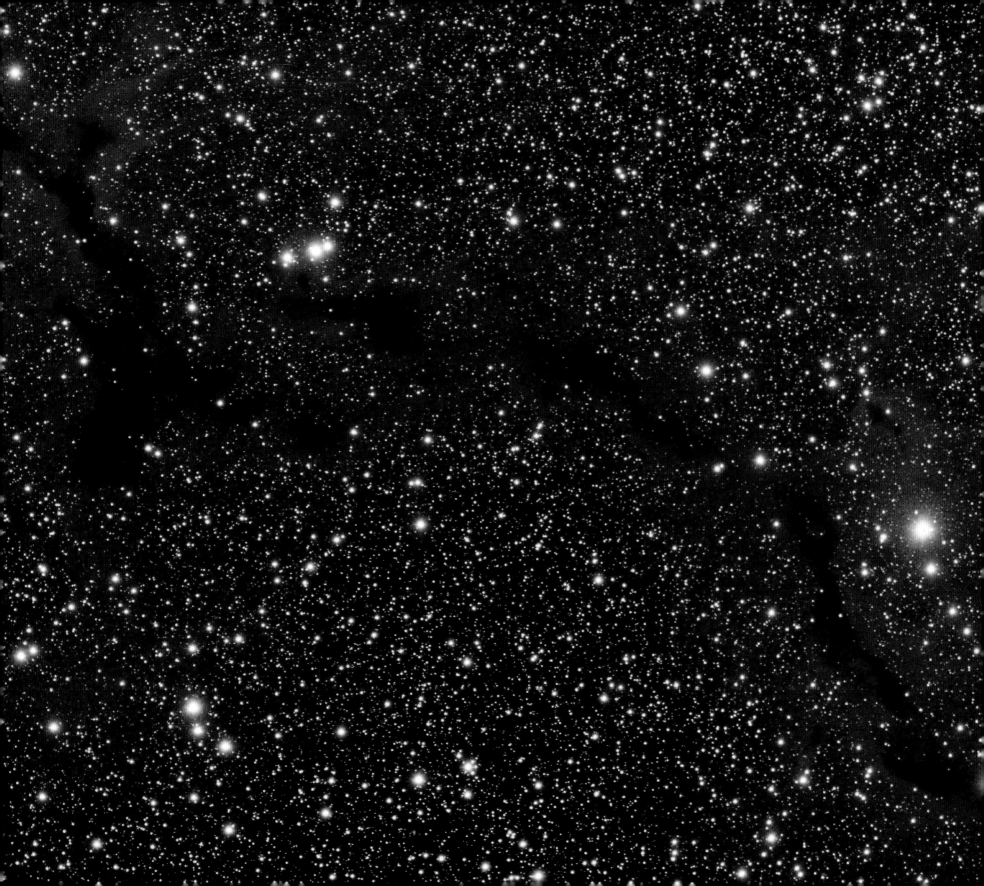

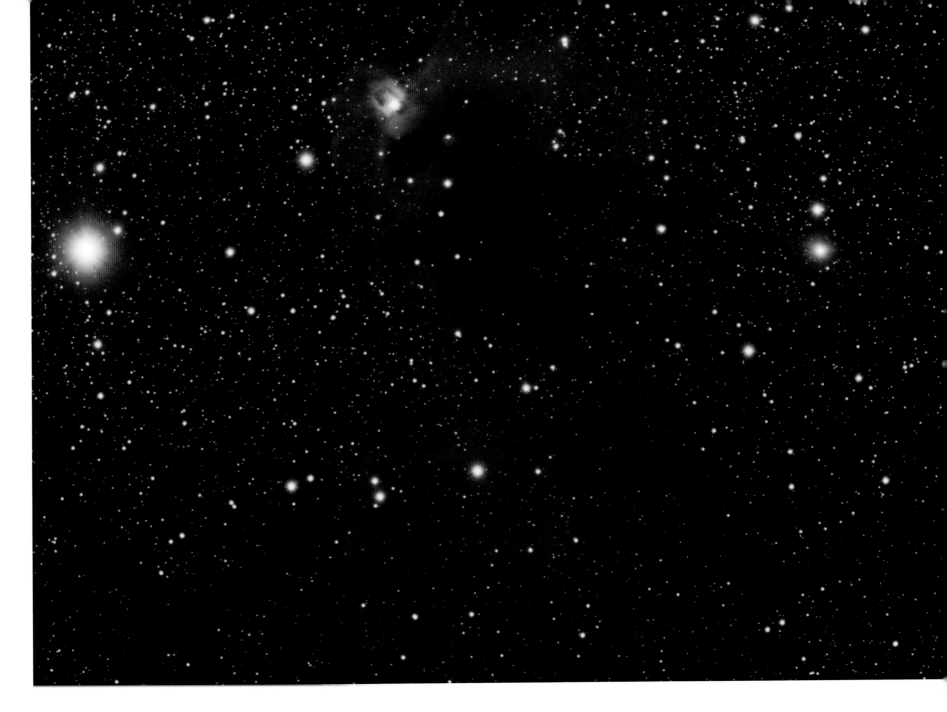

◄ B150

This portrait of number 150 on Barnard's catalog of dark nebulae (see page 16) typifies the dark rifts of obscuring nebulosity seen against the faint glow of distant stars that so intrigued the pioneering astrophotographer.

▲ LDN 1622

This complex of dark and bright nebulosity lies near the plane of our galaxy, close to the famous glowing cloud known as the Orion Nebula (M42). (See page 95 for a portrait of M42.)

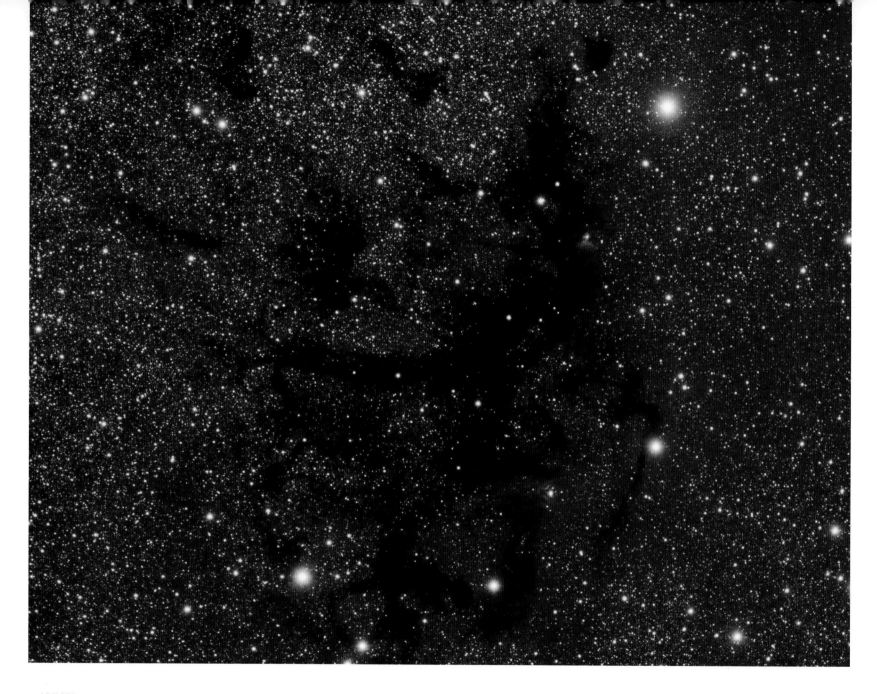

▲ LDN 673

This field represents number 673 in *Lynds' Catalog of Dark Nebulae*. The catalog, published by American astronomer Beverly Lynds in 1962, was based on photographic plates made by the National Geographic–Palomar Observatory sky atlas and, in many cases, can be cross-identified with Barnard's catalog.

IC 446 and IC 447 ▶

This field in Monoceros underscores the essential relationship between stars and bright and dark nebulae. Both the bright and dark clouds of dust and gas are the consequence of illumination or obscuration of collective starlight from innumerable suns.

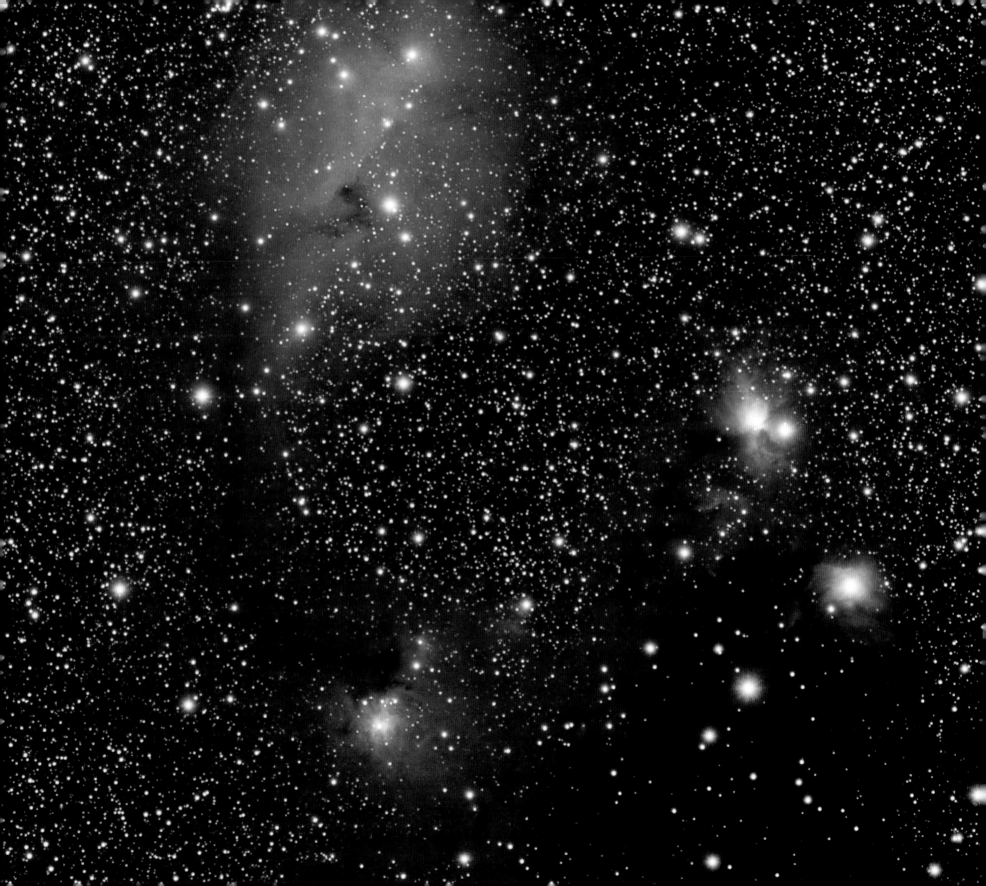

GERALD RHEMANN

AUSTRIAN ASTROPHOTOGRAPHER GERALD RHEMANN HAS BEEN taking pictures of the night sky since 1989. He travels to remote locations such as the Austrian Alps, the Canary Islands, and the deserts of Namibia to photograph the sky under the most pristine conditions. Rhemann specializes in deep, wide-field vistas of the Milky Way using short-focal-length telescopes and large-format CCD cameras. His special interest is searching for and photographing undiscovered comets, which he does in partnership with his friend Michael Jäger. Rhemann considers his astrophotography to be both works of art and contributions to science. His signature images are striking, vibrant portraits of Milky Way nebulae, and his famous comet images capture the majesty of famous and lesser-known interlopers of our solar system.

Courtesy of Christoph Rhemann

Cederblad 111

Sweeping clouds of interstellar dust conceal an active stellar nursery in the constellation Chameleon in the Southern Hemisphere. Dust, a major component of galaxies, is opaque to the passage of visible light but becomes amazingly transparent at infrared wavelengths. Studies in infrared light often reveal dust clouds to be teeming with embryonic stars.

22

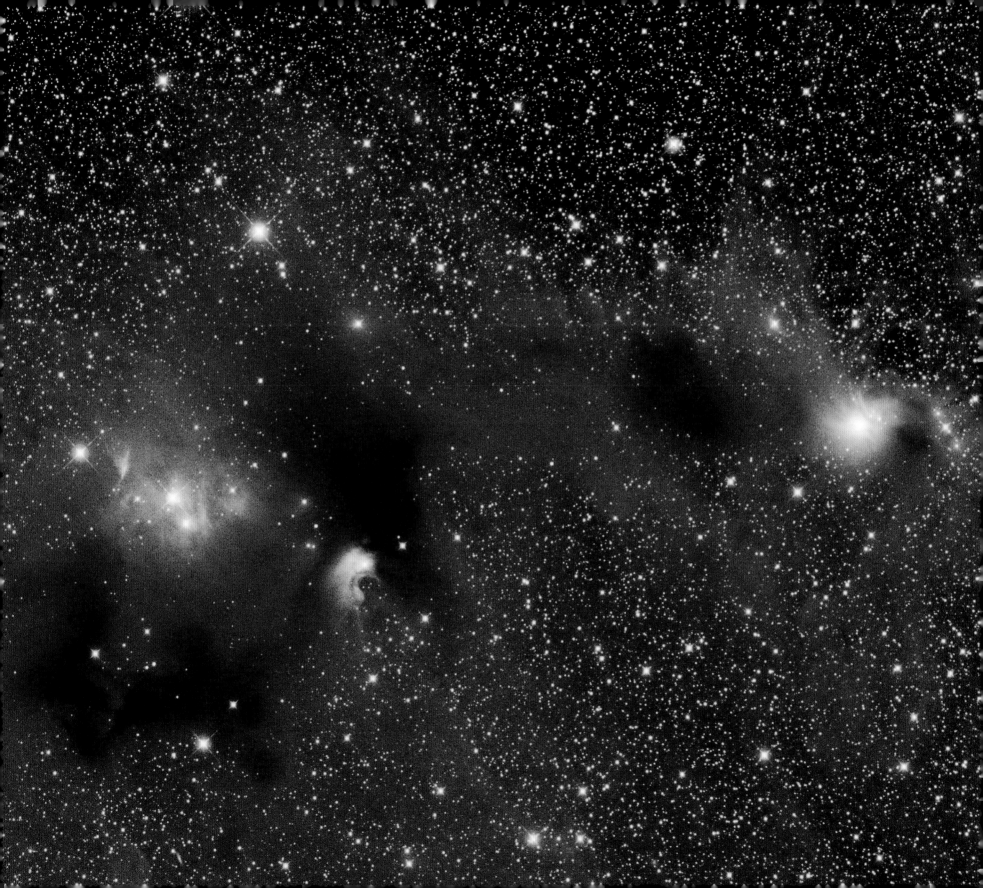

The Summer Milky Way

The idea of two homes, terrestrial and galactic, are skillfully juxtaposed in this rich composite image of the summer Milky Way seen from the green and lush planet Earth.

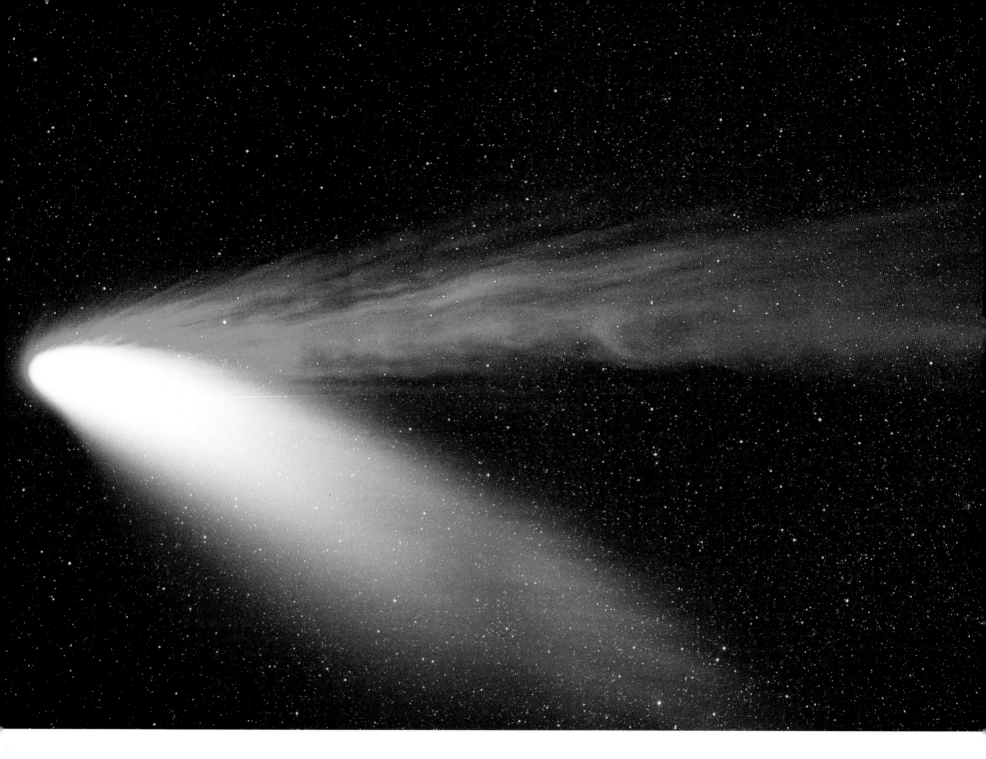

Comet Hale-Bopp

Comet Hale-Bopp made mainstream headlines in 1997 as it passed close to the sun and became one of the brightest and most widely observed comets of the twentieth century.

\mathcal{A}XEL MELLINGER

Courtesy of Axel Mellinger

AXEL MELLINGER IS A PHYSICIST at the University of Potsdam in Germany. He took his first hand-guided piggyback astrophotographs in 1980 at the age of thirteen. While doing post-doctoral work at the University of California, Berkeley, he had the opportunity to do astrophotography under the extremely dark skies of the Sierra Nevada. At the same time, personal computers had become powerful enough to allow the processing of scanned slides and negatives at high resolution. Using the mathematical and programming skills he acquired during his career in physics, Mellinger created large mosaics from a set of overlapping individual frames. Between 1997 and 2000, he acquired a set of fifty-one wide-angle images taken from seven different locations around the world and combined them into a panoramic image of the entire night sky. The result, Mellinger's "Milky Way Panorama," is one of the most published and widely recognized astronomical images in the world.

The Deep Sky

Arguably one of the most recognized astronomical images that exist today, this panoramic mosaic of the Milky Way represents a masterwork of planning, execution, and assembly. Mellinger spent three years traveling to seven different locations around the world to acquire the fifty-one individual frames needed to assemble this masterpiece.

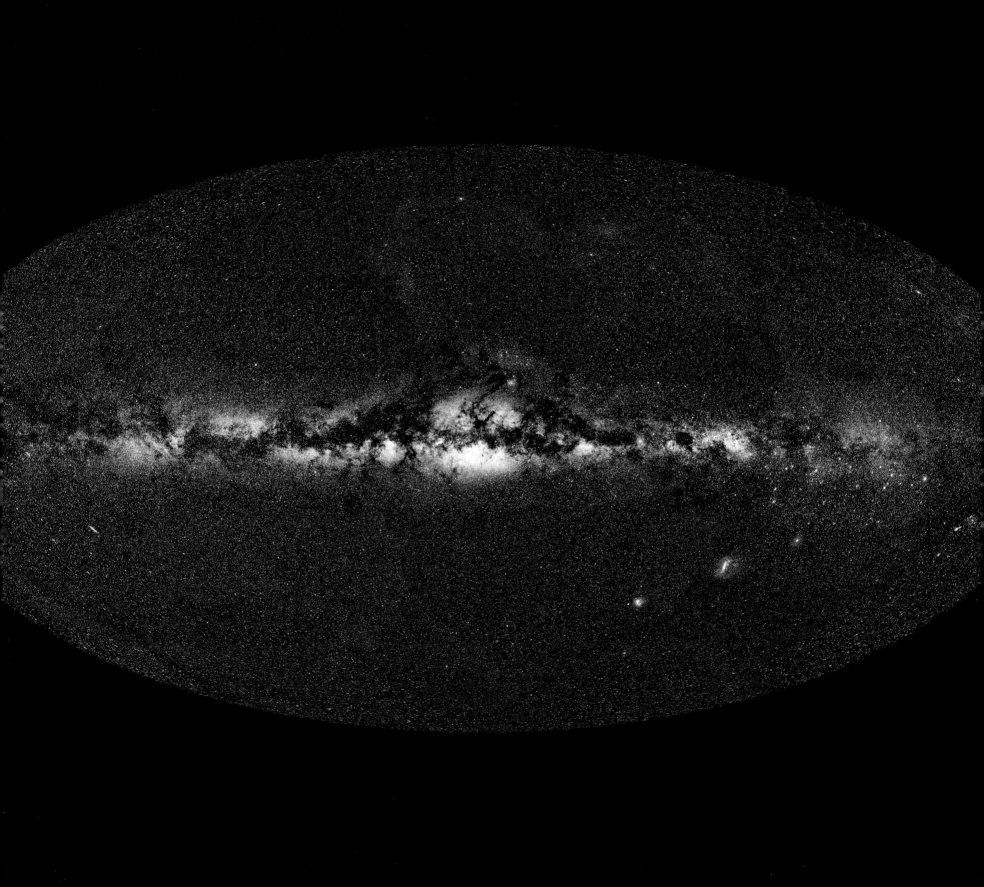

JOHANNES SCHEDLER

Courtesy of Roswitha Schedler

AUSTRIAN ENGINEER JOHANNES SCHEDLER VENTURED into astrophotography in 1997 as a father-son activity. He quickly learned the technical aspects of astrophotography and was soon producing quality images of the moon and planets. As his enthusiasm evolved, he became proficient at webcam and digital single-lens reflex imaging of the solar system and deep-sky objects. The next phase for Schedler began in 2004 as he moved on to high-resolution deep-sky imaging using a full-frame CCD camera from his newly constructed 3-meter home observatory near Graz, Austria. With great attention to detail at the telescope and abundant image-processing sophistication, Schedler has produced some of the most stunning and detailed deep-sky images the world has seen in recent years.

The Trapezium

The thin blister of ionized gas we call the Orion Nebula would be invisible if not for the four Trapezium stars that illuminate the nebula. Of the four stars, the brightest, Theta-1C, is by far the most prodigious contributor, supplying more than 99 percent of the ultraviolet energy illuminating the nebula. Amazingly, Theta-1C is 210,000 times more luminous than our sun and produces a gargantuan stellar wind 100,000 times stronger than that from our own sun.

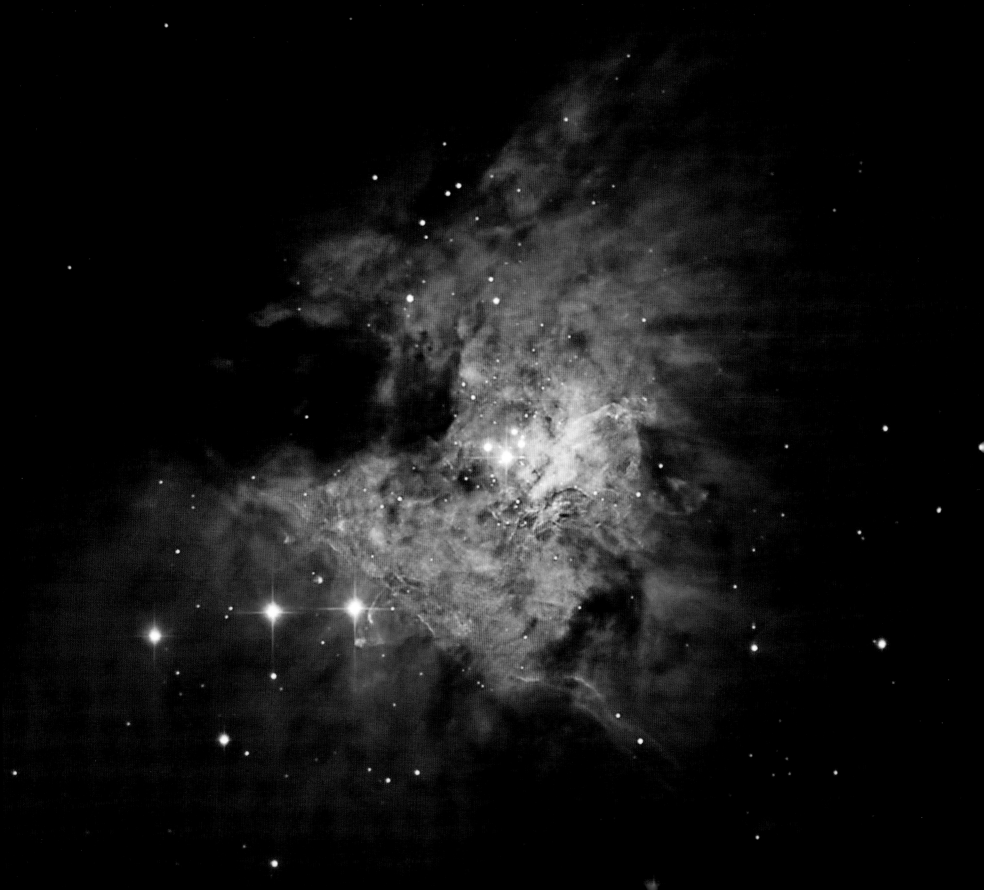

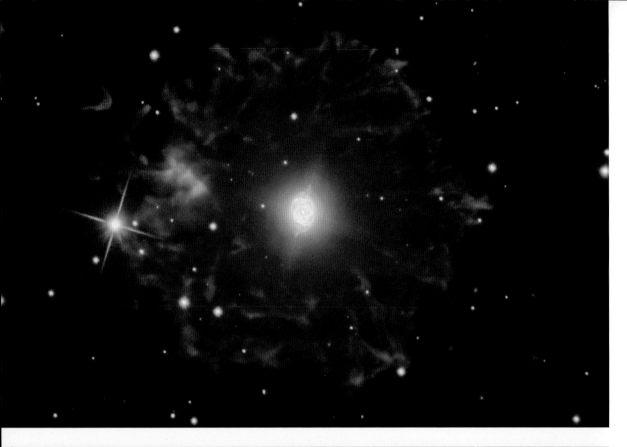

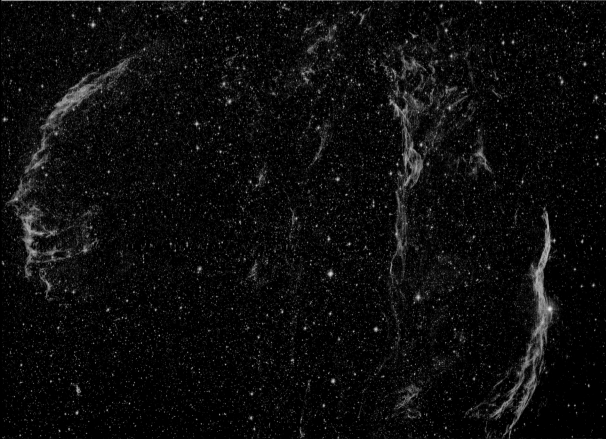

◄ The Cat's Eye Nebula

The Cat's Eye Nebula (NGC 6543) represents a transient phase of stellar evolution following the death of a sunlike star. This stunningly deep image reveals both the innermost bright layers and the rarely seen outer halo. The outer halo represents material ejected some sixty thousand years before by the fierce stellar winds of the dying star.

◣ The Veil Nebula

Spanning eighty light years, the Veil Nebula (NGC 6960-6992-6995) represents the glowing shock front produced by a massive star that exploded as a supernova in our galaxy some ten thousand years ago.

Centaurus A ▶

One of the most luminous galaxies in the sky, Centaurus A (NGC 5128) likely acquired its peculiar appearance by way of a large-scale collision between a giant elliptical galaxy and a barred spiral galaxy a billion years ago.

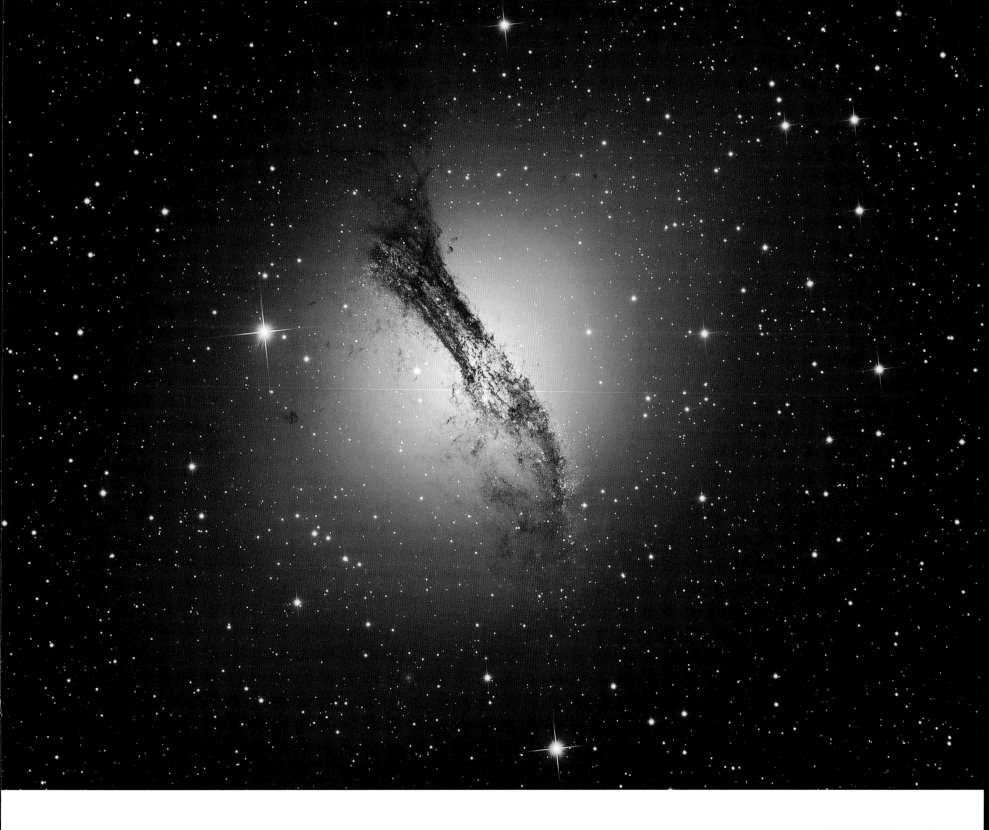

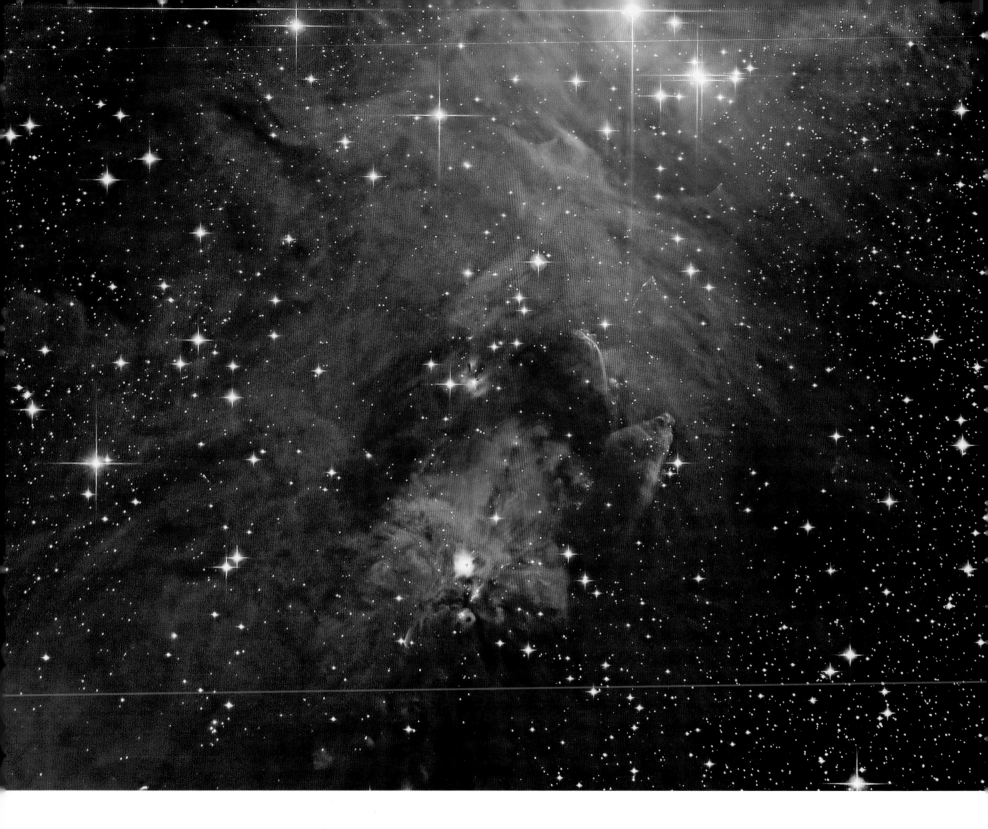

JOHANNES SCHEDLER

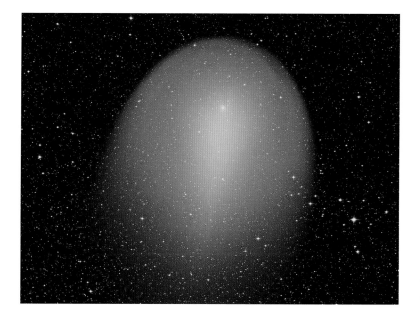

▲ Comet Holmes

Comet Holmes, a periodic comet in our solar system, made an appearance in late 2007. Its coma, the thin dust cloud surrounding the comet nucleus head, grew to a diameter greater than the sun, which briefly qualified it as the largest object in our solar system.

IC 1396 ▶

IC 1396 is a large nebula in the constellation Cepheus spanning 3 full degrees of winter sky, the same angular distance of six full moons. This image highlights the conspicuous globule IC 1396A (*top*), a striking structure sculpted by the radiation of nearby stars.

◀ NGC 1999

Located 2 degrees south of the Orion Nebula, this fertile star-forming region is replete with glowing clouds and young suns in varying stages of stellar evolution.

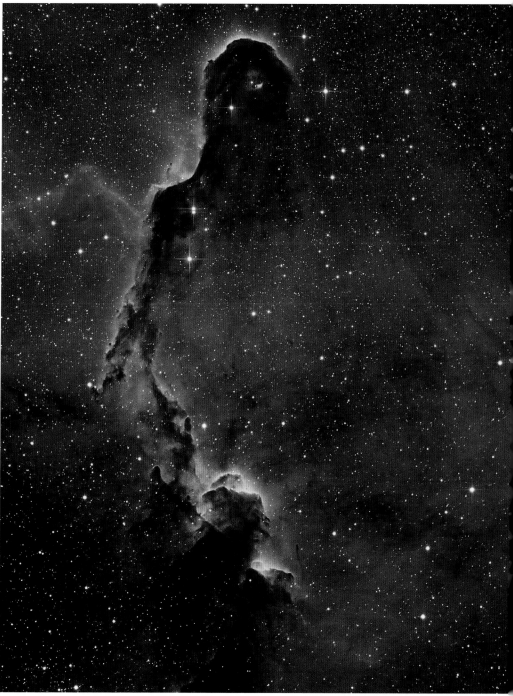

JEAN-CHARLES CUILLANDRE

AND

GIOVANNI ANSELMI

Courtesy of Rob Ratkowski

Courtesy of Giovanni Anselmi

JEAN-CHARLES CUILLANDRE AND GIOVANNI ANSELMI COLLABORATE long-distance to produce digital mosaic images of the universe. Cuillandre's interest in astronomy was triggered at the age of sixteen, when he read an article about the Canada-France-Hawaii Telescope (CFHT) Observatory in Hawaii. Today, he has realized his dream and works as an astronomer for the CFHT, specializing in developing and optimizing digital mosaic cameras. Inspired by the work of David Malin, he developed a public outreach program at CFHT called "Hawaiian Starlight."

Anselmi lives in Venice, Italy, where he is chief editor of the magazine *Coelum Astronomia*. He enjoys taking existing images from NASA and other sources and realizing their full potential through the magic of digital processing. His talents caught Cuillandre's attention, and collaboration quickly ensued. Anselmi optimizes Cuillandre's images and together they publish the yearly CFHT and *Coelum* "Hawaiian Starlight" wall calendar. Nine years of this collaboration have led to an incredible collection of true-color, ultra-high-resolution images of the universe.

IC 1274

Fiery colors and conspicuous dark structures define one of the most glorious stellar nurseries in the summer sky. The scattered starlight of powerful suns has produced magnificent blue clouds among the crowded starfields.

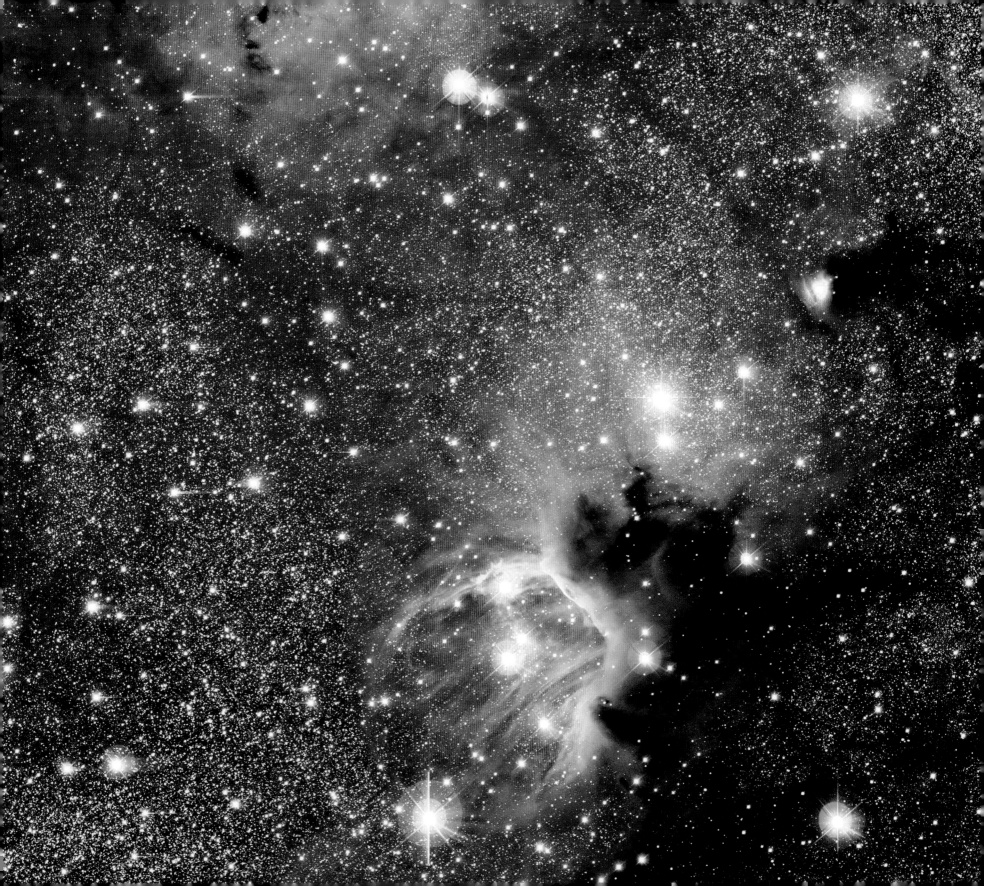

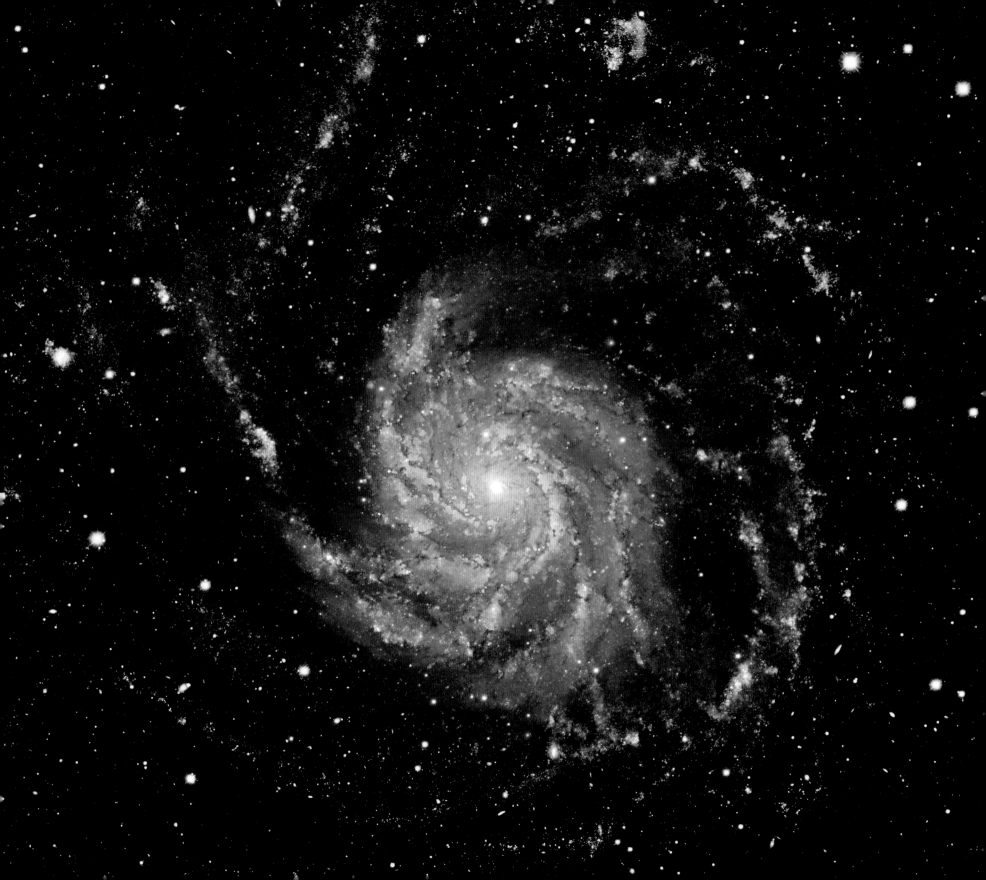

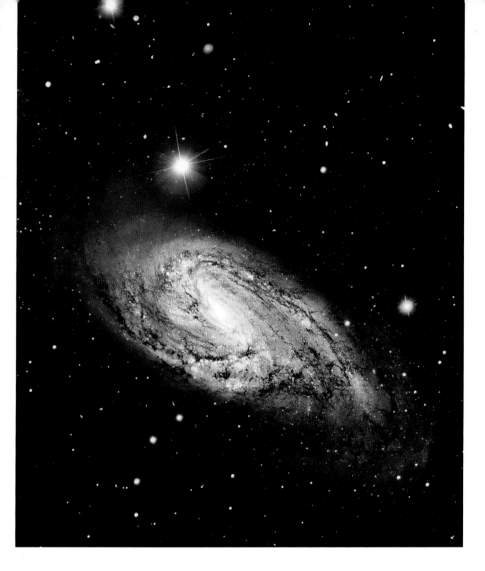

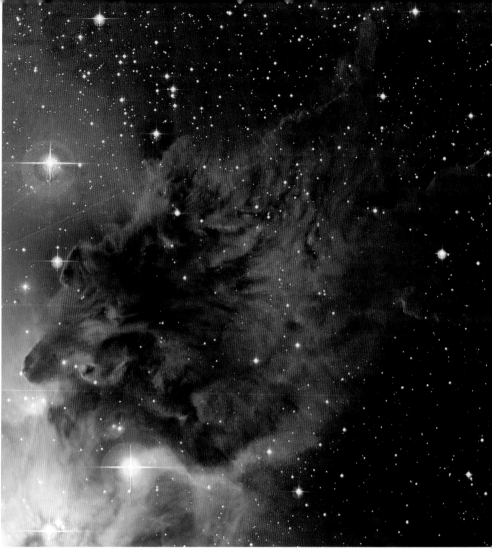

▲ M66

The spiral galaxy M66 belongs to the Leo Triplet, a dramatic grouping of three fine galaxies in the constellation Leo. A faint tidal stream of stars and gas stripped from M66's outer reaches (*upper left*) is a clue to an earlier gravitational struggle it experienced with the other galaxies.

◀ The Pinwheel Galaxy

A true galactic giant and one of the finest examples of a grand design spiral, the Pinwheel Galaxy (M101) has vortexlike arms that extend over a distance of 170,000 light years.

▲ The Foxfur Nebula

The clouds of the Foxfur Nebula comprise curious shapes and textures sculpted by the radiation of massive nearby stars.

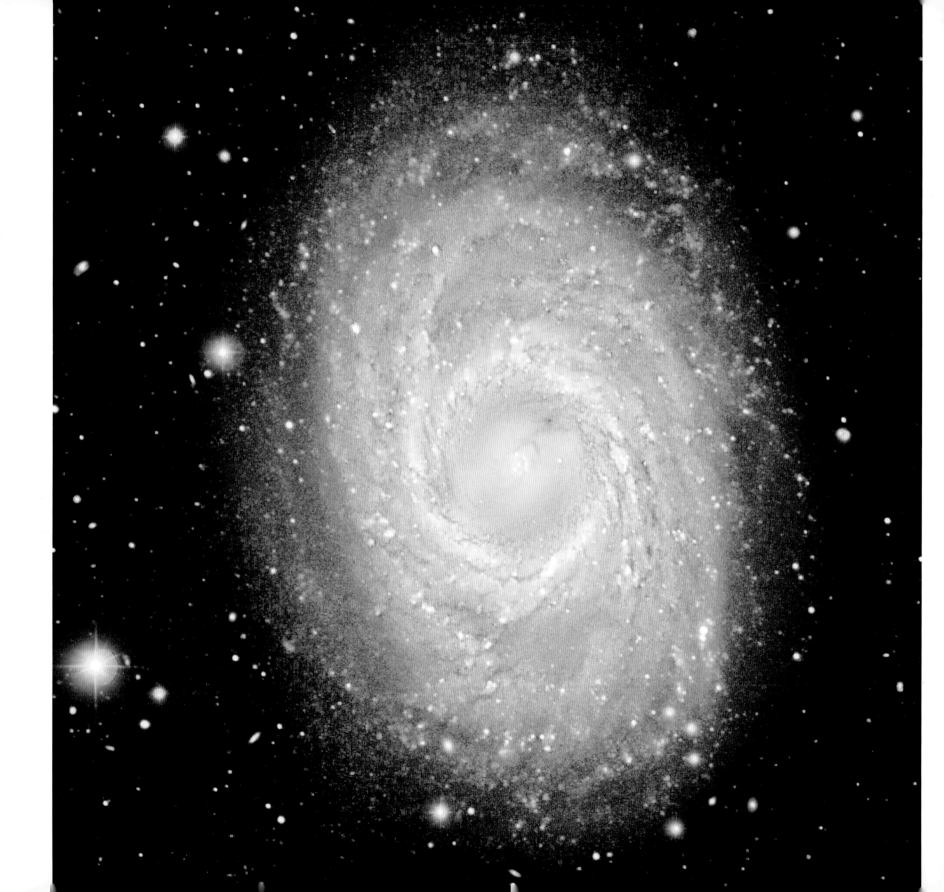

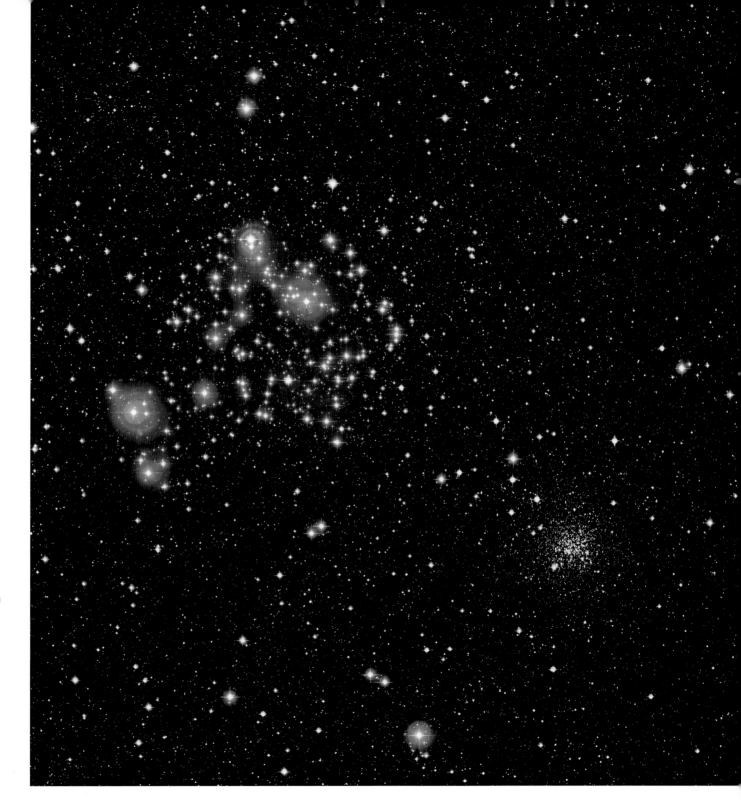

◄ M95

A prototypical barred spiral galaxy, M95 played a critical role in establishing Hubble's constant, a value that defines the rate of recession of galaxies. American astronomer Edwin Hubble first established the constant in 1929. The refinement of Hubble's constant has great implications for cosmology and our knowledge about the ultimate fate of the universe.

M35 and NGC 2158 ►

The star clusters M35 (*left*) and NGC 2158 (*right*) appear close to each other in the night sky, but in actuality, they are separated by over 12,000 light years. The young blue stars of M35 are considerably closer to Earth than the ancient red stars of NGC 2158, which are more than a billion years old.

R. JAY GABANY

Courtesy of Andrew GaBany

R. JAY GABANY IS A TRAVEL SOFTWARE SPECIALIST living in San Jose, California. As a boy growing up in the 1960s, he was captivated by manned space exploration. He says, "My interest in the universe became a stowaway that soared ever higher with each successive rocket launch." GaBany was further inspired by the writings and documentaries of astronomer Carl Sagan. He first dabbled in film astrophotography during the 1986 apparition of Halley's Comet, but it wasn't until the turn of the millennium that GaBany rekindled his dream of producing imagery of his own creation. He was inspired to return to amateur astrophotography by the modern era of CCD technology: "Digital imaging made it easier to be expressive by enabling the transformation of galaxies and nebulae into objects with aesthetic qualities."

GaBany brings an artist's perspective to the digital assembly of astroimages. He recognizes it as a fine art and says, "Astrophotographers have the means to control their medium with the same finesse that painters exercise with a palette and brush."

The Iris Nebula

Like a cosmic beacon, the penetrating light of the brilliant star HD 200775 floods the surrounding dusty expanse, transforming the Iris Nebula (NGC 7023) into a stunning array of hues and textures.

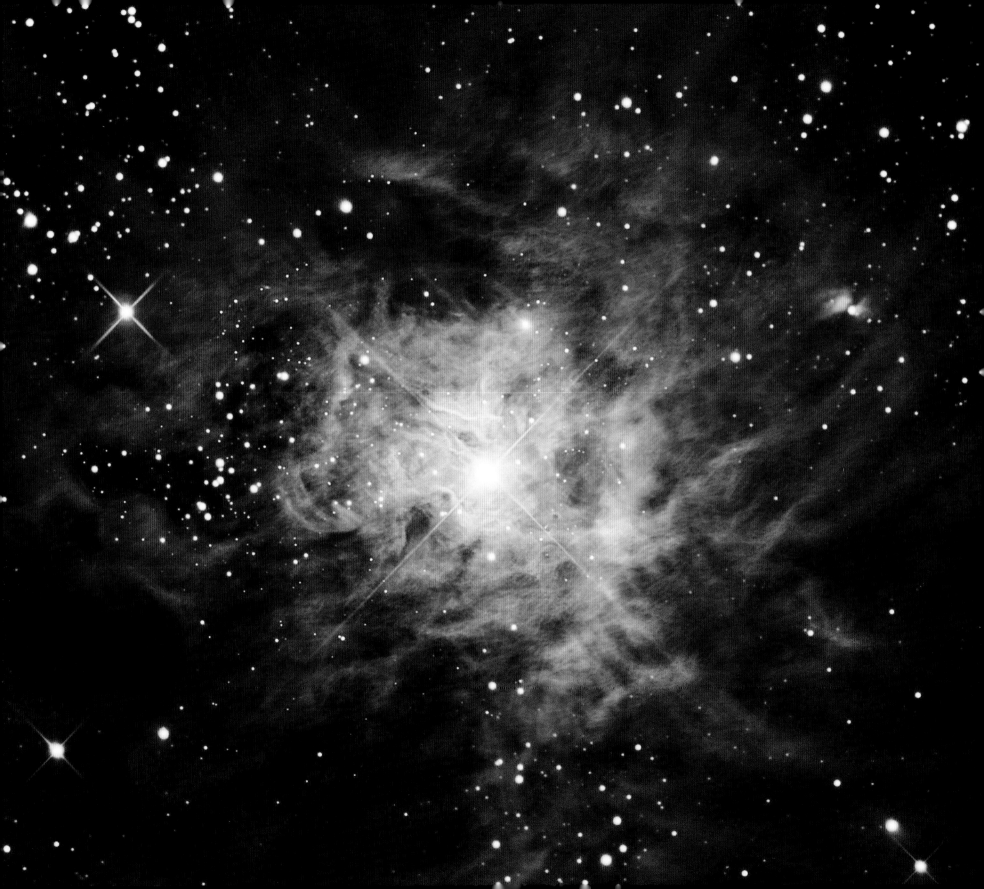

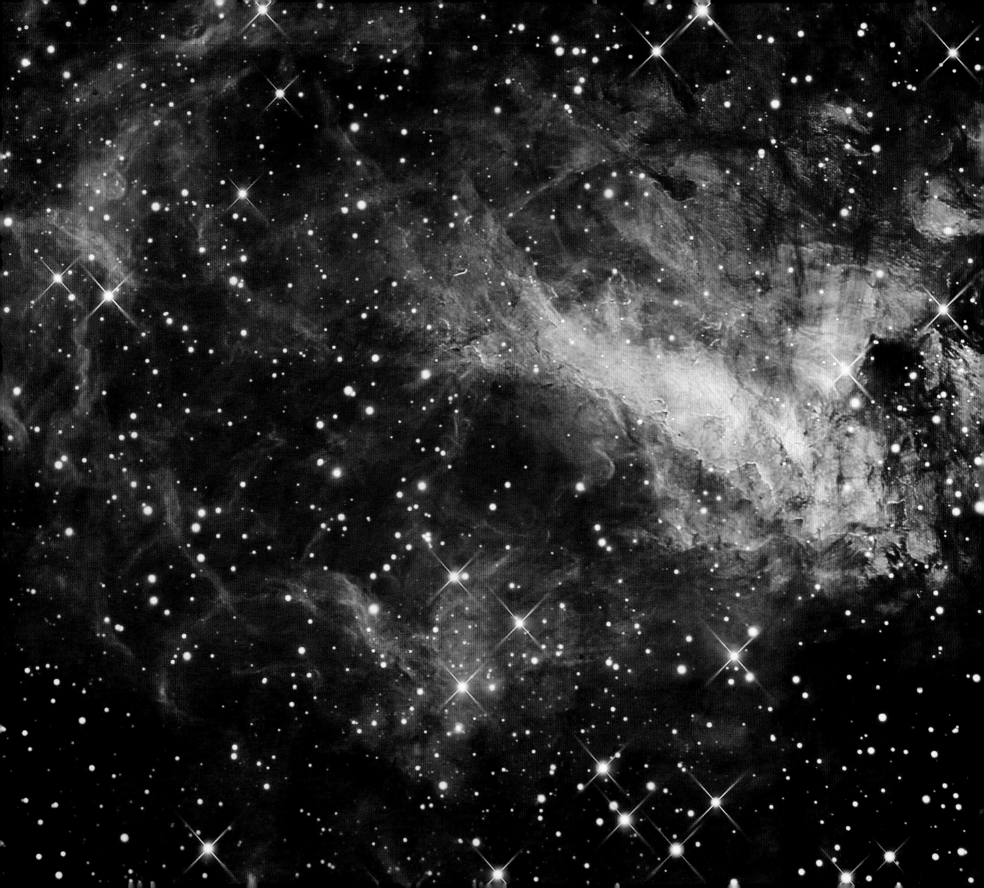

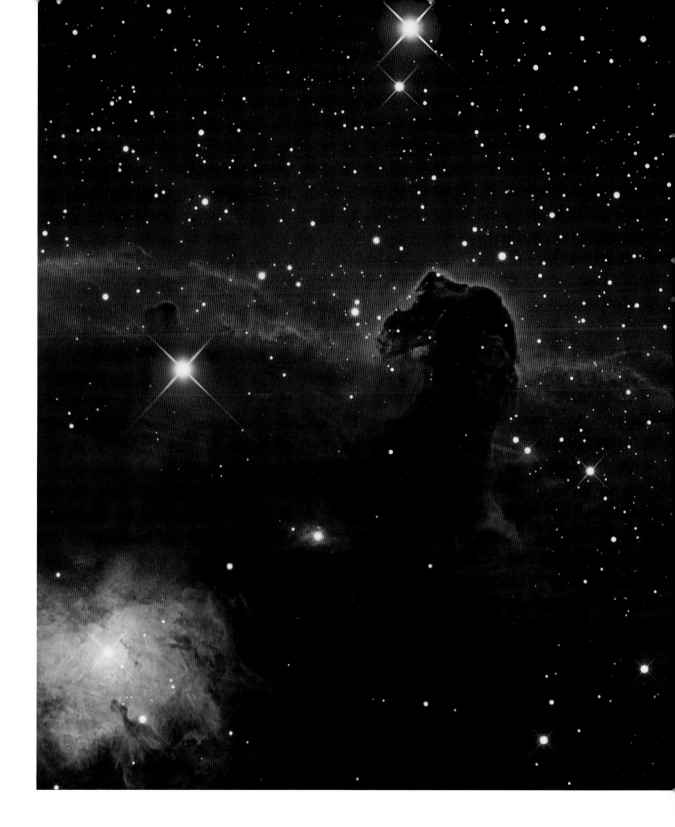

◁ The Swan Nebula

This photograph reveals the intricate small-scale structures and vibrant colors of one of the most prolific star-forming systems in our galaxy, the Swan Nebula (M17). The cloud receives its illumination from a powerful cluster of hidden stars.

The Horsehead Nebula ▷

One of the most photographed objects in the sky, the famous Horsehead Nebula (B33) is presented here with unparalleled vitality, clarity, and depth.

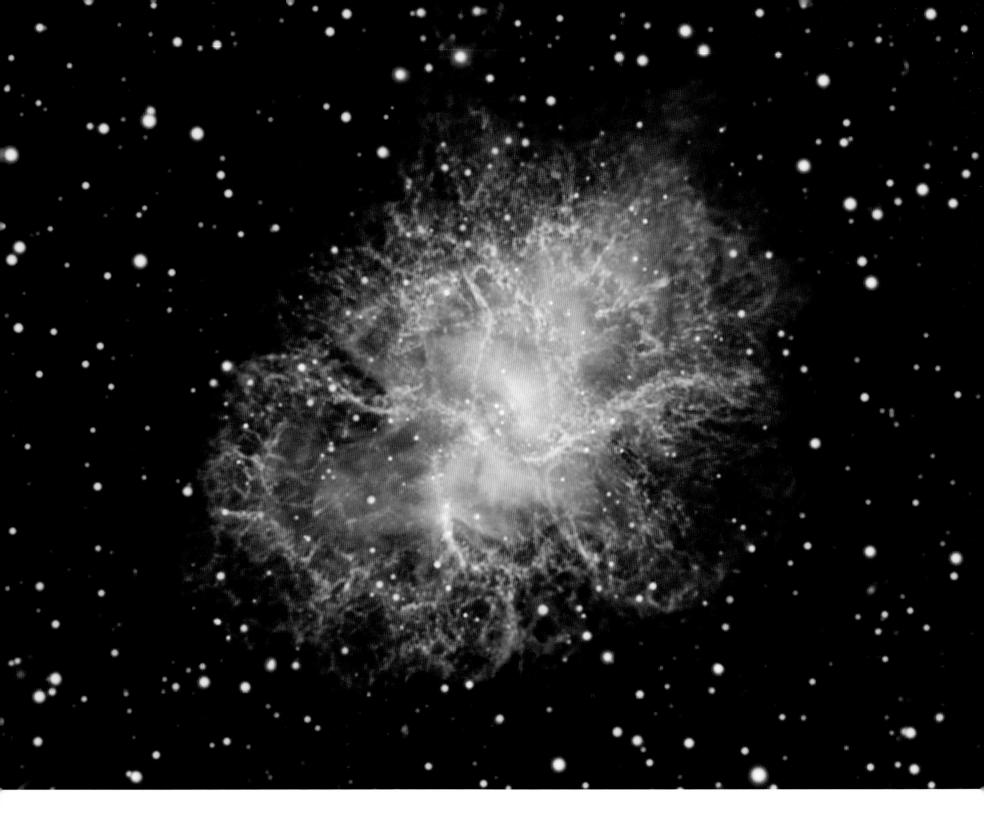

R. JAY GABANY

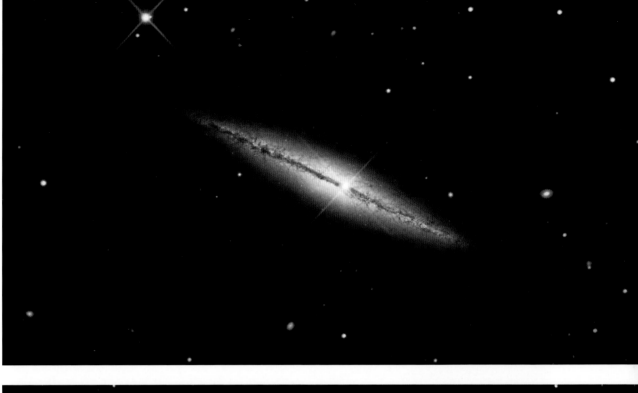

The Crab Nebula

The supernova remnant known as the Crab Nebula (M1) represents the remains of a shattered star that met its explosive end in the year 1054. Documented by Chinese astronomers, the supernova was observed to be four times brighter than the planet Venus and remarkably visible in the daytime sky for twenty-three days after the event. The Crab Nebula is composed of gaseous and filamentary material that has been expanding since the time of the supernova. It now spans approximately ten light years.

NGC 4013

A chance foreground star projects its light over the disk of the edge-on spiral galaxy NGC 4013. From a distance of 55 million light years, our Milky Way would appear remarkably similar.

NGC 1097

Resembling a celestial squid, the spiral galaxy NGC 1097 possesses a large optical jet, visible in this deep image and projecting out from the core past the tentacle-like spiral arms above and below the plane of the galaxy. A jet is the ejection of matter and energy from the center of a galaxy, usually related to the dynamics of a black hole.

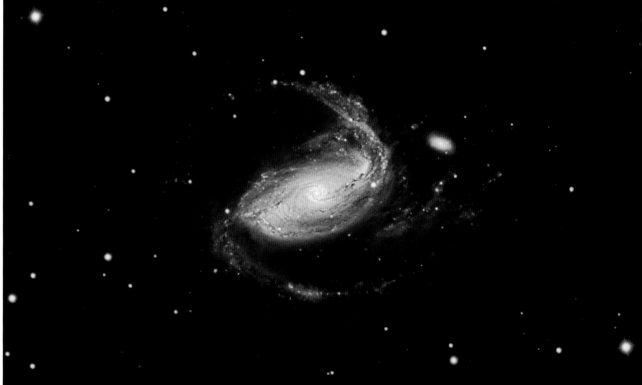

27

KEN CRAWFORD

Courtesy of Lisa Crawford

KEN CRAWFORD RECENTLY RETIRED from the floor-covering business in Camino, California. His interest in astronomy began in grade school, and he built his first telescope in the eighth grade. Astronomy took a back seat in 1985 as he started up his first company, a carpet store. In 2001, Crawford re-entered the field of astronomy and combined his longtime interest in computers and software programming with his knowledge of telescopes to foray into deep-sky astrophotography. With his technical skills and his attention to detail, Crawford quickly mastered the art of high-resolution deep-sky imaging. His images have received considerable attention in the astronomy community, and he is known for revealing extremely faint structures and details in objects not previously seen.

Dust Fingers of the Rosette Nebula

Dark fingerlike filaments of dust radiate from the center of the Rosette Nebula (NGC 2244). The dark structures are believed to have formed via the interplay of stellar winds, radiation, and electromagnetic forces.

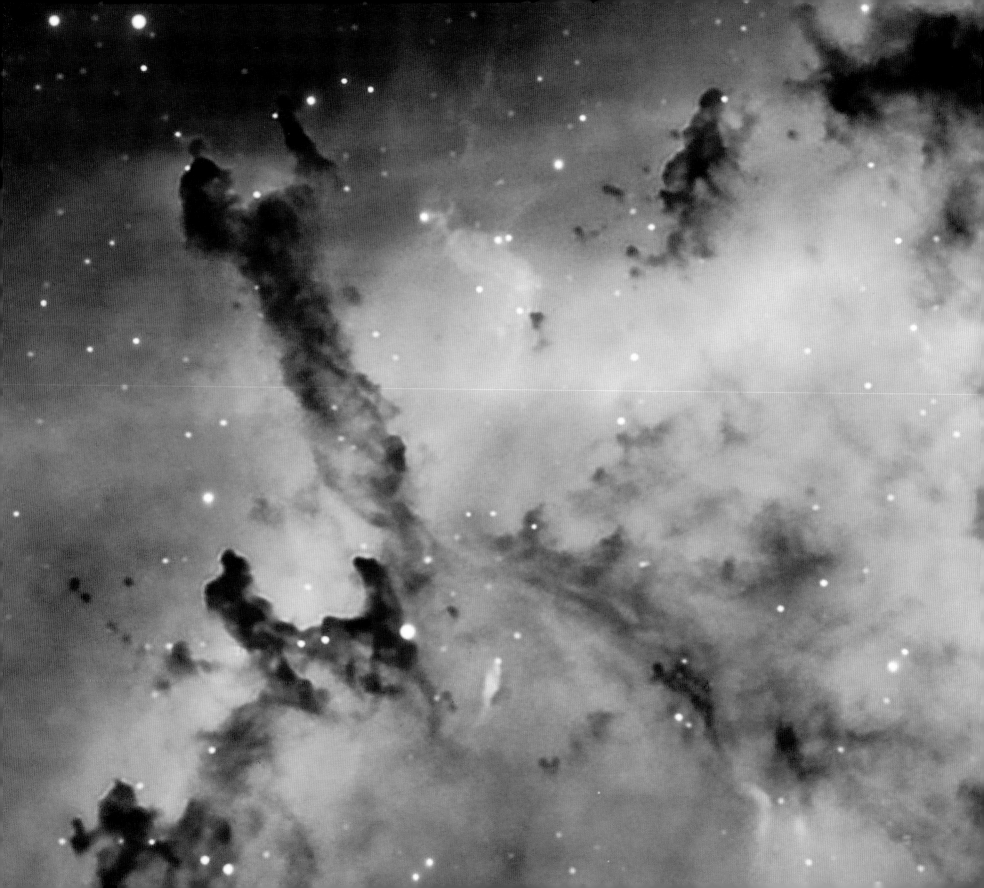

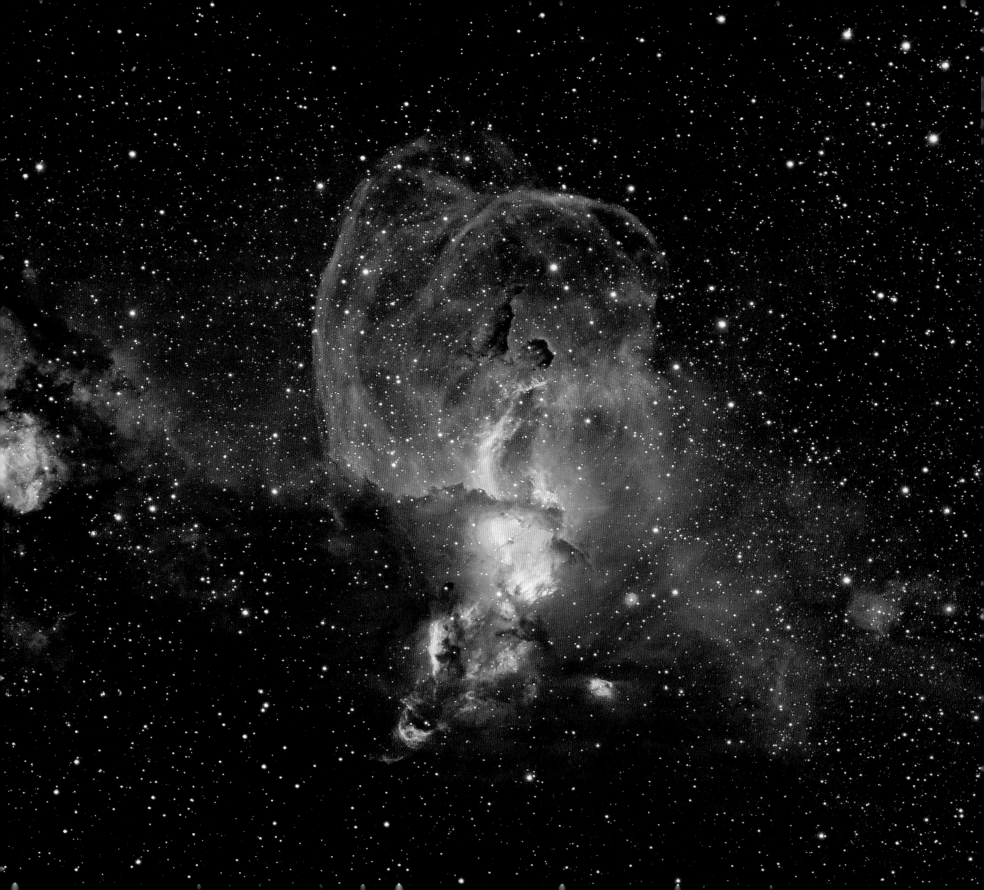

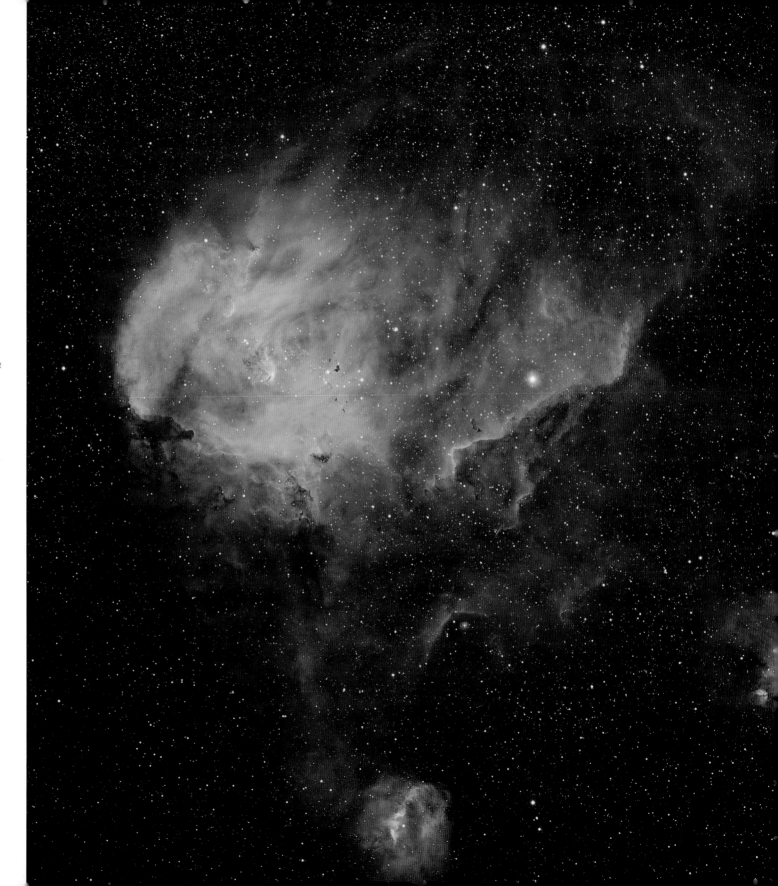

◄ NGC 3576

This elaborately shaped spiral nebula resides in the Sagittarius arm of our galaxy and spans more than one hundred light years across. The scattered compact dark nebulae in the center are known as Bok globules.

The Running Chicken Nebula ▶

A loose cluster of young, hot stars illuminate the expansive Running Chicken Nebula (IC 2944), located in the southern constellation of Centaurus.

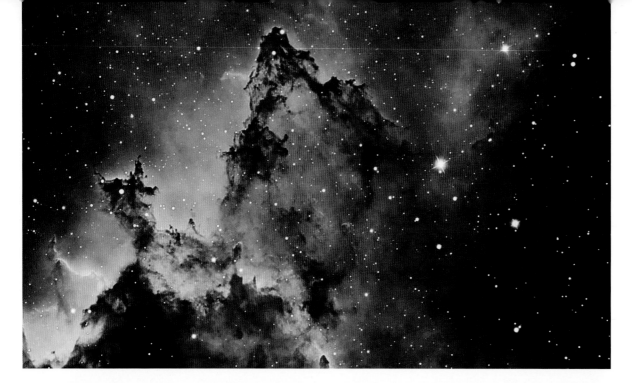

IC 1805

Ominous dark structures rise up from cold molecular gas in the Perseus arm of the Milky Way. These structures have formed from one of the largest molecular clouds in our galaxy, harboring enough material to make 100,000 suns.

Melotte 15

In the core of the Heart Nebula (IC 1805) is a cluster of hot stars known as Melotte 15. The energy from the stars powers the entire nebula complex and is configuring the nearby clouds into intriguing, gracefully sculpted forms.

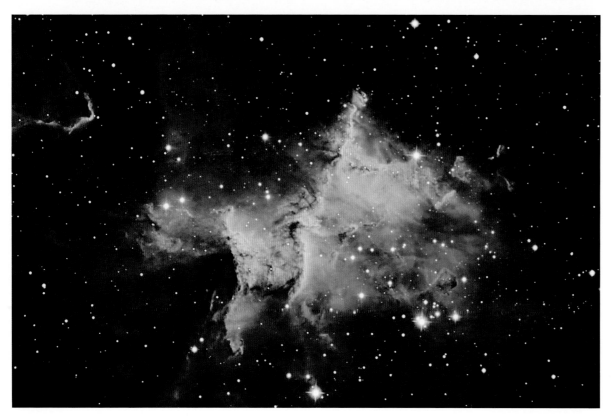

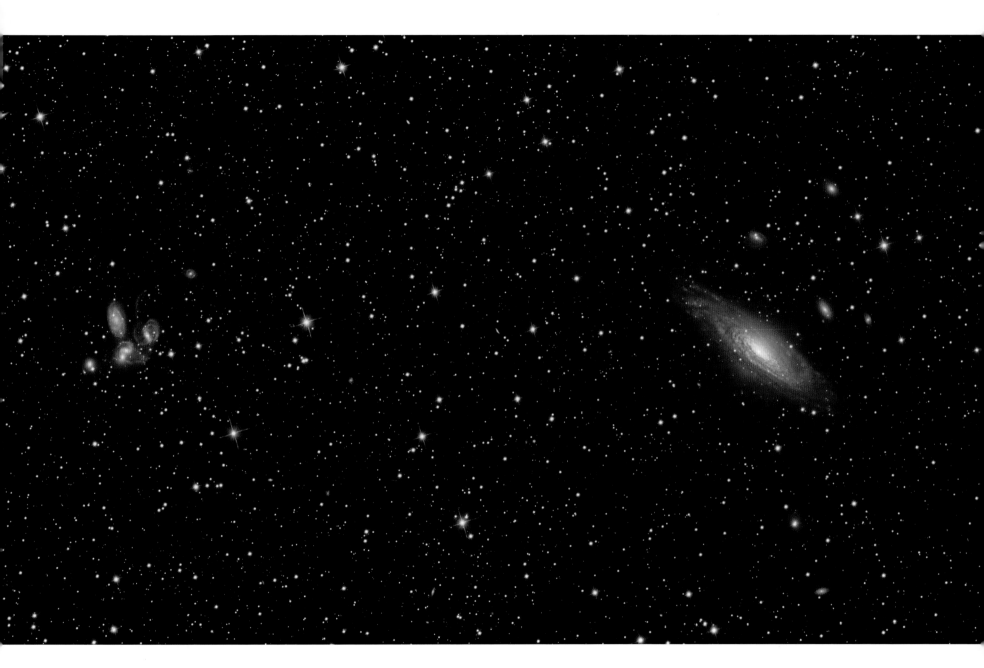

NGC 7331 and Stephan's Quintet

This outstanding mosaic captures two famous galactic fields. The large spiral NGC 7331 (*right*) is located 50 million light years from Earth, the same distance as the largest member (blue spiral) of the galactic group known as Stephan's Quintet (*left*). The other faint galaxies in both groups are ten times more distant.

DAM BLOCK

Courtesy of Miwa Block

ADAM BLOCK RECALLS BEING INTERESTED IN THE NIGHT SKY as a toddler. He would say "goodnight" to the moon, even if it was not visible in the sky. Later on, his grandfather would take him on nighttime walks and point out the wonders of the sky. His first real telescope was a 4.5-inch Astroscan from Edmund Scientific.

Block ran the campus station telescope at the University of Arizona where he earned his degree in astronomy and physics and also began CCD imaging. After taking his first photograph of the Ring Nebula, he recalls feeling "forever captivated!"

After college, Block spent the next nine years refining his skills at the Kitt Peak National Observatory in Arizona. There he became the chief observer and produced a prodigious series of outstanding astronomical images as part of its public outreach program. He continues to share his passion for astronomy in the form of public speaking and the creation of astronomical images. He is now continuing his dream through new public programs at Steward Observatory in Arizona.

The Cygnus Loop

Cataloged as NGC 6960, this spectacular shock front of superheated gaseous material represents the western arc of the much larger Cygnus Loop, the remnant of a supernova blast that occurred some ten thousand years before. The bright star, 52 Cygni, centered within the nebula is an unrelated foreground star.

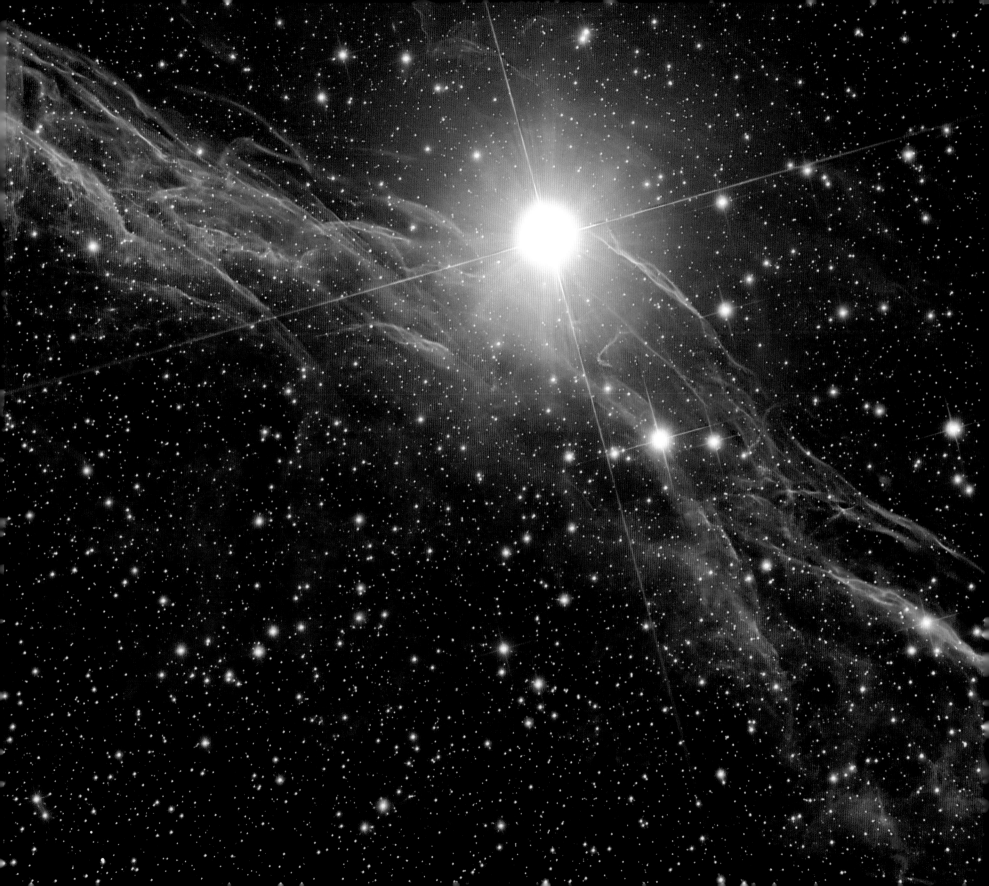

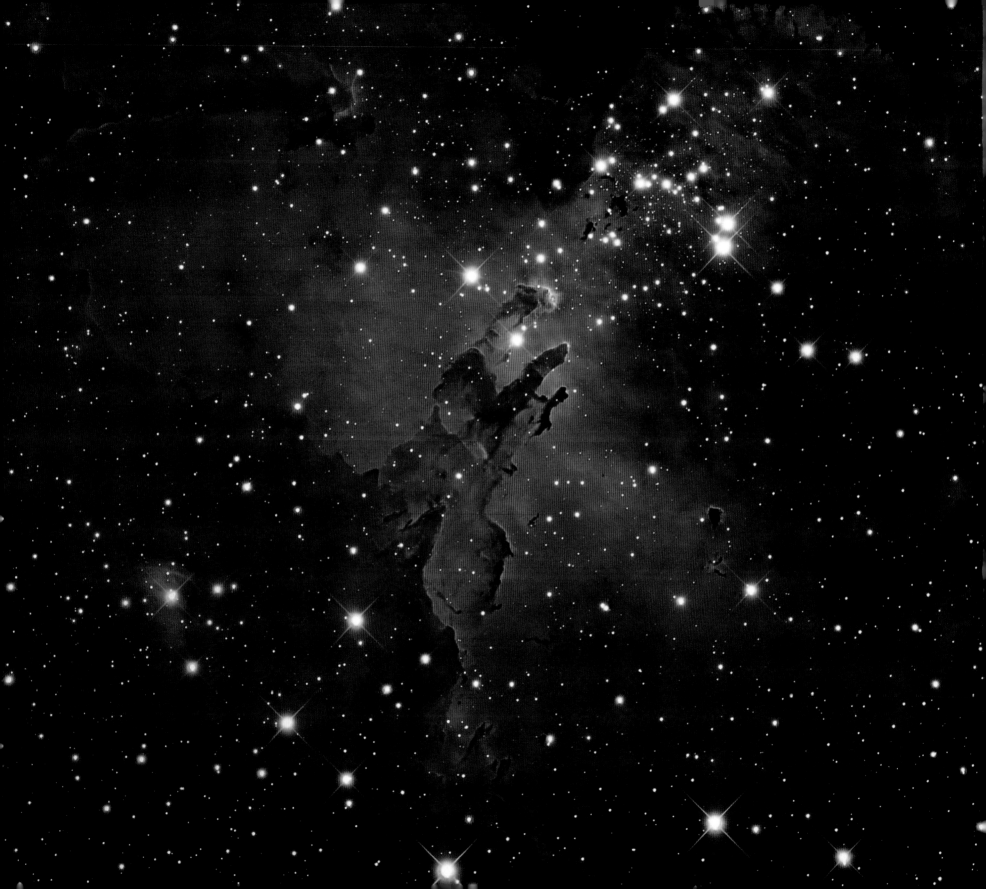

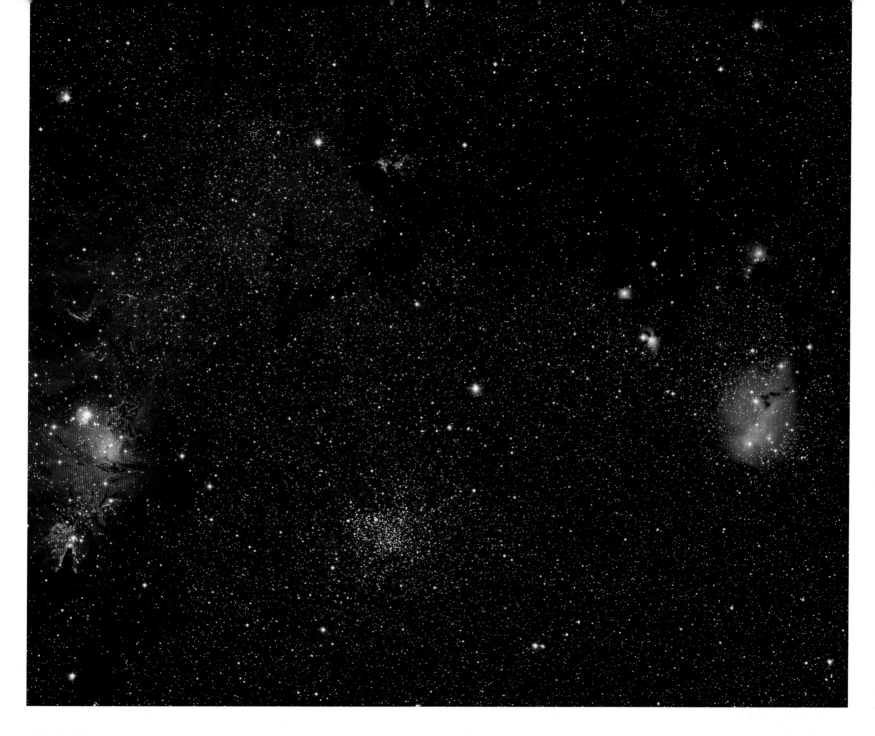

◀ The Eagle Nebula

Akin to the formation of sandstone buttes on Earth, the gas pillars of the Eagle Nebula (M16) have survived the erosion of their surroundings, remaining intact and protected from the evaporating power of intense ultraviolet radiation produced by nearby massive stars.

▲ Nebulosity in Monoceros

This rich cosmic vista reveals a diverse sampling of celestial objects. From left to right are the Cone Nebula (NGC 2264), the open star cluster Trumpler 5, and the reflection cloud IC 2169.

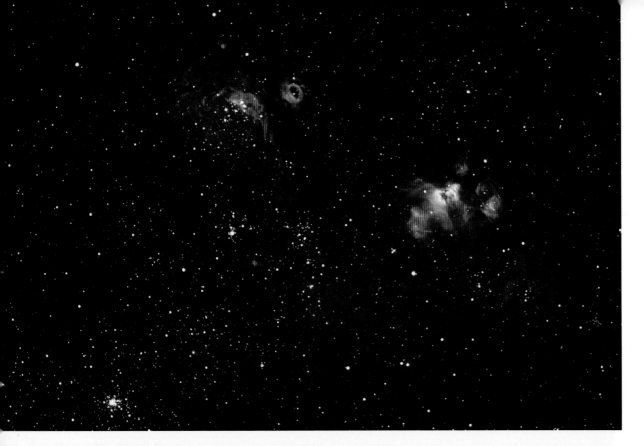

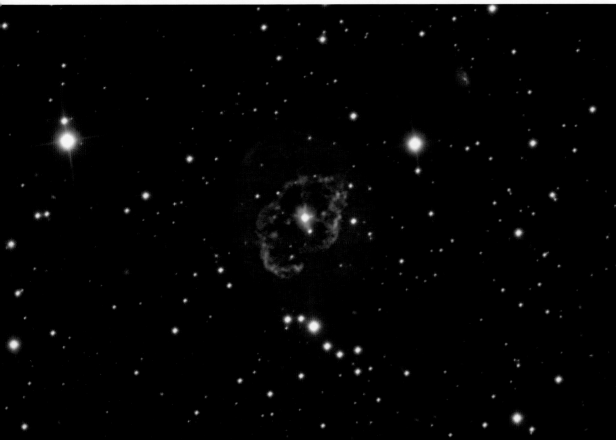

◀ NGC 2030

Ghostly forms within the Large Magellanic Cloud are actually shells and cavities created by generations of massive stars and their supernovae. The giant hollowed-out clouds release their energy in the red light of ionized hydrogen.

◣ Abell 78

This unusual nebula was formed by matter expelled during the late stages of a dying star similar in size to our sun. The bright inner shell of helium and the outer shell of hydrogen were once the fuel for the star's internal nuclear engine.

Cassiopeia A ▶

This exceedingly faint and continually expanding shell of stellar material represents the gaseous remnants of the last supernova visible from Earth with the naked eye. Traced to an exploding star around the year 1667, the shell of shocked gases, which currently measures ten light years across, is expanding at ten million miles per hour. The temperature of the glowing cloud exceeds 30 million degrees Kelvin.

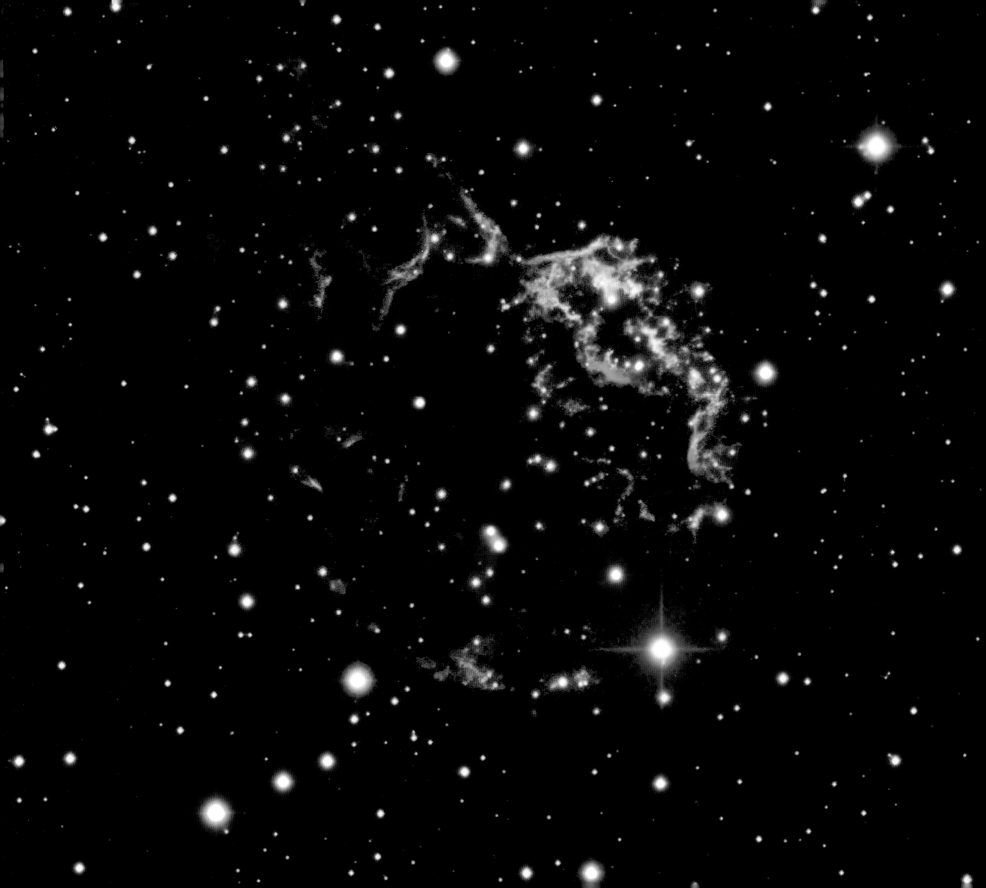

ROBERT GENDLER

Courtesy of Lawrence Gendler

ROBERT GENDLER IS A PHYSICIAN living in Connecticut. His joy for astronomy was born in the theatre of the Hayden Planetarium, which he visited frequently as a child growing up in New York City. He was initially inspired by the monumental images of deep space made by the professional observatories of that era. His secret dream of doing amateur astrophotography remained dormant until years later when, as an adult, he moved to darker skies and began photographically exploring the universe. Self-taught and imaginative, he tinkered with new methods of assembling digital astronomical images. His contributions to astrophotography include pioneering techniques used in the assembly of large mosaics, the blending of mixed focal length data, and techniques for creating narrowband color composites.

The Rho Ophiuchus Nebula

Probably no other celestial region provides such an impressive spectacle of colorful glowing gases juxtaposed with converging dark rivers of thick dust as the Rho Ophiuchus Nebula (IC 4604).

Antares, a red supergiant star forty thousand times more luminous than our sun, lies embedded in an unusual yellow cloud formed by the ionization of the fierce stellar winds blown by the dying star.

(See page 17 for Barnard's original grayscale image of this region. See page 65 for a close-up of Antares.)

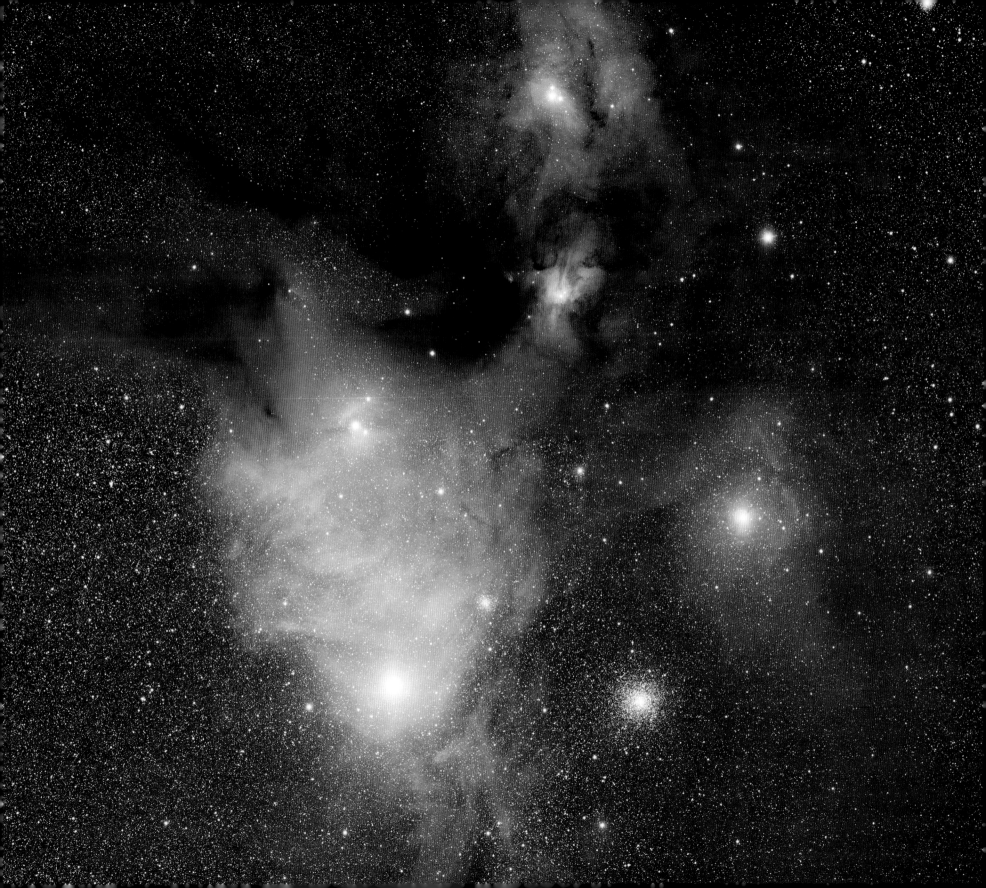

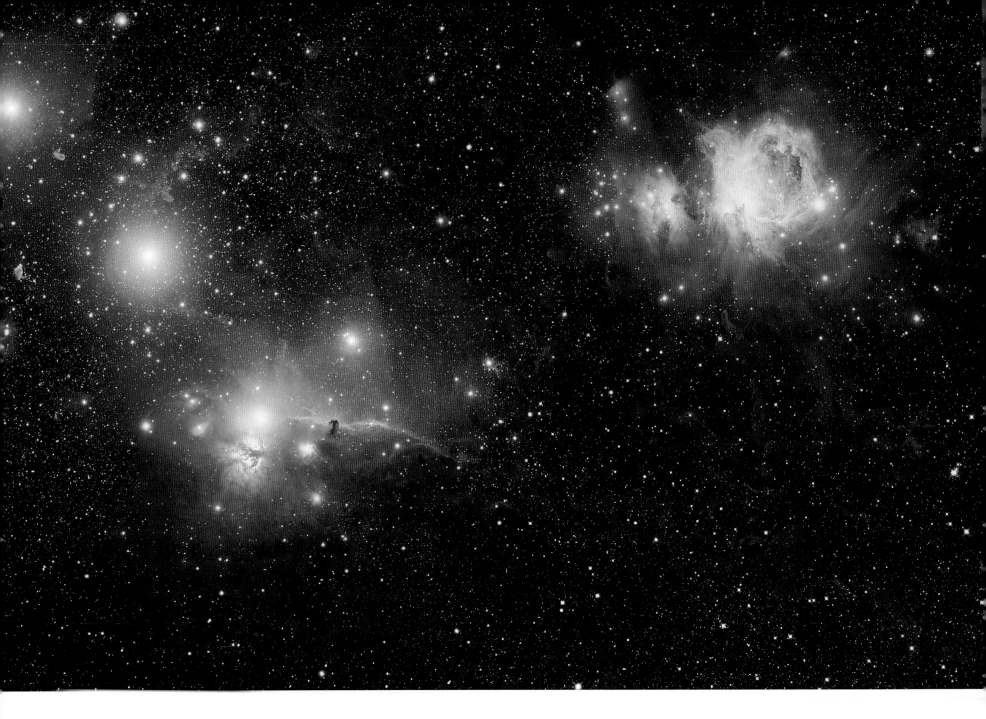

▲ The Orion Deep-Field

The well-known nebulae of the Orion region are thin blisters of glowing gases on the surface of dark, cold molecular clouds. Their illumination comes from the young massive stars in various stages of evolution within the Orion cloud complex.

Omega Centauri ▷

A blizzard of ancient suns, Omega Centauri is one of the brightest and most massive stellar systems in the Milky Way. Composed of several million stars, it is similar in size to a small galaxy.

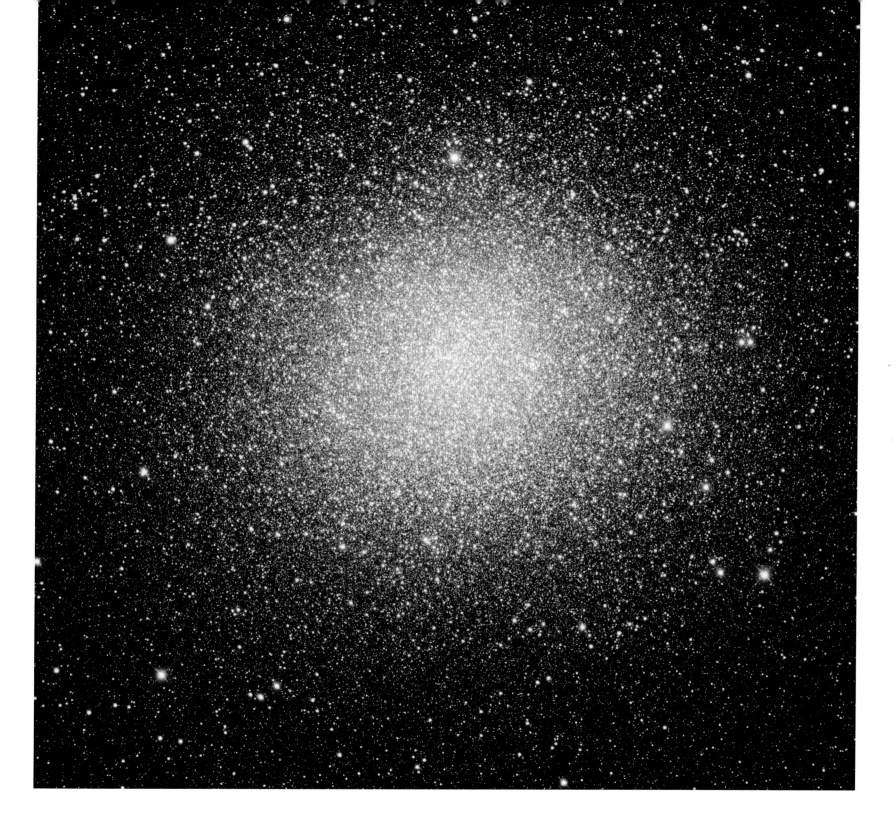

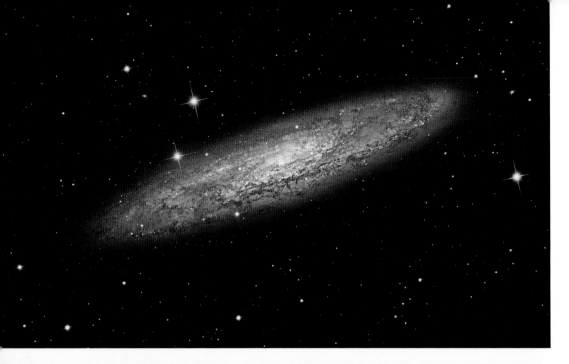

◀ NGC 253

Ancient stars typically emit cool yellow or red light, while young stars emit hot blue light. In the case of the starburst galaxy NGC 253, however, the conspicuous yellow-orange core originates not from old stars but from the dust-attenuated light of young, hot stars, which release a massive output of energy and matter from the center of this starburst galaxy.

◤ The Southern Pinwheel

The Southern Pinwheel (M83) is a classic grand-design spiral galaxy defined by its two dominant spiral arms that merge symmetrically with its core. This cosmic vortex has been active in the last century, producing a record eight supernovae.

The Vela Supernova Remnant ▶

A giant star met an explosive end 11,000 years ago in the southern constellation of Vela, leaving behind a cosmic cataclysm of superheated filaments and glowing clouds known as a supernova remnant. Supernovae play a critical role in the ecology of galaxies and provide heavier elements essential to the formation of life.

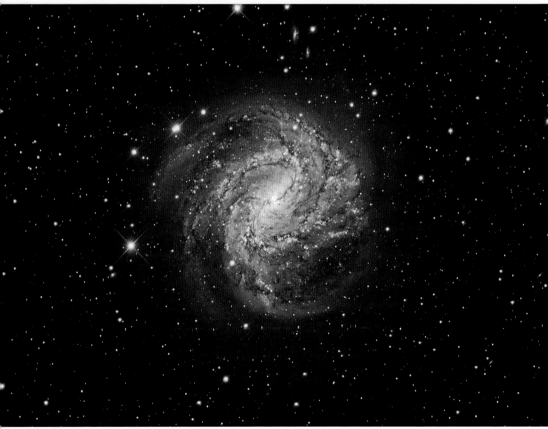

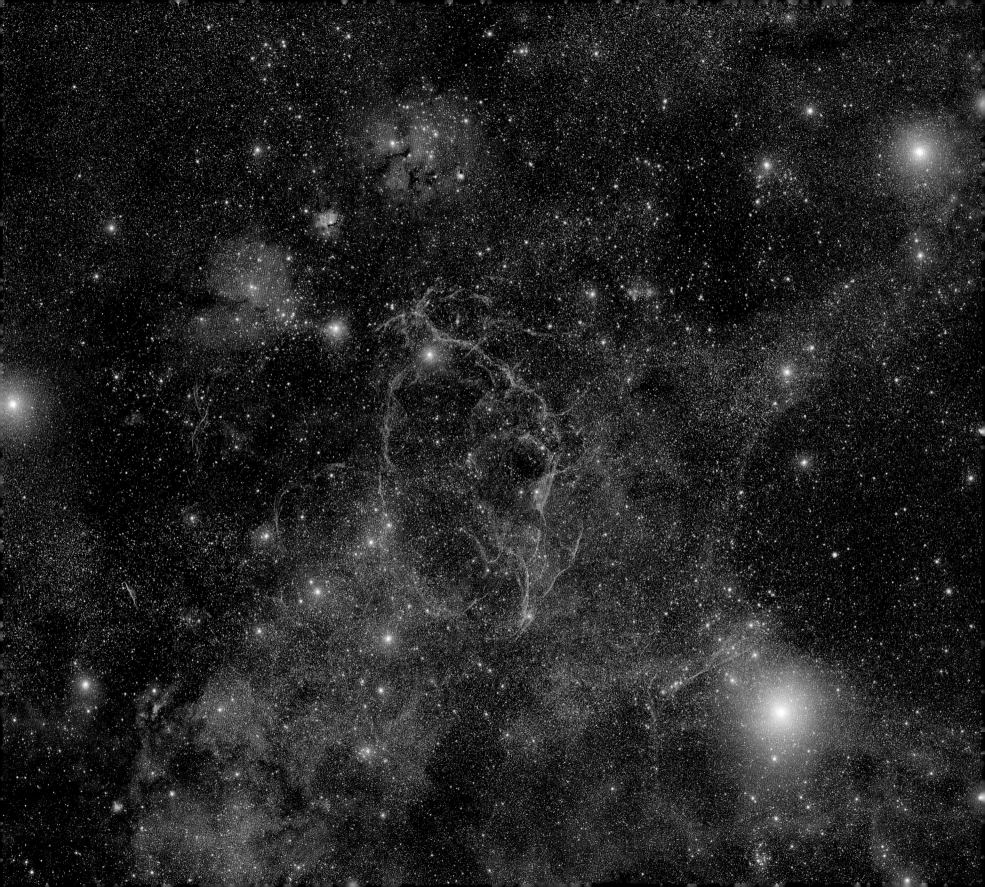

VOLKER WENDEL AND BERND FLACH-WILKEN

Courtesy of Volker Wendel

VOLKER WENDEL AND BERND FLACH-WILKEN ARE MEMBERS OF SPIEGELTEAM, one of the premier amateur astrophotography teams in the world. They live in Germany one hundred miles from each other. Wendel was first introduced to astronomy at the age of four, when his grandmother showed him a view of the moon through a small refractor placed through an open window. Although he began astrophotography by using film, he says, "The film images were scanned and processed digitally, paving the way toward learning image-processing skills that would later prove essential in the CCD era."

Flach-Wilken's first observations of the night sky came as a teenager under the dark skies of the Belgium Ardennes. He built his first of many telescopes in 1970 and found success in film astrophotography over the next two decades.

Beginning in 2002, Flach-Wilken and Wendel formed Spiegelteam, and together they have produced stunning astrophotographs using a variety of instruments from various places in Germany, as well as from very dark sky locations in Namibia and Switzerland.

The Helix Nebula

A preview of the fate of our own sun, this planetary nebula is one of the largest in the sky. The Helix Nebula (NGC 7293) is illuminated by the burned-out stellar cinder within its center, which was once a bright yellow sun similar to our own.

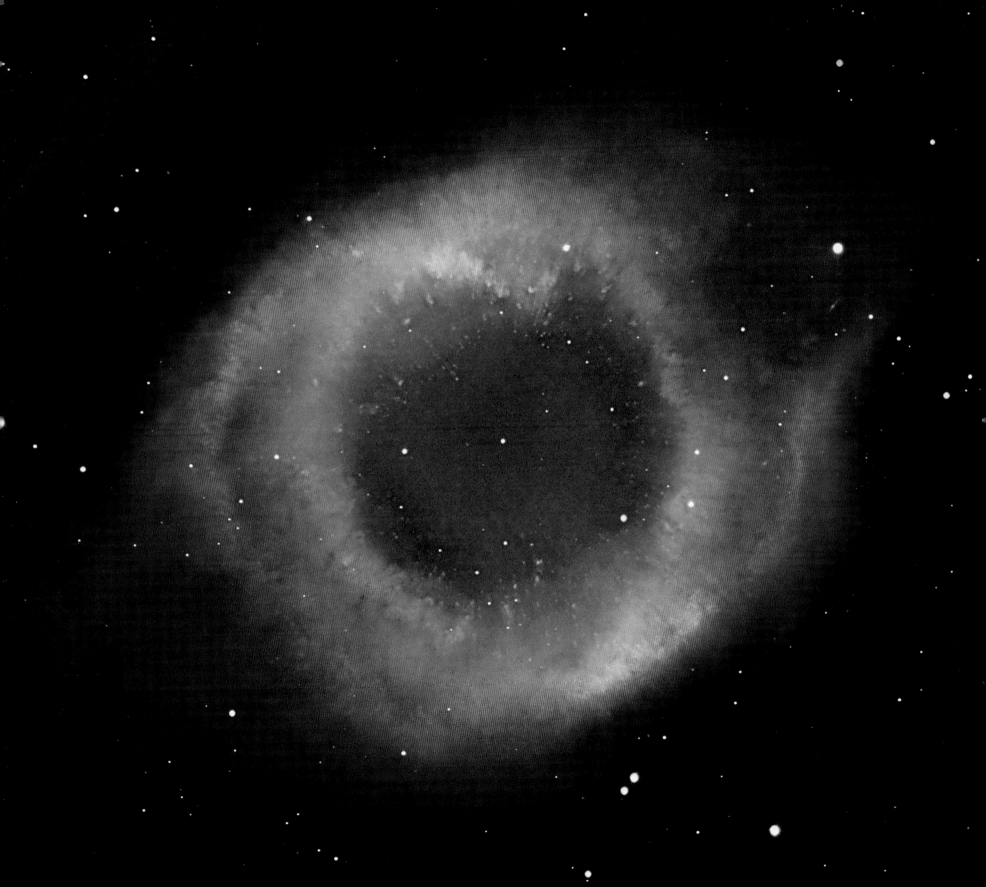

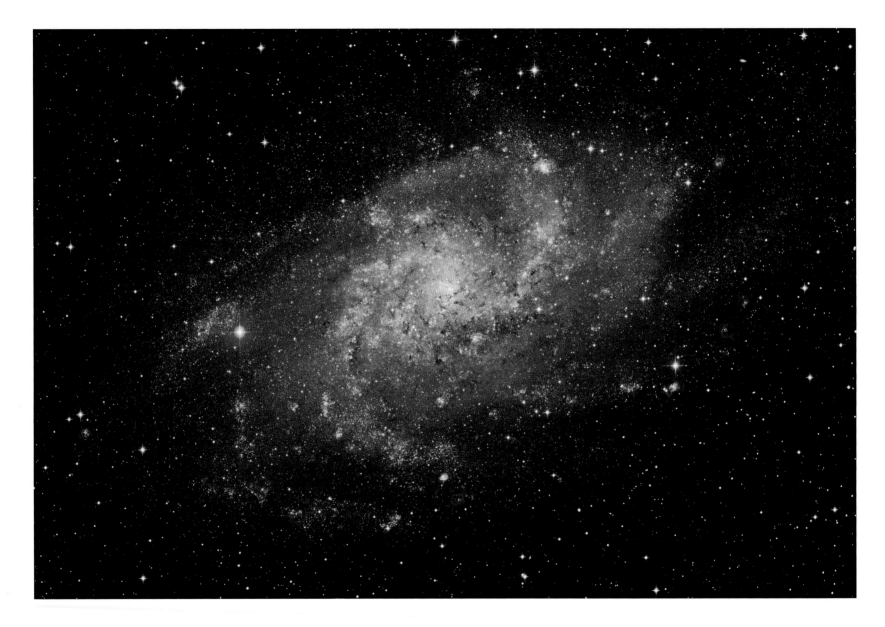

The Triangulum Galaxy

The Triangulum Galaxy (M33) is the third largest member of our local group, which includes the Milky Way, the Andromeda Galaxy (M31), and a host of smaller galaxies. Some of the data for this image was taken in hydrogen alpha light, which highlights the abundance of glowing rings, loops, arcs, and filaments that populate its broad spiral arms.

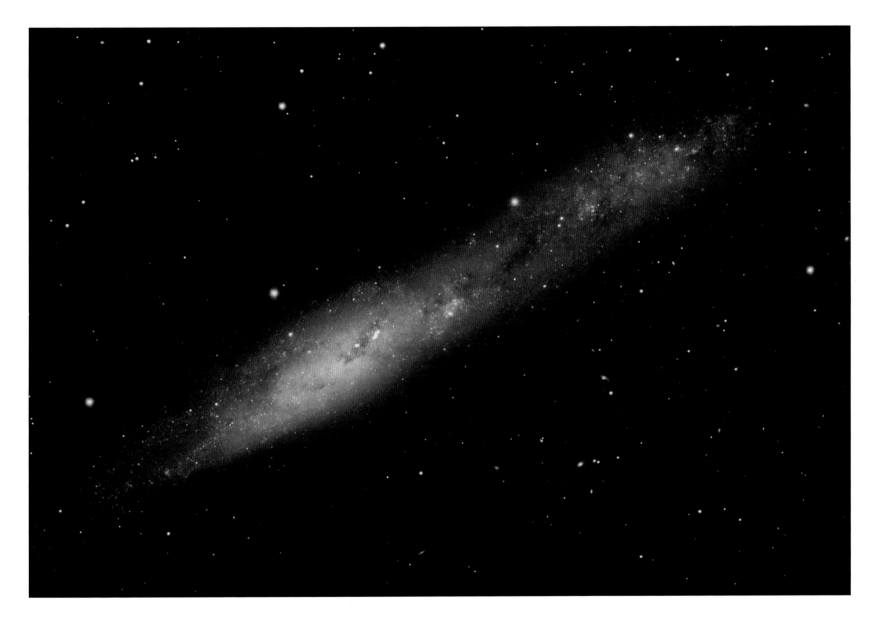

NGC 55

A member of the nearby Sculptor Group of galaxies, NGC 55 presents its disk edge-on to our line of sight. Giant nebulae and blue star clouds populate its disk, testifying to the dynamic state of this odd galaxy.

vdB 152

An ethereal scene is fashioned by the impact of hot massive blue stars on a serpentine complex of bright and dark nebulae in the constellation Cepheus.

INDEX